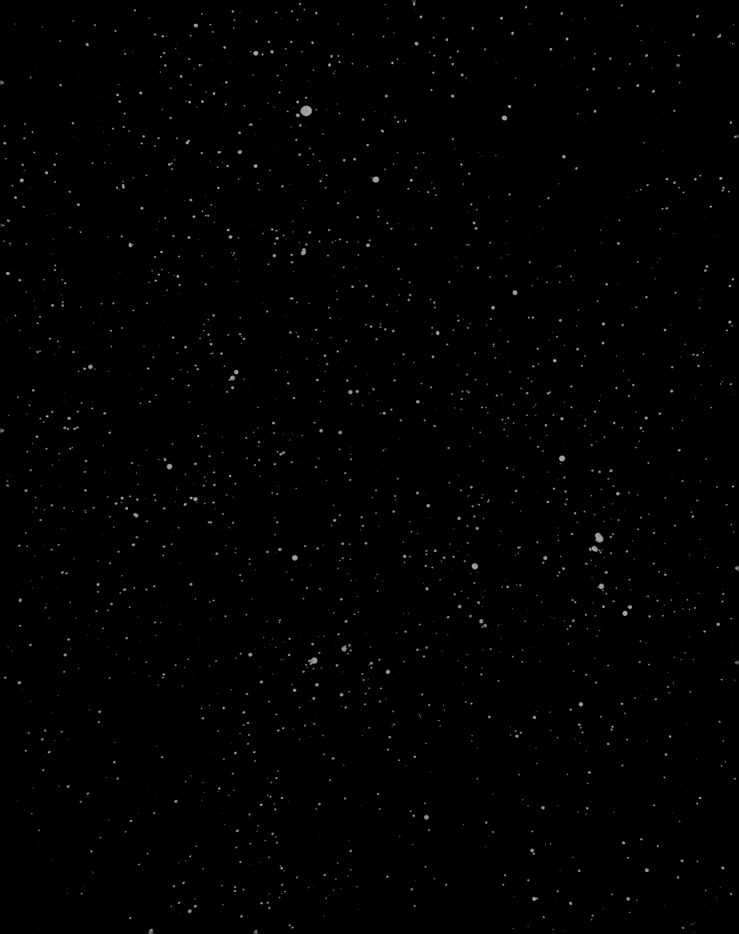

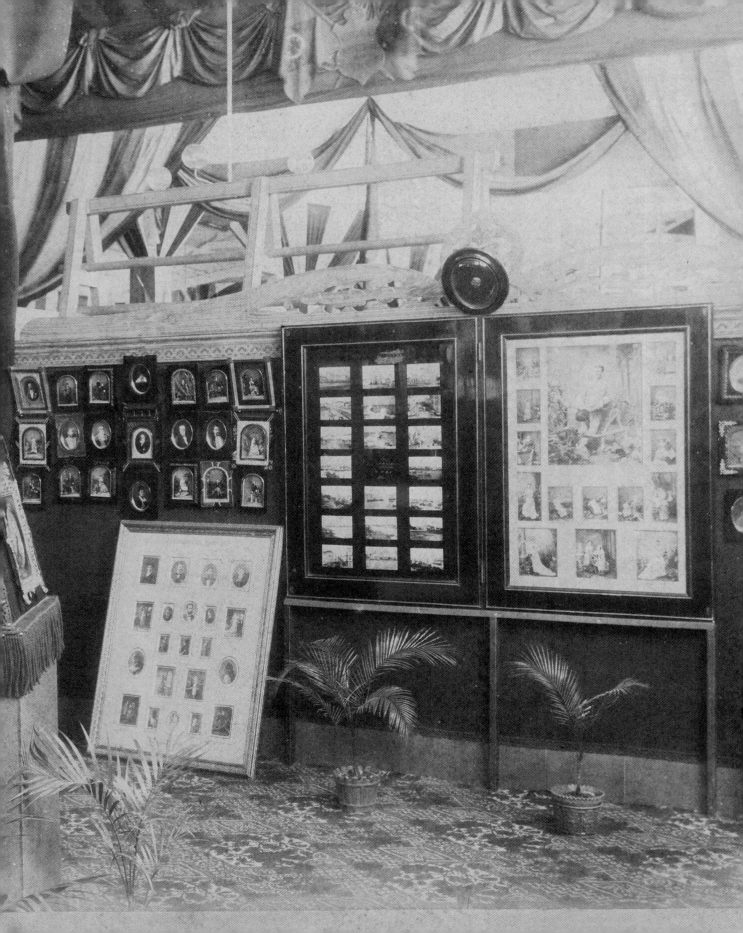

The Itinerant Languages of Photography

The Itinerant Languages
of Photography

Eduardo Cadava
Gabriela Nouzeilles

WITH CONTRIBUTIONS BY
Joan Fontcuberta
Valeria González
Thomas Keenan
Mauricio Lissovsky
John Mraz

Princeton University Art Museum
Distributed by Yale University Press,
New Haven and London

This book is published on the occasion of the exhibition

The Itinerant Languages of Photography
Princeton University Art Museum
September 7, 2013–January 19, 2014

The Itinerant Languages of Photography has been organized by the Princeton University Art Museum. The exhibition is supported, in part, by funds from the Council for International Teaching and Research, Princeton University, and by the Bagley Wright, Class of 1946, Contemporary Art Fund. Additional support has been provided by the Argentine Ministry of Foreign Affairs; by the Consulate General of Brazil in New York; by the David L. Meginnity, Class of 1958, Fund; and by the Department of Spanish and Portuguese, the Council of the Humanities, and the Program in Latin American Studies, Princeton University. Further support has been provided by Angelica and Neil Rudenstine, Class of 1956, and by the Partners and Friends of the Princeton University Art Museum. The publication has been supported, in part, by the Barr Ferree Foundation Publication Fund, Princeton University, and by the Joseph L. Shulman Foundation Fund for Art Museum Publications.

Front cover illustration
Rosângela Rennó, *A Última Foto / The Last Photo: Eduardo Brandão Holga 120*, 2006 (detail). (Plate 97)

Back cover illustration
Graciela Iturbide, *Cementerio* (Cemetery), *Juchitán, Oaxaca*, 1988 (detail). (Plate 52)

Frontispieces
Page 1: Prosper-Mathieu Henry and Paul-Pierre Henry, *Part of the Milky Way, Paris Observatory*, June 10, 1885 (detail). (Plate 8)
Page 2: Samuel Boote, *South American Continental Exhibition, Brazilian Section, Buenos Aires, Argentina*, 1882 (detail). (Plate 6)
Pages 4–5: José Medeiros, *Pátio do Palácio Gustavo Capanema, antigo Ministério da Educação* (Courtyard of the Gustavo Capanema Palace, former Ministry of Education), *Rio de Janeiro, Brasil*, 1960 (detail). (Plate 55)
Pages 6–7: Cássio Vasconcellos, *Múltiplos: É NÓIS (personas)* (Multiples: It is us [people]), 2011 (detail). (Plate 95)
Page 8: Joan Colom, *Gente de la calle* (People on the street), 1958–64. (Plate 62)

Produced by the Princeton University Art Museum
Princeton, New Jersey 08544-1018
artmuseum.princeton.edu

Curtis R. Scott, Associate Director for Publishing and Communications
Anna Brouwer, Associate Editor

Edited by Karen Jacobson
Designed by Miko McGinty and Rita Jules
Typeset by Tina Henderson
Index by Kathleen Friello
Proofread by Polly Watson
Prepress by The Production Department
Printed by Trifolio, Verona, Italy

Distributed by
Yale University Press
P.O. Box 209040
302 Temple Street
New Haven, CT
06520-9040
www.yalebooks.com/art

Library of Congress Control Number: 2013943619
ISBN: 978-0-943012-49-0 (Princeton University Art Museum)
ISBN: 978-0-300-17436-6 (Yale University Press)

The book was typeset in Fakt and printed on Multi Art Silk

Printed and bound in Italy
10 9 8 7 6 5 4 3 2 1

CONTENTS

Foreword

In an age of digital photographic production, dissemination, and consumption, in which photographic images pervade our lives perhaps more than ever before, examining the nature and history of image making—and the transmission of images—remains a critical task. From its inception, photography has involved the incessant circulation and exchange of images and technologies through varying contexts often far removed from their sites of origin. The history of photography is also the history of the camera itself, which—as it became lighter, easier to use, and less expensive—enabled image making and consumption to be democratized, ultimately allowing nearly everyone to become a maker of their own pictures. If photography seeks to capture and preserve images, it is only through processes of reproduction and displacement that the photographic act can be completed—if indeed it is accurate to say that it is ever completed.

As both book and exhibition, *The Itinerant Languages of Photography* asks us to consider the photograph as a globally transmitted, continually translated and annotated document, reinterpreted and reanimated through the lens of different histories, memories, and experiences. Presenting more than ninety works from public and private collections in Spain, Argentina, Brazil, Mexico, and the United States, including archival material that has rarely if ever been seen in the United States, the project explores the diverse, transnational history of photography. It is a history that calls attention to domains of production and circulation that move beyond what have been, until now, the dominant histories of photography.

Drawing on a heterogeneous corpus of photographic materials, guest curators and Princeton University faculty members Eduardo Cadava and Gabriela Nouzeilles have sought to trace photographic itinerancy from its origins in the nineteenth century to its present-day conceptual manifestations, including cultural practices and formations such as photojournalism, political photography, national forms of archivization, and what might be termed "collectionism." In doing so, they reveal the lines of passage through which images slip out of one visual archive only to enter another, in addition to showing how the same photographers alternately, and at times simultaneously, occupy different positions within the wider field of photographic practice. Such an approach restages photography's original conundrum, which is based on its contradictory relation to art, as it moves between high and low, unsettling definitions of what art is and can be. *The Itinerant Languages of Photography* also embodies the museum's possibilities and limitations as a home for photography, which is perhaps one of the most restless mediums.

This book and the exhibition that it accompanies attest to Princeton University's commitment to globalism as well as to the Princeton University Art Museum's long history of engagement with photography on an international stage. Many of the works selected for the exhibition now belong to the Museum's splendid and ever-growing photography collections, currently numbering more than twenty-seven thousand images, including classical modernist works by the Mexican photographers Manuel Alvarez Bravo, Enrique Metinides, and Graciela Iturbide, and new acquisitions in the field of Latin American conceptualism and political photography, such as Marcelo Brodsky's *The Undershirt*, Esteban Pastorino Díaz's *Carhué Town Hall*, and Gian Paolo Minelli's diptych *Chicas*. One of the happy outcomes of this project has been its role as a catalyst for deepening our holdings in Latin American photography, and I am delighted to recognize both Eduardo and Gabriela and the Museum's former curator of photography, Joel Smith, for their parts in seeing the multifaceted potential of a project of this kind.

From the time of its conception, this project has grown in scope and scale, and this has been possible only thanks to the many institutions and funders that have enthusiastically supported it. Our deepest gratitude goes to our international partners: the National Library and the Instituto Moreira Salles in Rio de Janeiro, Brazil; the Sistema Nacional de Fototecas (SINAFO) in Mexico; and the Fundación Foto Colectania in Barcelona, Spain, for granting the loans of exceptional pieces from their outstanding photographic collections. We are especially grateful to the Consulate General of Brazil in New York for its substantial support and its readiness to facilitate the transportation of the Brazilian works from Rio de Janeiro to Princeton and to the Argentine Ministry of Foreign Affairs for its generous support of the catalogue and its contribution to cover the costs of transporting the Argentine works.

Among our benefactors I must particularly thank the Council for International Teaching and Research at Princeton University and the Bagley Wright, Class of 1946, Contemporary Art Fund. Additional support has been provided by the David L. Meginnity, Class of 1958, Fund, and by the Department of Spanish and Portuguese, the Council of the Humanities, and the Program in Latin American Studies at Princeton University. Further support has been provided by Angelica and Neil Rudenstine, Class of 1956, and by the Partners and Friends of the Princeton University Art Museum. This publication has been supported, in part, by the Barr Ferree Foundation Publication Fund at Princeton University and by the Joseph L. Shulman Foundation Fund for Art Museum Publications. Without their generosity a project of this kind that asks us to consider a rich and previously unmined vein in the history of cultural production would not be possible.

The modes of transmission explored in *The Itinerant Languages of Photography* are ultimately limited neither to photography nor to the cultures and artists examined here. Indeed, the project's themes have tremendous potential for further investigation beyond the reach of the present volume. But by casting an eye to images as hauntingly memorable as those by Susan Meiselas, Graciela Iturbide, and Gian Paolo Minelli, to name but three of the artists who deserve wider recognition in this country, as well as works by acclaimed masters such as Tina Modotti, Henri Cartier-Bresson, and Manuel Alvarez Bravo, this project brings together a unique corpus of photographs with the power to transform our understanding of modernity.

James Christen Steward
Director
Princeton University Art Museum

Acknowledgments

It is a great pleasure to have this opportunity to express our indebtedness to all the people who have made this three-year project, and the exhibition and catalogue with which it concludes, possible.

We would like to extend our warmest thanks to everyone who participated in the workshops that we organized in Barcelona, Rio de Janeiro, Buenos Aires, and Mexico City over the last three years, each of whom has contributed to our ongoing and developing conception of what we hoped to achieve: Rafael Argullol, Ariella Azoulay, Ulrich Baer, Jennifer Bajorek, Mario Bellatin, Miguel Berga, Florencia Blanco, Fabienne Bradú, Marcelo Brodsky, Sergio Burgi, Alberto del Castillo, Anne Cheng, Natasha Christia, Esther Cohen, Tom Cohen, Paola Cortés-Rocca, Helouise Costa, Leila Danziger, Bruno Dubner, Okwui Enwezor, Manel Esclusa, Daniel Escorza Rodriguez, María de los Santos García Felguera, David Ferris, Joan Fontcuberta, Hal Foster, Esther Gabara, Valeria González, Maria Gough, Carles Guerra, Graciela Iturbide, Alfredo Jaar, Michael Jennings, Mauricio Kartun, Inés Katzenstein, Thomas Keenan, Jo Labanyi, Pamela Lee, Consuelo Lins, Mauricio Lissovsky, Angel Loureiro, Ricard Martinez, Jorge Luis Marzo, Joana Masó, Ana Maria Mauad, Susan Meiselas, Pedro Meyer, Antonio Monegal, Rebeca Monroy Nasr, Alfonso Morales, John Mraz, Martin Parr, Alan Pauls, Christopher Pinney, Gyan Prakash, Juan Priamo, Rachel Price, Salvatore Puglia, Rosângela Rennó, RES, Jorge Ribalta, José Antonio Rodriguez, Martha A. Sandweiss, Márcio Seligmann-Silva, Irene V. Small, Joel Smith, Graciela Speranza, Veronica Tell, Andrés Di Tella, Francesc Torres, Juan Carlos Valdez Marin, Cássio Vasconcellos, Samuel Villela, Samantha Zaragoza Luna, and Marcos Zimmerman.

We are particularly grateful to the coordinators of the four institutional partners in our research network—Antonio Monegal (Universitat Pompeu Fabra, Barcelona), Mauricio Lissovsky (Universidade Federal do Rio de Janeiro, Brazil), John Mraz (Universidad Autónoma de Puebla, Mexico), and Inés Katzenstein (Universidad Torcuato Di Tella University, Buenos Aires)—who helped co-organize the workshops that we hosted in Barcelona, Rio de Janeiro, Buenos Aires, and Mexico City, and who helped introduce us to so many outstanding photographic archives. In addition, we wish to recognize Sergio Burgi, of the Instituto Moreira Salles, who helped organize the Rio colloquium, and Esther Cohen, of the Instituto de Investigaciones Filológicas at UNAM, who helped coordinate our workshop at the Museo Memoria y Tolerancia in Mexico City. We are grateful to the staff at each of our venues, including, in addition to the institutions already mentioned, the Centre de Cultura Contemporània de Barcelona, and also for the support of the Instituto de Ciencias Sociales y Humanidades "Alfonso Vélez Pliego" at the Universidad Autónoma de Puebla.

Turning to the exhibition and the publication that accompanies it, we would like to thank Joel Smith, the former Peter C. Bunnell Curator of Photography at the Princeton University Art Museum, who initially helped us conceive the exhibition, and James Steward, the Museum's director, for his enthusiastic and steady support of the project. We would also like to extend our gratitude to the archives, collections, and galleries that lent or helped facilitate the acquisition of the works represented in the exhibition: the Instituto Moreira Salles and the National Library of Brazil in Rio de Janeiro; the Fundación Foto Colectania in Barcelona; the Sistema Nacional de Fototecas in Mexico; the Center for Creative Photography in Tucson; the Alejandra von Hartz Gallery in Miami; the Museum of Modern Art in New York; the Photographs Do Not Bend Gallery in Dallas;

the Princeton University Art Museum; the Rose Gallery in Santa Monica, California; the Universidad Panamericana in Mexico; and the Jorge G. Mora Collection in New York. For their extraordinary generosity and support, we want to thank the artists Florencia Blanco, Bruno Dubner, Joan Fontcuberta, Eduardo Gil, Graciela Iturbide, Susan Meiselas, Pedro Meyer, Pablo Ortiz Monasterio, Gian Paolo Minelli, Esteban Pastorino Díaz, Rosângela Rennó, RES, and Cássio Vasconcellos. Marcelo Brodsky deserves a special mention for his enthusiastic collaboration on so many fronts, and from the very beginning of our project.

The success of an exhibition of this scale requires the kind and expert efforts of many people. In regard to the support we received from the Princeton University Art Museum, we wish to thank Bart Thurber, associate director for collections and exhibitions, for his presence and for his always timely interventions. We wish to acknowledge Katherine Bussard, Peter C. Bunnell Curator of Photography, who was particularly helpful and supportive in the later stages of the planning and conception of the exhibition. We thank Michael Jacobs, manager of exhibition services, and his team of exhibition preparators for their attentive and caring exhibition design and installation. We owe associate registrars James Kopp and Emily McVeigh a felt debt for their capacity to negotiate the often complex loan arrangements and the movement of works from distant sources. Cathryn Goodwin, manager of collections information, secured images and reproduction rights, and Jeff Evans, photographer and digital image specialist, photographed artworks and reviewed images for the publication. Juliana Ochs Dweck, Andrew W. Mellon Curatorial Fellow for Collections Engagement, assisted in the preparation of labels, wall texts, and other didactic materials, and Caroline Harris, associate director for education and programming, helped coordinate a variety of associated educational programming. Nancy Stout, associate director for institutional advancement, and Kelly Freidenfelds, manager of corporate, foundation, and government relations, assisted with fundraising. Erin Firestone, manager of marketing and public relations, provided publicity for the exhibition. We enjoyed working with Curtis Scott, associate director for publishing and communications, and we especially appreciated his understanding of the project. We also thank Lehze Flax for her thoughtful graphic design.

The catalogue was beautifully designed by Miko McGinty and Rita Jules—we were particularly moved by their capacity to embody what we wanted to convey within the very production of the book—and the entire publication was overseen wonderfully by associate editor Anna Brouwer, whose humor, kindness, and generosity are a model for all of us. We are grateful to Karen Jacobson for her scrupulous and intelligent copyediting and for her wonderful ear for the rhythm of sentences. We also thank Sue Medlicott and Nerissa Dominguez Vales for their skillful production and color management. The catalogue was printed in Italy by Trifolio under the direction of Massimo Tonolli.

We wish to thank the authors of the essays included in the catalogue: Joan Fontcuberta, Valeria González, Thomas Keenan, Mauricio Lissovsky, and John Mraz. We also wish to express our gratitude to Sabrina Carletti, Carolina Carvalho, Elizabeth Holchberg, Jeffrey Lawrence, Ana Sabau, Melissa Tuckman, and Nathaniel Wolfson for their help with translations and wall texts; to Gerardo Muñoz for helping secure permissions for the reproduction of images; and to Silvana Bishop, Karen González, Sharon Kulik, and Patricia Zimmer for their generous administrative support.

Finally, but importantly, we would like to acknowledge the sponsorship and financial support provided by the Princeton Council for International Teaching and Research, the Princeton Institute for International and Regional Studies, the Program in Latin American Studies, the Department of Spanish and Portuguese Languages and Cultures, the Council of the Humanities, the Barr Ferree Foundation Publication Fund, and, beyond Princeton University, the Brazilian consulate and the Argentine Ministry of Foreign Affairs. We are immensely grateful for this support.

We thank everyone who made this project possible, in all its manifestations, and we hope that its existence confirms everyone's confidence in it.

Eduardo Cadava and Gabriela Nouzeilles

Introduction

Eduardo Cadava and Gabriela Nouzeilles

The Itinerant Languages of Photography begins with a simple axiom: that photography—as a set of technologies and practices, a series of discourses and languages, an ever-expanding archive—resists being fixed in a single place or time. It seeks to trace the movement of photographs as physical artifacts, as means of communication, as disembodied images and, indeed, to begin to develop a visual and linguistic lexicon for understanding and speaking about their migratory character. Like postcards, which often bear photographs and therefore evoke the itinerancy of images in general, photographs are moving signs that, traveling from one context to another, carry any number of open secrets. These secrets are simultaneously exposed and veiled, postmarked and yet full of dormant, unexpected meanings waiting to be viewed and read in the future. They travel from one forum to another—from the intimacy of the family album to the semiprivacy of museums and galleries, from print media into electronic, digitized states—and with each recontextualization and rereading, they redefine themselves and take on different and expanding significances. The history of photography is the history of a Pandora's box, which, opened at its beginnings, still lies in wait to have its inexhaustible worlds opened and circulated even further.

The Itinerant Languages of Photography began in the fall of 2010 as an experimental three-year interdisciplinary project, sponsored by the Princeton Council for International Teaching and Research, that sought to develop a photography research network in collaboration with the Universidad Torcuato Di Tella (Buenos Aires), the Universidade Federal do Rio de Janeiro and the Center for Photographic Research at the Instituto Moreira Salles (Rio de Janeiro), the Centro de Historia Gráfica at the Universidad Autónoma de Puebla (Puebla, Mexico), and the Universitat Pompeu Fabra (Barcelona). Our aim was to initiate and develop new forms of international interdisciplinary collaboration, across widely varied fields of expertise, that could bring together scholars, curators, photographers, and artists from Latin America, Europe, the United States, and potentially other areas of the world, all of whom are involved in international circuits of image production.

The project sought to study what we call the itinerant languages of photography and, in particular, how these languages operate within the history of photography in general and within international and global networks of collaboration and exchange. The phrase "itinerant languages" refers to the various means whereby photographs not only "speak" but also move across historical periods, national borders, and different mediums. This movement may be one of the key signatures of our modernity. Indeed, despite the many ominous predictions of photography's imminent and irreversible disappearance, we all have become *homines photographici*—obsessive archivists taking and storing hundreds and thousands of images, exchanging photographs across borders with other equally frenzied, spontaneous archivists around the globe. From this perspective, the ubiquity and mass circulation of images that characterize the present are the latest manifestation of an itinerant condition that has belonged to photography from its beginnings. Tracing the movement of photographs across different national photographic traditions, we hoped to explore the always-changing contours of modernity and the role and place of images within it, and even the identification between modernity and the production and reproduction of images.

Our exploration has taken as its point of departure Latin American and Spanish Catalonian archives, even as it also has sought to demonstrate that these archives cannot be contained within national or regional narratives. In the context of an explosion of "world photography"—an explosion that lets us know that there has been not just one photographic archive but rather innumerable archives and histories, all of which deserve to be studied "independently" and in relation to one another—Latin America has been at the forefront of the development of new aesthetic paradigms in modern and contemporary photography. The region also possesses some of the world's most outstanding photographic archives, including the Instituto Moreira Salles collection, which holds more than 550,000 photographs by Brazilian and foreign photographers; the Sistema Nacional de Fototecas (SINAFO), which holds more than 800,000 images; and the Hermanos Mayo archive, housed in Mexico's General National Archive, with more than five million images taken over several decades by a family of Spanish exiles and photojournalists. Equally significant to us is the diversity that characterizes Latin American photography, as it has been deeply affected by the continent's regional histories and its vast cultural and ethnic heterogeneity. Across the Atlantic, and marked by the complexities of a country with many languages and many conflicting cultural and political traditions, Barcelona gave us access to a rich Catalonian tradition of modern photographers with a long history of exchanges with Latin America and Europe, to remarkable public and private photo collections such as Foto Colectania, and to a vibrant community of scholars, curators, and artists, including Joan Fontcuberta and Francesc Torres, who have engaged in debates about the nature of photography in relation to history, truth, and the contradictory uses of the archive. These different "sites" have helped us call attention to significant but often neglected histories of photography beyond the dominant European and American canon and, in particular, to the transnational dimension of image production at a time when photography is at the center of debates on the role of representation, authorship, and communication in global contemporary art and culture.

The project began with a series of international conferences, colloquia, and workshops in Princeton, Barcelona, Rio de Janeiro, Buenos Aires, and Mexico City, involving not only scholars and cultural critics but also curators, writers, photographers, and artists from different countries. Viewing photography as a transnational cultural practice, as a complex, multi-layered field of technological, aesthetic, social, and critical traditions, we encouraged the participants to think about different forms of photographic itinerancy. The meetings included presentations by, among many others, AtelieRetaguardia, Mario Bellatin, Marcelo Brodsky, Okwui Enwezor, Joan Fontcuberta, Hal Foster, Graciela Iturbide, Alfredo Jaar, Susan Meiselas, Pedro Meyer, Pablo Ortiz Monasterio, Christopher Pinney, Salvatore Puglia, Rosângela Rennó, Graciela Speranza, and Francesc Torres.

In particular, we asked the participants to consider the itinerancy of photographs in at least the following three contexts, which are discussed in greater detail below: (1) the circulation and exchange of images beyond cultural, social, ethnic, and national borders; (2) the dialogue between photography and other mediums—such as literature, cinema, architecture, and art—in an international context; and (3) the relationship between photography and the archive with regard to questions of memory, history, and what we might call a "photographic poetics."

Circulation and exchange. From its beginnings, photography has been another name for the circulation and displacement of images. Whatever form photography has taken, it has been destined to travel, to move across the globe, and in innumerable guises. If we have wanted to think about itinerant photographs in relation to their provenance or in relation to particular "national" archives, we also have been interested in how these origins and archives are produced, affected, and transformed by the circulation, appropriation, and reinterpretation of images by different political and cultural agents, including state and scientific institutions as well as local and foreign photographers, artists, and writers. The unforeseeable political transformations of Susan Meiselas's "Molotov Man" or the contradictory uses of Alberto Korda's famous photograph of Che Guevara, "Guerrillero heroico," are examples of the malleability of the itinerant photographic image, as is the wonderfully itinerant history of the "Mexican Suitcase," containing Robert Capa's long-lost Spanish Civil War negatives, which arrived at the International Center of Photography in New York in 2007 after a journey that included at

least Spain, France, and Mexico and spanned several decades. The readings and rereadings of photographs of the horrendous form of execution called *lingchi*, taken in China by a French colonial officer in 1904, in works of the French philosopher Georges Bataille and the Latin American avant-garde writers Julio Cortázar and Severo Sarduy illuminate even further the unpredictable effects of photography's potential for transformation and recoding.

This movement has been facilitated by traveling photographers with different aesthetic, scientific, and political agendas, who helped define the visual iconography of whole regions, societies, cultures, and even continents and whose pictures continue to intervene in international debates on development, human rights, and ecology. (The high visibility and wide circulation of the Brazilian photographer Sebastião Salgado's work on displaced peoples and exploited workers from all over the globe comes to mind here, as does the itinerant work of the Parisian guerrilla photographer JR and the human rights photographer Fazal Sheikh, who have worked in Brazil and other parts of Latin America.) It was intensified by technological means and, for this reason, we also wanted to think about images that were produced in order to be circulated, beginning with the invention of postcards in the context of national and international tourism and the economic and symbolic transactions associated with it, and continuing all the way to the radical transformations in image production and exchange that have emerged in the aftermath of new electronic and technological developments such as the Internet, social networking, cell phones, laptops, and tablets.

Photography and other mediums. Since 1839, when the invention of the daguerreotype was made public, photography has established itself in dialogue with other mediums—borrowing, adapting, and incorporating traits of these mediums but also questioning the logics of representation that it presumably shared with them. At the same time that it struggled to distinguish itself from painting, for example, it continued to share many of its compositional rules and generic conventions. Born from the elements of photography, cinema sought to separate itself from it by establishing a different relationship to narrative, perception, and the experience of time, even while it remained anchored in the theoretical underpinnings of the photographic image, between the stillness

of the isolated image and its continuous dissolution into others. The construction of the modern writer as a public persona owes much of its success to the adoption of photography as a means of self-representation. From Charles Baudelaire to Samuel Beckett and Jorge Luis Borges, from André Breton to Julio Cortázar and Mario Bellatin, the photographic portrait has helped define the theatricality of writing as a public practice.

In light of contemporary debates on intermedia or the postmedium era—debates that seek to describe the crossing of borders between traditional and contemporary media, that view every medium as a multimedium—the project poses the question of the itinerant languages of photography as it approaches, engages, and intersects with different mediums that, in turn, transform our sense of photography itself. Indeed, what happens to the photographic image when it assumes the shape of a photo sculpture, becomes a projection on a screen, or travels from a newspaper to an art gallery or to the pages of a book? How does literature, as in the case of the work of the Spanish writer Javier Marías or the Mexican media artist and writer Bellatin, frame, resist, or adapt photography through language and the written word? And how does photography—through captions, quotations, and paratexts—engage writing and the literary world in the work of photographers and artists such as Manel Esclusa, Abelardo Morell, or Jeff Wall? How do films incorporate photographs as signs through which they critically discuss the nature of time, memory, and identity? How do photographs expand their arresting power in order to record the virtual passing of time in film? Paolo Gasparini's cinematic photo books, Chris Marker's *La jetée* (1962), Cindy Sherman's *Untitled Film Stills* (1977–80), and Hiroshi Sugimoto's movie theater photographs (1978–) are exemplary of the radical possibilities of such a collaboration, and of the ways in which such intersections require a reconceptualization of photography and its relations to its various "others."

Photography and the archive. The project also explores the archival uses of photography and the photographic uses of the archive as a system of traces that are preserved but also categorized and recategorized in accordance with its use, its development or diminishment, or its mobilization in relation to different interests,

political or otherwise. The archive's materials are always moving and changing and, in doing so, enacting all the paradoxes that we have come to associate with the archive: at once a repository and a proteiform memorial, a record and a mechanism of transformation, a passive means of storage and a performative event. If the photograph is always viewed as an archival trace, it is a trace whose significance always changes in relation to the context in which it is situated or displaced.

From the moment Kodak made commercial processing possible, photography has feverishly generated pictures and all sorts of archives, including the massively ambitious archival structures established by the state and its disciplinary apparatuses. This is perhaps why the role of the photographic archive as an aspect of public memory has retained its power over a diverse group of artists and intellectuals, who continue to use archival images as documentary responses to historical events, especially traumatic ones. Here we wanted to study, on the one hand, the archival uses of photography as a means of producing a legal, historical, or anthropological record and, on the other, the photographic uses of the archive as a principle of organization that stores, exchanges, and transmits images. Consequently we have been especially interested in artists and photographers who produce photographic archives, or whose work, reflecting on the misuses and limitations of archival work, nevertheless seeks to rescue forgotten archives or to create counterarchives. Such a gesture is legible in Marcelo Brodsky's *La camiseta* (The undershirt, 1979; fig. 1, pl. 88), a photograph of Victor Basterra's hand holding a picture of Brodsky's disappeared brother Fernando. (Basterra is a photographer who, having been kidnapped, escaped and smuggled the negative of Fernando's portrait out of the Escuela de Mecánica de la Armada, which functioned as a detention and torture center under the Argentine dictatorship.) Brodsky's photograph is a photograph of a photograph and therefore itself a kind of archive, a repository for an image, particularly one that can be viewed only in relation to the trauma that it references, at least in Brodsky's eyes. It is also a recontextualization that challenges and counters the photograph's original disciplinary purpose by transforming the photograph into an image, "in spite of all," of survival and of the demand for justice. Preoccupied with issues of human rights, ethnic genocide, or social injustice, such works

understand that the photograph can represent the physical trace of a forced absence, the building stone of a collective monument, and the fragility of memory.

Taking these three contexts as a point of departure, we have sought to create a kind of manual for addressing, engaging, and reading the most significant and pervasive concepts and terms of photographic discourse and practice. We have also attempted to establish a kind of lexicon based on a sense of the itinerary of the languages that, ever since photography's invention, have enabled us to speak about photography and about photography as a medium that is never just one. If photography—as a word, a concept, or a set of practices—is never at rest, is always moving, it is because it is always divided against itself. A wandering image and a historical artifact, the photograph opens onto a multiplicity of contexts, which is what moves the archive to its own demise and to the possibility of new archival formations through which images are appropriated and made to speak new languages.

The Itinerant Languages of Photography completes its cycle with a photography exhibition, which we have envisioned as at once a multilayered material installation and a conceptual apparatus through which we can further explore photography's itinerant condition. Enacting an instance of this essential itinerary by transporting photographs across oceans and continents to the Princeton University Art Museum, the exhibition represents a collaboration between the Museum and the Fundación Foto Colectania in Barcelona, the National Library of Brazil and the Instituto Moreira Salles in Rio de Janeiro, the Sistema Nacional de Fototecas in Mexico, and modern and contemporary photographers across different national borders. It is divided into four sections—"Itinerant Photographs," "Itinerant Revolutions," "Itinerant Subjects," and "Itinerant Archives"—each seeking to illustrate an aspect of the itinerary of photographs in relation to particular archives, even as, because of the permeable borders between the sections, each serves as a kind of caption for the others. Beyond this explicit narrative organization into four sections, there is a second order of understanding at work, according to which Spanish, Argentine, Brazilian, and Mexican photographic images converse across temporal, political, and cultural boundaries, speaking a language of graphic figures, historical citations, and visual echoes

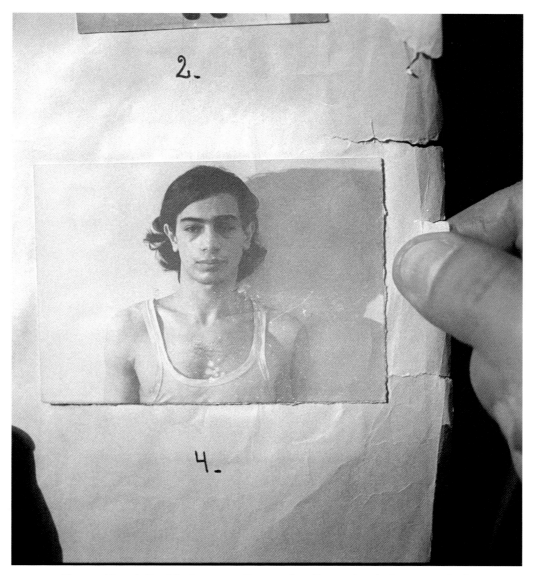

Figure 1. Marcelo Brodsky (born 1954, Buenos Aires; lives and works in Buenos Aires),
La camiseta (The undershirt), 1979 (printed 2012). LAMBDA digital photographic print, 62 x 53.5 cm.
Courtesy of the artist

that seek to replicate photography's itinerancy in the experience of the viewer who moves from room to room, carrying memory traces of images seen in one room into another. Indeed, the exhibition embodies and displays our interest in the unpredictable and creative ways in which photographic images speak to one another across time and space, producing visual narratives or poetic counterpoints through the repetition and displacement of figures, colors, and compositional arrangements.

This visual echolalia is legible in, among other repeating motifs, the shadows, the watery reflections, the crowds, the telephone wires, the corpses, and the photographs within photographs that punctuate the exhibition. These visual conversations are juxtaposed with images from European and American photographers in order to open the exhibition to other traditions and archives and to highlight the ways in which no "national" photographic tradition can ever remain closed to "outside" influences.

The selection of materials also points to the inherent instability and ambivalence of photographs and the difficulty of categorizing and valuing them across time. This is legible in the fact that many of the images that are included in one of the four sections could also have been included in another section. This mobility points to the richness, depth, and flexibility of images in general but also to the variety of works on display. The exhibition includes prints by European photographers that were collected by the Brazilian emperor, images that were widely circulated as picture postcards during the Mexican Revolution, iconic images from the tradition of Mexican art photography, photographs by Ibero-American street photographers, and contemporary Argentine and Brazilian conceptual artifacts.

The first section of the exhibition, "Itinerant Photographs," offers a glimpse into the transnational history of early photography by displaying the circulation of images in Brazil in the second half of the nineteenth century. It draws its materials from two important Brazilian photography collections: the Thereza Christina Maria Collection, which consists of more than twenty-one thousand photographs assembled by Emperor Pedro II, and the Instituto Moreira Salles's collections of early Brazilian photography. Corresponding to a political desire to take possession of the world by amassing pictures of it, the emperor's collection includes myriad photographs that arrived in Rio de Janeiro from Europe, Africa, and North America. The section also includes photographs by the itinerant inventor and photographer Marc Ferrez, whose Brazilian landscapes transferred images of the interior of Brazil to Brazil's cities and then circulated as postcards that helped create the modern perception of Brazil, both inside and outside the country.

The second section, "Itinerant Revolutions," displays archival materials from Mexico's Sistema Nacional de Fototecas and representative works by renowned international and Mexican modernist photographers. The notion of itinerancy appears in this section in two interrelated forms: first, in relation to the explosion of photographic desire ignited by the Mexican Revolution (1910–20), which produced a massive movement of images across the country and abroad, and, second, in relation to the development of a photographic revolution based on dialogues and exchanges between local photographers, such as Manuel and Lola Alvarez Bravo and their heirs, and an international artistic and political

avant-garde of peripatetic photographers represented by Tina Modotti, Henri Cartier-Bresson, and Paul Strand. Rejecting the notion of photographic transparency and picturesque aesthetics that photographers such as Hugo Brehme had used to portray Mexico and its peoples, these photographers sought to renew the medium through formal experimentation and a modernist rereading of "Mexican" visual identity. The section also includes a vitrine curated by the historian John Mraz that focuses on iconic images from the revolution.

The third section, "Itinerant Subjects," seeks to reflect on the different ways in which photography approaches moving subjects. It draws materials from the Fundación Foto Colectania and for the first time introduces to the American public the work of the street photographer Joan Colom, particularly his expressionist photographs of Barcelona's underground worlds, and a segment of the Mexican photojournalist Nacho López's surrealistic cinematic photo-essays. The section includes photographs by Eduardo Gil, Graciela Iturbide, Elsa Medina, Susan Meiselas, and Pedro Meyer that depict various forms of political itinerancy and migration, as well as a number of wildly different scenes that stage the relation between walking and seeing, between moving and attending to one's shifting surroundings.

The last section of the exhibition, "Itinerant Archives," explores the way in which archival traces are duplicated and revitalized through quotation and recontextualization within a selection of works drawn mostly from Argentine experimental photographers. This section is defined by a strong conceptualist poetics that looks at photography as a multidimensional, complex historical apparatus, always defining itself vis-à-vis other mediums and in relation to its own history. While Toni Catany and RES use quotation as a means of paying tribute to classic photography and literature, Florencia Blanco's, Brodsky's, and Meiselas's works serve as reframing devices that present older photographs whose original meanings are slowly vanishing. Rosângela Rennó, Esteban Pastorino Díaz, and Bruno Dubner, in contrast, offer conceptual meditations on the photographic condition by resorting to older photographic technologies and processes, such as the analog camera, gum printing, and the photogram. In the works of Fontcuberta and Cássio Vasconcellos, the infinite possibilities of the digital archive provide ways of creating or re-creating images that are the result of the reality

effect achieved by visual duplication and cloning. This section includes a vitrine containing several significant Latin American photo books, many of which portray urban and rural scenes of walking, dancing, and other kinds of movement, and a visual correspondence between photographers and artists from Latin America and Europe, who exchanged images by e-mail in a wonderfully playful and self-reflexive enactment of photography's itinerary.

This publication corresponds to but also transcends the display of photographic works at the Princeton University Art Museum. In its approach to the narrative sequencing of the images and their presentation on the page, it seeks to inscribe the potential of a new series of iterations, as the photographic contents of the exhibition continue their journey within its pages. Like Duchamp's restless suitcase, the book format provides a means of transportation and the open promise of future readings and interpretations.

It also offers the possibility of productive connections between word and image, through the inclusion of essays about photographic itinerary: two general essays written by us, the co-curators; four by scholars and writers from the sites represented in the project, Joan Fontcuberta (Barcelona), Valeria González (Buenos Aires), Mauricio Lissovsky (Rio de Janeiro), and John Mraz (Mexico City); and one by a guest scholar from the United States, Thomas Keenan. Each contributor was invited to explore one or more aspects of photography's itinerant condition in relation to particular photographers or photographs, without the requirement that the materials had to be represented in the exhibition. Their archival choices and critical approaches complement and enhance the materials in the exhibition.

Cadava's opening essay seeks to lay out the terms of the questions raised by our more general project by focusing on a series of photographs from different national traditions—from the very first photograph, by Joseph Nicéphore Niépce, to its iterations in Fontcuberta's *Googlegram: Niépce* (2005; pl. 1), from a photograph by the Guatemalan photographer Luis González Palma to the Brazilian artist Rosângela Rennó's *A Última Foto / The Last Photo* (2006; pl. 97) and the transnational, multimedia *Visual Correspondences* project (2006–10; pls. 82–84), initiated by Marcelo Brodsky—in order to delineate the historical and theoretical consequences of itinerancy for the history of photography. Nouzeilles's

essay begins with a detailed meditation on the nature of the photographic archive, and its inherently mobile condition, and then proceeds to analyze two conspicuous cases of archival itinerary: the imperial fantasy of collecting the world as pictures that informs the collection of Pedro II and the experimental archival works of Rosângela Rennó, who mobilizes neglected visual materials in order to create a different set of archives that might work against the repressive power and negligence of the state apparatuses that instrumentalize photography toward disciplinary ends. The media critic Lissovsky links photographic itinerary not with actual movement but with the figure of the double in modern photography, from the duplication of a photographed subject through the manipulation of images to the religious precedent of duplicating the trace of a body on a white surface, which becomes a kind of figure for the transfer and movement of the photographic trace. The historian Mraz offers a fascinating reconstruction of the movement and transformation of a small but representative group of iconic and highly unstable photographs—images that, in his words, float—related to the Mexican revolutionary archive. González and Keenan meditate on Walter Benjamin's concept of the optical unconscious in relation to the works of artists and photographers, including the Argentine photographer RES and the Lebanese artist and activist Walid Raad, who question the transparency of the photographic document and call for a political reading of images that begins with "taking a second look" at them in order to elicit their hidden meanings, to register what remains unseen, and to imagine a politics that would begin with these invisible traces. Finally, the photographer and essayist Fontcuberta writes about the exponential growth in the production, circulation, and accumulation of images through the massive introduction of visual technologies into our everyday lives, and the fantasies that the possibility of absolute surveillance and control, of a completely autonomous camera eye, have produced in photography, film, and literature.

Whether as project, symposia, exhibition, or catalogue, *The Itinerant Languages of Photography* seeks to explore, embody, and enact photography's essential itinerancy, which defines a medium that, as Benjamin so often told us, has no other fixity than its own incessant transformation, its endless movement across space and time.

The Itinerant Languages of Photography

Eduardo Cadava

The years 1860 to 1880 witnessed a new frenzy for images, which circulated rapidly between camera and easel, between canvas and plate and paper—sensitized or printed; with all the new powers acquired there came a new freedom of transposition, displacement, and transformation, of resemblance and dissimulation, of reproduction, duplication, and trickery of effect. . . . There emerged a vast field of play where technicians and amateurs, artists and illusionists, unworried about identity, took pleasure in disporting themselves. Perhaps they were less in love with paintings or photographic plates than with the images themselves, with their migration and perversion, their transvestism, their disguised difference. Images—whether drawings, engravings, photographs or paintings—were no doubt admired for their power to make one think of other things; but what was particularly enchanting was their ability, in their surreptitious difference, to be mistaken for one another. The emergence of realism cannot be separated from this great surge and flurry of multiple and similar images. . . . Fidelity to things themselves was both a challenge to and the occasion for this glide of the images that danced and turned about them, always the same and imperceptibly different.

How might we recover this madness, this insolent freedom that accompanied the birth of photography? In those days images traveled the world under false identities. To them there was nothing more hateful than to remain captive, self-identical, in *one* painting, *one* photograph, *one* engraving, under the aegis of *one* author. No medium, no language, no syntax could contain them; from birth to last resting place they could always escape through new techniques of transposition.

—Michel Foucault

I. Never Just One Thing

Photography is mad, even insolent. It refuses to be fixed or to be defined in a determinate way. It is, in the words of Roland Barthes, "unclassifiable."[1] Its signature characteristic is perhaps its capacity to take on different forms, relentlessly and restlessly, to migrate, to travel, to move, often away from itself, and often in relation to other mediums. Indeed, within this frenzy of circulation—this irresistible movement of transposition, displacement, transformation, and reproduction—how can we even say what a photograph is, especially when, as Michel Foucault would have it, the birth of photography did not announce the birth of a discrete medium but rather an unprecedented explosion of incessantly changing visual phenomena, of all sorts of hybrid interactions among several mediums, including drawing, painting, engraving, and photography? Evoking the early photogenic drawings of William Henry Fox Talbot and the experiments of Hippolyte Bayard; the composites of Oscar Rejlander and the painterly, often literary-based images of Julia Margaret Cameron; photographs of books from *Don Quixote* to *Robinson Crusoe* and beyond; photographs that sought to cite and even become paintings; collages and photomontages that incorporated elements from different mediums; scratched and manipulated negatives that helped produce Impressionist photo-paintings; images developed on all kinds of material surfaces (eggshells, silk, lampshades, porcelain, and so forth), Foucault traces the wild itinerary of the photograph and what he calls the "transvestism" of nineteenth-century images in general. He delineates a world in which mediums can appear only under false names, false identities, which disguise or minimize each medium's multimedia character, its capacity to exceed the name that would

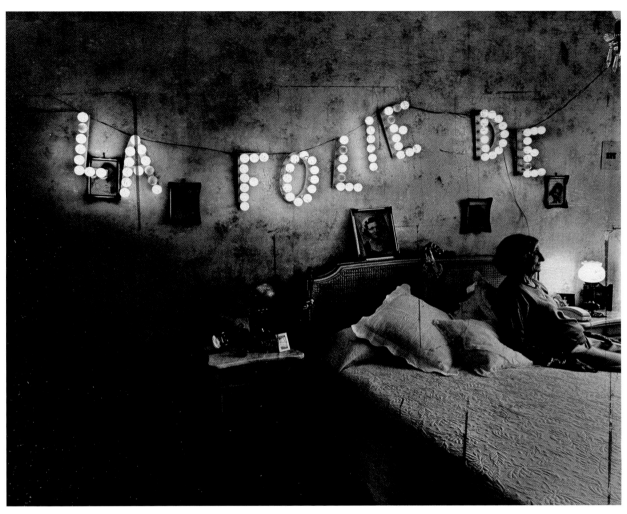

Figure 2. Luis González Palma (born 1957, Guatemala; lives and works in Córdoba, Argentina), *Estrategia que nos une* (Strategy that unites us), 2005. Kodalith, gold leaf, and red paper embedded in resin, 50.8 x 61 cm and 101.6 x 127 cm. Courtesy of the artist and Schneider Gallery, Chicago

distinguish it from other mediums, its refusal "to remain captive, self-identical, in *one* painting, *one* photograph, *one* engraving, under the aegis of *one* author."

Within this endless itinerary, this incessant movement and transformation, how can we specify what a photograph is? What is it that makes a photograph a photograph, as opposed to something else? How can we know what a photograph is when it has appeared in so many different guises (heliograph, photogenic drawing, calotype, talbotype, cyanotype, daguerreotype, photogram, pinhole image, analog or digital photograph) but

also in relation to so many different processes (among others, silver chloride, collodion, gelatin emulsion, pinhole, celluloid film base, and digitization)? In reviewing the history of photography, the only thing we can say with any kind of clarity is that a photograph has never been a single thing, has never had a consistent form, has never remained identical to itself. Instead it has continually been altered, transformed, and circulated and is by definition itinerant. We might even say, following Walter Benjamin, that the photographic image comes into being only as a consequence of reproduction, displacement,

and itinerancy.[2] This is why, from the very moment the daguerreotype was invented, there was less interest in the invention itself than in the way in which it could be transposed onto engraving plates from which multiple ink-on-paper copies could be printed.[3] But this is simply to say that the photographic image always has been destined to take on other forms. Indeed, if the whirlwind of metaphors unleashed by photography since its historical appearance revolves with conspicuous constancy around several motifs—including technology, memory, forgetting, reproduction, death, mourning, and language—with equal constancy, this proliferation of metaphors bears witness to the fact that photography eludes strict definition. Whatever transparency or "fidelity to things themselves" photographs may suggest, they must be understood as surfaces that bear the traces of an entire network of historical relations, of a complex history of production and reproduction, that gives them a depth that always takes them elsewhere, always links them to other times and places.

This wildness is evident in Luis González Palma's *Jerarguías de intimidad* (Hierarchies of intimacy), a series begun in 2002 and organized around four themes: the encounter, mourning, the annunciation, and separation. The image here (fig. 2) is from the "mourning" sequence and is, among other things, a photograph of photographs, a photograph that suggests that every photograph bears multiple images within it, that every photograph is as much about memory, silence, and solitude as it is about mourning and relation. Surrounded by images—photographs but also framed, miniaturized reproductions of paintings—an elderly woman sits on a bed, frozen like the children and the woman in the photographs around her (the portrait of the woman above the bed is likely an earlier image of her and therefore suggests an identification between the woman and the images within the image, even though her relation to these other images remains indeterminate), with her age seemingly replicated in the distressed, worn appearance of the image itself. The woman looks beyond the frame of the photograph, into a future that, however unknown it may be, nevertheless includes her death, if not the word or words that would follow the incomplete phrase "La folie de . . ." strung along the wall. Her disappearance already is anticipated by the disordered photographs that, suggesting a kind of movement from left to right that leads only to her, evoke the absence of the photographed—a point

that is reinforced by the way in which the lights along the wall fade as they move closer to her, suggesting the darkness that may soon engulf her.

That the image is staged, that it appears as a kind of scene, opens the private, intimate space to public view and therefore suggests the circulation of images inside, across, and beyond the private sphere. Titled *Estrategia que nos une* (Strategy that unites us) by González Palma's wife, Graciela de Oliveira, and not by the photographer himself, the image inscribes us into its nearly surreal space, into this strange photograph that, before our very eyes, ruins the distinctions it proposes and unites us in relation to this ruin. It bequeaths to us a space—the space of the photograph as well as the photographed space—in which we can no longer know what space is. It offers us a time—the time of the photograph and the photographed time—in which we no longer know what time is. The limits, the borders, and the distinctions that would guarantee our understanding of the image have been shattered by a madness from which no determination can be sheltered, by a "strategy that unites us" within a time-crossed space that joins the past, the present, and the future in such a way that none of them can exist alone.

Using Kodalith, red paper, and gold leaf, painted over with a watery layer of resin, González Palma here produces a photograph that seems to belong to an earlier era, a photograph that, evoking older and even lost printing techniques, incorporates traces of other mediums. (This is beyond the fact of González Palma's own itinerancy: born in Guatemala, he now lives and works in Argentina, and before turning to photography, he studied architecture, painting, and cinematography.) Moving between different historical periods, the brushstrokes and bits of red showing through the gold produce a luminous patina that seems to bear the traces of time, as if the photograph's relation to the past were itself reiterated in the image's materiality, something that is reinforced by the resin that encases the image, transforming it into a kind of mysterious memorial or photographic reliquary. If time would seem to ruin the photograph, however, this ruined photograph also interrupts the movement of time, in a manner that has not the form of time but rather the form of time's interruption, the form of a pause, of a wound. This ruined photograph wounds the form of time. It suspends and deranges time. But since time—and all time—can be deranged in this way, the time inscribed in

this image perhaps names a kind of madness. And this madness is nothing else than the madness of light, a delirium and danger that are inscribed in the phrase "La folie de . . . ," "the madness of . . . ," which appears across the wall and above the woman. Within the image's visual grammar and syntax, "La folie de . . . " could refer to the madness of photographs, since photographs are directly underneath the phrase, as if they are themselves a kind of alphabet (in this instance, an uncertain, nonlinear sequence of letters), but because the phrase is incomplete and therefore mobile in its reference, because it is spelled out by lightbulbs, it also could refer to the madness of light itself. The image seems to tell us that whatever is illumined by this light—the emergence of the image, for example—is immediately touched by death and finitude (we need only recall that this image belongs to the "mourning" sequence of the larger project). Since the photograph is not simply a photograph, then— it is interwoven with other materials—it is a photograph that withdraws from itself, that announces its mortality, its incapacity to remain itself. This is a photograph, in other words, that has, sealed within it, a story of photography's mad history.

II. First and Last Photographs

This madness can be seen even in the history of what we have come to view as the very first photograph, Joseph Nicéphore Niépce's *View from the Window at Le Gras* (fig. 3), a photograph whose itinerancy and intermedial composition tell us what is true of every photograph. In 1826, seeking to develop different techniques that might help him improve the process of making lithographs, Niépce set up a camera obscura in the bedroom window of his country house, Le Gras. He placed a polished pewter plate coated with bitumen in it and opened the lens. Accounts of the length of the experiment differ, but because the exposure time seems to have been any- where from eight hours to three or more days, what is clear is that the duration made it impossible for the photographed buildings and landscape to correspond to what the human gaze would see. Niépce removed the plate and washed it, enabling the image of the view from the window to appear, however faintly. The result was a permanent direct positive picture whose gradations of light were produced by the alternations between the hardened bitumen and the surface of the pewter plate. The view represents (from left to right): "the upper loft

Figure 3. Joseph Nicéphore Niépce (French, 1765–1833), *View from the Window at Le Gras*, ca. 1826. Heliograph, 16.7 x 20.2 x 0.2 cm. Gernsheim Collection, Harry Ransom Center, The University of Texas at Austin

(or so-called 'pigeon-house') of the family house; a pear tree with a patch of sky showing through an opening in the branches; the slanting roof of the barn, with the long roof and low chimney of the bake house behind it; and, on the right, another wing of the family house."[4]

Immediately after its production, and already as Niépce moved and carried it around his household, this first "heliograph" began its itinerant life. The nineteenth century would see it pass from Niépce through a variety of hands, beginning with a trip to London in 1827, via Paris, where he met with Daguerre. Niépce also tried to attract attention to his experiment at Windsor Castle and with the Royal Society, but unable to succeed, he ended up leaving several examples of his work with the painter Francis Bauer, including *View from the Window at Le Gras*, framed like a presentation piece, like a kind of painting. As the historian of photography Helmut Gernsheim notes in his essay "The 150th Anniversary of Photography," the photograph was sold on Bauer's death in 1841 to Dr. Robert Brown of the Royal Society, and finally to J. J. Bennett, also of the Royal Society. As Gernsheim explains, "at Bennett's sale in 1884 the relics were split between H. P. Robinson and H. Baden Pritchard, editor of the *Photographic News*, with Pritchard buying the camera picture. . . . Both Mr. Pritchard's widow and Mr. Robinson exhibited their treasures at the International Inventions Exhibition in London in 1885 and at the great

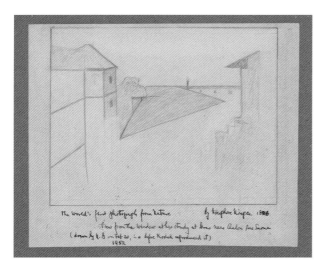

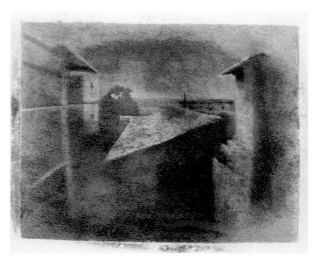

Figure 4. Helmut Gernsheim (British, born in Germany, 1913–1995), drawing of Joseph Nicéphore Niépce's *View from the Window at Le Gras*, 1952. Gernsheim Collection, Harry Ransom Center, The University of Texas at Austin

Figure 5. Helmut Gernsheim and Kodak Research Laboratory, Harrow, UK, gelatin silver print with applied watercolor reproduction of Joseph Nicéphore Niépce's *View from the Window at Le Gras*, 1952. Gernsheim Collection, Harry Ransom Center, The University of Texas at Austin

retrospective Crystal Palace Photographic Exhibition in London in 1898."[5] After its last public exhibition in 1898, Niépce's image slipped into obscurity and did not surface for more than fifty years.

It was only in 1952 that Gernsheim was able to follow the traces, "establish the work's provenance, and discover where family members of the plate's last recorded owner had forgotten that it was stored."[6] Securing the photograph but concluding that he would hand it over to a research library, Gernsheim decided that he would make a drawing (fig. 4) of the scene in the original size first, and he did so in February 1952. He initially contacted Scotland Yard and then the Kodak Research Laboratories, hoping to draw on their expertise in different modes of decipherment and reproduction to have the photograph reproduced. It was first photographed by the Kodak Research Laboratories in March, but because Gernsheim was disappointed in this print—he claimed that "the reproduction in no way corresponded with the original"— he spent nearly two days trying to "eliminate with watercolor the hundreds of light spots and blotches" (fig. 5). Although his efforts resulted in "a more uniform and clearly defined image," his reproduction only approximated the original. As he explains, "its pointillistic effect is completely alien to the medium, for the silver-grey surface of the Niépce photograph is as smooth as a

mirror."[7] The photograph, "housed in its original presentational frame and sealed within an atmosphere of inert gas in an airtight steel and Plexiglas storage frame," is now in the Gernsheim Collection at the Harry Ransom Center at the University of Texas and must be viewed under controlled lighting in order for its image to be visible.[8] However nonitinerant it may seem to be in its final resting place, it continues to circulate in all its reproductions and to escape, in Foucault's words, "through new techniques of transposition."

I have wanted to rehearse, however telegraphically, the history of this photograph, not only to suggest the wild itinerary of the image we know as the first photograph—the literal itinerary of an image that travels geographically and from hand to hand, its itinerary across different modes of reproduction (heliograph, drawing, photograph, watercolor, and so forth), and its movement across the innumerable contexts in which it has been reproduced in thousands of books and articles. I have also wanted to suggest that the photograph we know as the first photograph is not a photograph, or rather is not simply a photograph, since, beyond its being framed like a painting, it is an archive of an entire network of relations and traces, of several different practices and processes, many of which were related to other mediums, including engraving, lithography, and painting.

The fact of the photograph's itinerary—the itinerary of this particular photograph but also that of all photographs—is displayed and intensified in Joan Fontcuberta's *Googlegram: Niépce* (2005; fig. 6, pl. 1), which is based on *View from the Window at Le Gras* and is the photograph with which the exhibition *The Itinerant Languages of Photography* begins. This is an extraordinary object, not only because of the way in which it was created but also because of what it tells us about photography in general. The photograph was created by processing the results of a Google image search—in which the prompting keywords were simply *photo* and *foto*—through photo-mosaic software. Bringing together words from different languages that refer to photographs but within different cultures and contexts, Fontcuberta gathered ten thousand images, what he calls "archive noise," and re-created Niépce's photograph as a composite of these images. As he explains, the software program "selects each sample from a bank of available images" on the Internet. It then places these images, according to their "chromatic value and density," in "the position that most closely coincides with a portion of the larger

image being recreated, as if it were making a gigantic jigsaw puzzle."[9] From a certain distance, we recognize Niépce's photograph, but as we get closer to the print's surface, we can see that this "original" is composed of a multiplicity of images, of an unforeseeably mediated set of pictures and relations (and a set of images that would change in relation to the moment in which the Google search was performed). The photo-mosaic constitutes an imagistic palimpsest that incorporates and recontextualizes these earlier traces and, in doing so, suggests that images can never remain identical to themselves, precisely because the memories and traces they bear are always multiple. Identifying the earlier Niépce image with a mesh of many different images, it also suggests that every image, including Niépce's, is itself a kind of archive but an archive that permits us to think about the relation between an image and all the networks of relations that have helped produce it.

If *Googlegram: Niépce*'s target image is a visual citation of Niépce's original photograph, its pixelated surface and composition call attention to the process that created it, a process that depends on the itinerancy

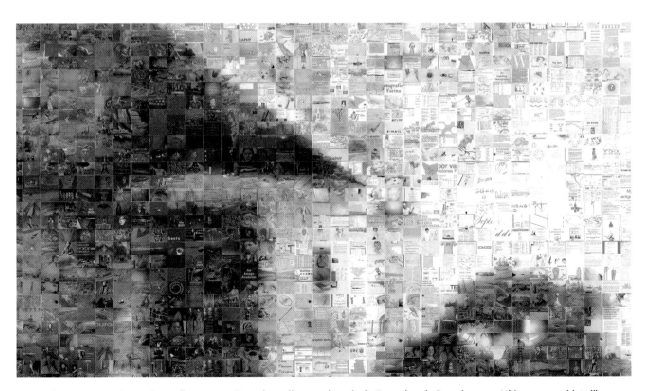

Figure 6. Joan Fontcuberta (born 1955, Barcelona; lives and works in Barcelona), *Googlegram: Niépce*, 2005 (detail). Inkjet print from a digital file, exhibition copy. Courtesy of the artist

of images. Indeed, the images had to be gathered and transferred from the Internet—where they had already been reproduced, displaced, uploaded, and moved—in order to form Fontcuberta's print. What the photograph tells us is that the development of new technologies and media that have modified the dynamics, volume, and speed of the production, circulation, and reception of photographic images, mainly through the Internet, has turned every photograph into a potential readymade that can be recycled by photographers who no longer need to take pictures but can instead become curators of an infinite archive. The print not only establishes an essential connection between image and archive; it also tells us that when we read an image we need to read what is not readily visible in it but what nevertheless has left its traces on the image's surface. This is what makes Fontcuberta's work so remarkable: it argues for the necessity of reading images historically, for reading, in this instance, the relations between photography's chemical origins and its pixelated present. We could even view the Googlegrams as a kind of training manual on how to read images, how to read them at the intersection of the past, the present, and the future, how to register the fact that there can be no image that is ever a single, self-identical image. What Fontcuberta's *Googlegram: Niépce* tells us is that every image is already a constantly changing archive, and this insight is one of his pedagogical aims. As he puts it: "Exploiting this archive noise is basically a way of entering into a new dialogue with the archive. Over and above the intellectual game that defuses the archive, the gestures of Googlegrams, although strictly symbolic, have a pedagogical dimension. On the one hand they expose the elaborate semantic camouflage with which the archive invests information. On the other, they light up the space between memory and the absence of memory, between useful data and the undifferentiated magma of raw information."

A meditation on the circulation and itinerancy of images—although Fontcuberta stresses the intensification of this circulation and itinerancy today in the era of digitization, he also suggests that this movement has always formed part of the photographic image—*Googlegram: Niépce*, produced as it is via a database of information that is constantly in flux, is a living, ever-changing testament to the vitality of images. An inscription of the transience and errancy of both images and archive, it stages the itinerancy of the archive itself. Indeed, what Fontcuberta's work presents is an archive that wanders, that changes in time. It references the possibilities of transformation inscribed within every photograph—from the very "first" photograph to the unprecedented number of photographs produced today, and by innumerable technologies.[10] It also tells us, in an intensified and accelerated manner, that what we see is always determined by what we do *not* see, by what Benjamin once called "the optical unconscious."[11]

This image therefore evokes a series of questions at the heart of the relations and differences between analog and digital photography: What is the status of the referent in general, and especially in relation to these two modes of photography? In what way does the itinerancy of the image—an itinerancy that includes every image's movement away from itself and toward other images—unsettle the relation between the photograph and the photographed? In what way are the relations between the singular and the multiple, presence and absence, immobilization and movement, memory and forgetting, and the past, the present, and the future sealed within these different processes?

If these questions are already legible in the "first" photograph, and if they take on a denser and more intense aspect in Fontcuberta's image, they are explored further in Rosângela Rennó's 2006 *A Última Foto / The Last Photo* project, one of whose diptychs forms the penultimate work in the exhibition (pl. 97). For the project, Rennó gave a different mechanical camera to forty-two Rio de Janeiro photographers. She instructed the photographers that they could photograph anything in Rio as long as the photograph included the statue of Christ the Redeemer of Corcovado. After the photograph was made, each camera was sealed and then framed, alongside the last photograph taken with it, inside a box and arranged as a diptych. Presented as specimens in a kind of museum, each camera and its photograph would seem to bear witness to the passing of a medium: they present a photograph that, with the arrival of the digital era, is increasingly difficult to take. With her collaborators, Rennó stages the singular qualities of images produced by different analog cameras, and in doing so, she offers a kind of elegy for this earlier photographic practice, an elegy that signals the loss of textures and tones that—with the advent of electronic image sensors and

microchips, with the transmission of electronic data that is the signature of digital photography—are disappearing along with analog photography.

If *A Última Foto* stages the death of analog photography, it is appropriate that each of the cameras she lends to the photographers enacts a kind of last rite. As Cuauhtémoc Medina has argued, "each camera paid obeisance to the effigy of Christ for the last time, and was then blinded forever, the inside of its lens irrevocably fogged—the ideal enactment of a romantic death, in which a dying person fixes his gaze on a crucifix in anticipation of the delights of eternal life."[12] If each camera would seem to signal the demise of mechanical film cameras, it at the same time, in its now permanently blind state, says something about the incapacity of cameras to see in the first place.

A Última Foto evokes a number of contradictions and paradoxes associated with Brazilian modernity, beginning with the role of photography in the dream of Brazilian progress. In Medina's words, "Brazil is one of the mythical birthplaces of the art of fixing shadows: it is well known that Antoine Hércules Romuald Florence was the inventor of photography in Brazil, and the first—in 1824, a decade before John Herschel—to coin the term 'photography.' It is more than fitting, then, that a Brazilian should record the death of photography."[13] That there are forty-three diptychs in the series (including Rennó's) suggests that the series could continue indefinitely, however, which implies that none of these photographs are ever "the last photograph." This is confirmed in the diptych that is included in the exhibition. Produced with a Holga 120s, the image, taken by Eduardo Brandão, shows a hand that extends into the frame from the right and holds a digital camera that has the image of the redeemed Christ statue framed in its display. This is a remarkable image, not least because, in a series that references the obsolescence of analog photography, it seems to reverse the narrative that holds the works together by having an analog camera take an image of a digital camera, as if the digital existed before the analog, as if what the digital has introduced into the history of photography is already comprehended by earlier practices of photography, is already accounted for by the lens of an analog camera. Even within a series that presents itself as a lament for the passing of film photography, this work suggests that digitization is still survived by earlier modes of reproduction.

But if there can be no last photograph, it is also because we, too, remain as vestiges of photography, being nothing more or less than archives of images ourselves. Like Fontcuberta's *Niépce*, Rennó's diptychs tell us that we are most ourselves when we register the relation between what is before our eyes and the technological mediations that enable and interrupt our seeing, when we register our mortality but also all the different ways in which we ourselves are the first and last photographs, the enduring ruins, the ones who—never just ourselves, and indeed like the *Googlegram*—remain as images of all the relations and traces that, making us who we are, also prevent us from ever being simply ourselves. If Fontcuberta's image is called simply *Niépce* and not *View from the Window at Le Gras*, or even *Another View from the Window at Le Gras*, it is because he wishes to confirm an identification between persons and photographs that in turn helps to explain why, in *The Last Photo*, dying persons can be associated with dying cameras, and why photographs endure.

Fontcuberta and Rennó tell us that we need to be as clear as possible in our efforts to delineate the conditions of the presumed transition from photography and photo-based mediums to the new regimes of virtual and digital images. Despite the repeated announcements that the advent of video, computer graphics, and digitalization have sounded film photography's death knell, these new imaging processes in fact demand that we try to understand the transformations in the meaning and value of the photographic images that result from these new technologies. These transformations may point to a change in how we understand photography's place within contemporary culture—its privilege or lack of privilege in relation to other image technologies—but I would argue that they already belong to what makes photography what it is. In other words, while it might be said that the specificity and use of film and paper-based photography are changing, the very profound philosophical questions raised by such photography—the relation between original and reproduction, memory and archivization, identity and difference, relation and representation, photography and death, and so on—are still with us today. Going even further, I would argue that the changes in photography and film were already part of these mediums, even before the era of digitization.

The manipulations and transformations of images that we associate with digitization were always possible

with traditional photography—even if they took place with a different rhythm and speed or, as Benjamin would have it, with a different acceleration (and even if now the manipulations, which can also be delayed and are increasingly autonomous from the camera, can continue to be made). In other words, the transformations that are supposed to signal photography's death can also be shown to belong to its history. We need only remember that the production of every photograph involves some degree of manipulation (minimally, the manipulation of light, exposure times, and tonal differences). If neither the so-called death of photography nor the supposed transformations of photography have resulted in its "death," it is because the history of photography has never been a single, linear history, and also because, as Geoffrey Batchen has noted, photography itself has never been a single technology: its very history has been defined by "numerous, competing instances of techno-logical innovation and obsolescence," and this without any threat to its survival. Indeed, it is because, as he puts it, "a change in imaging technology" can never alone "cause the disappearance of the photograph" that contemporary debates over the relation between photography and the new reproductive technologies must remain as concerned with photography's past and present as they are with its future.[14] This is why a meditation on the issues of memorialization, archiviza-tion, reproduction, technology, death, the relation between the past and the present, and the experience of mourning remains urgently pertinent to us as we seek to understand the various ways in which photography's very obsolescence (an obsolescence that, as I wish to suggest, belongs to its very beginnings) confirms its relation to the future. What is at stake is thinking exactly what photography is today, even after all its obituaries have been written.[15]

III. Correspondences

The Itinerant Languages of Photography begins in the conviction that a photograph can never remain in a single location. While it travels around the globe, it constantly redefines itself whenever it is recontextual-ized and reread. What happens, for example, when the photograph taken by Susan Meiselas of a Nicaraguan rebel as he is about to throw a Molotov cocktail during the Sandinista uprising against Somoza's rule in 1978–79 (fig. 7) is later appropriated and recirculated by different artists and political groups—in murals, posters, and even matchbox covers commemorating the first anniversary of the Sandinista revolution—sometimes for an opposing agenda? What makes the responses to the circulation of "Molotov Man" (as the image came to be known) possible—from Meiselas's initial acceptance of some of the image's uses to her eventual filing of a cease and desist order on the basis of her copyright and of her wish that the image not be decontextualized, to the increased reproduction and distribution of the image across the Internet in response to her filing? What happens when Meiselas herself returns to Nicaragua twenty-five years after taking the photograph and, in a kind of repatriation, reinstalls it as a mural-size image in the same place in which it was taken? What spatial and temporal dynamics are at play when the photo-graphic archive moves, in different forms, to the streets or the countryside, and becomes exposed to the public, beyond the confining walls of the institutional archive, the art gallery, and the museum? This process becomes a means of thinking about the relation between the past and the present and, in particular, a means of measuring the changes that have occurred since the photograph was first taken. As is confirmed throughout Meiselas's 2004 *Reframing History* project (see pl. 89), the act of reintroducing the event or referent of the initial photo-graph into the context in which it was taken, even if decades later, functions as a kind of window onto both the past and the present, and onto a photograph's relation to the context in which it was produced. It is the photograph's capacity to be reproduced, in other words, that enables it to be distributed and exhibited across the globe, and its significance is simultaneously altered and preserved in this movement. If, on the one hand, it is the photograph's universally (yet variably) perceived "self-evidentiality" that contributes to its potency as a language of suasion across national and linguistic barriers—this is part of the reason that Meiselas's photographs of the Nicaraguan Revolution were so powerful as they made their way around the globe—its portability (its capacity to be reproduced and distributed in relatively affordable ways) also means that it can easily appear in contexts very different than the one in which it first was taken. This is why, as Walter Benjamin explains in his 1931 "Little History of Photography," in the long run it is the inscription or caption of a photograph that becomes its most important feature.[16] This also is why

Figure 7. Susan Meiselas (born 1948, Baltimore; lives and works in New York City), *Sandinistas at the Walls of the Estelí National Guard Headquarters, Estelí, Nicaragua*, 1979. Chromogenic print, dimensions variable. Courtesy of the artist

it is in photography—rather than in painting or other modes of representation—that the most fundamental questions in the last few decades about the limits of representation and the limits of the critique of representation have been raised.

To delineate another aspect of the itinerancy of photography, we might consider a second series of questions: what happens when in the early 1980s, during the Argentinean dictatorship, the Argentine photographer Marcelo Brodsky leaves for Spain and studies photography with the Catalonian photographer Manel Esclusa? In what way do their respective photographic practices change because of their encounter? Can the photographs that either one produces after this encounter continue to belong to a specific national perspective or tradition, or does the very fact of the encounter influence or alter the way in which each of them views the world—or views a particular detail or set of details of the world? Does such influence subsequently prevent

their practices from being identified solely with this or that particular national photographic practice or history? Does Brodsky's photographic practice, in other words, become less Argentinean because it is partially formed through a "Catalonian" lens, and what happens when such influences involve more than one other country? (This question is relevant to any photographer who has a sense of the history of photography, since that sense inevitably will inform the pictures that he or she takes.) How does photographic influence affect the way in which we understand a photograph's provenance? Is it possible, as Foucault thinks it is not, for a photograph to remain under the "aegis of one author"? How can we begin to describe the life and afterlife of photographs as they get circulated and inserted into different contexts? What do these questions about influence suggest about a practice of citationality within photography that has its counterpart in textual practices, and how do visual and linguistic languages relate to, or differ from, one another?

Figure 8. Marcelo Brodsky (born 1954, Buenos Aires; lives and works in Buenos Aires), *Visual Correspondences / Correspondencias visuales: Manel Esclusa–Marcelo Brodsky*, 2006–10. Courtesy of the artist

We can see these questions at work in the *Visual Correspondences* project initiated by Brodsky and including the photographers Esclusa, Pablo Ortiz Monasterio, Martin Parr, and Cássio Vasconcellos and the artist Horst Hoheisel. Each correspondence consists of a series of images e-mailed between Brodsky and his interlocutors. Brodsky would send a photograph to one of them, and the photographers would reply with a photograph while Hoheisel would respond with a drawing. Each photographer or artist would respond to the other's last image, poetically and playfully—sometimes without knowing exactly why a particular response took a particular form—combining the chance of a kind of readymade with the complexity of photographic memory and production. These correspondences were not only one of the earliest provocations of our project, but they also helped inform the syntactical and serial interplay of the works chosen for the exhibition. In a certain sense, the exhibition reads, even if only virtually, as a series of letters sent between the works and between the various sections of the exhibition, a kind of back-and-forth that, like the correspondences, raises several timely questions about agency, relation, communication and correspondence, the relation between the visual and the linguistic, and especially the itinerary of images.

These questions are raised in the work with which Brodsky began the *Visual Correspondences*, a triptych he sent to Esclusa (fig. 8). Each of its three images represents a building reflected in water, with the images becoming increasingly blurry and watery as our eyes move from left to right. Paying homage to Esclusa's

preferred mode of presentation—the photographic series—Brodsky's multiple image suggests a process of disappearance, a decline in the clarity of vision and, in doing so, evokes several of Esclusa's most cherished motifs: the relations between water and dissolution, water and earth, reflections and repetitions of all kinds, memory and forgetfulness, presence and absence, stillness and movement, light and darkness, and day and night. The possibility of this photograph, therefore, depends on what Brodsky has already read, learned, and received from his teacher's work: he could not have sent this image without already having been the recipient of these earlier traces of light.

Brodsky confirms this as well by having his first image encrypt so many of Esclusa's photographic obsessions, as if he wanted to tell Esclusa that his photographic production is linked to what he has learned to see through his teacher's eyes. If he sends an image of a residential building reflected in water and increasingly disappearing from sight, it is perhaps because he wants to suggest that, in "his" eyes, Esclusa's photographic "homes" include water, the play between light and darkness, and the relation between presence and absence. Indeed, Esclusa's eyes are inundated with water and, in particular, the sea—we need only recall the role that water plays in his *Venezia* (1979), *Naus* (1983–96), *Aquariana* (1986–89), and *Aiguallum* (2000)—and this theme is central to his photographic project. We could even say that, in Esclusa's nocturnal world, the earth, the air, plants, fish, all things inanimate and animate, and perhaps especially the clouds that so often punctuate his photographs are

Figure 9. Manel Esclusa (born 1952, Vic, Spain; lives and works in Barcelona), *Visual Correspondences / Correspondencias visuales: Manel Esclusa–Marcelo Brodsky*, 2006–10. Courtesy of the artist

all animated by water. While water in his work becomes a figure for the mobility, instability, and even the dissolution of perception itself—something that is legible in Brodsky's triptych—it is perhaps more precise to say that it works against everything that resists alteration or change.[17] If water is a force of dissolution and transformation, survival and destruction, life and death, its initiation of a new "beginning" also includes the gesture of leaving something or someone behind.

Within the world of Esclusa, water is perhaps another name for leaving, which is why Brodsky's "beginning" is both an homage and a departure, something that is legible in the process of disappearance that he stages in his triptych and something that he reinforces in the series of five images that constitutes his third photographic missive to Esclusa. The first of the five images depicts the meeting of sea and land, a beach that has the word *comienzo* (beginning) written on the sand in the image's foreground. The subsequent images show the ebb and flow of the water over the word and its gradual erosion. Suggesting that he begins in relation to the sea and the sand, that the sea and the sand are his beginning, and that this "beginning" is linked to a fugitive word written and dissolved by water washing over sand, he again tells Esclusa (at least as I imagine it) that he begins with him: "I begin, I begin in relation to you, in relation to the beginning that you are for me, in relation to your photographs of earth and water, traces and imprints, forms and colors. I begin with this trace of a word, *comienzo*, which, because it suggests everything I am saying here, already implies my correspon-

dence with you, my being with an other, my being with you. This is why, I could say, I begin only on the condition that I am not alone, that I see through the eyes of another, that I have no self but the self that disappears in its relation to an other, in this instance, 'you.'" Suggesting that, because of his relation to Esclusa, his identity is as transient, as itinerant, as the word *comienzo* written on the sand, Brodsky's first and third missives to Esclusa present us with the open secret of his indebtedness to his teacher and with the different forms of itinerancy— not the least of which is simply the way in which each one influences and moves the other—that circulate between them and that enable their correspondence and relation to take place.

In both instances, Esclusa responds with a generosity and gratitude that reveal his own relation to Brodsky's work. In response to Brodsky's first triptych, Esclusa replies with a triptych that returns to the relations between presence and absence, preservation and disappearance, and memory and forgetting (fig. 9). His triptych moves from the image of a snake on a patch of dry earth, with grass and bushes in the background, to the image of the trace or imprint left by the snake on the earth, alongside what seems to be a second trace of the snake, the skin that it perhaps sheds and leaves behind, and finally an image with only the trace of the snake, the same trace that is visible in the previous image. Like Brodsky's triptych then, this one, too, records the process of a disappearance. Putting aside the fact that Esclusa's snake may allude to Brodsky's *Serpiente de película* (Celluloid serpent), an image he produced in

2000, which consists of a roll of film winding its way along the ground in a shape that is remarkably similar to that of Esclusa's snake and, in particular, to the skin it leaves behind, the triptych implies the passage of time, a transformation and disappearance, a memory trace that indicates this loss and, in doing so, meditates self-reflexively on the photographic medium.

The vertigo of this series, of this speculative game of mirroring, invites a kind of endless reflexivity that permeates the entire *Visual Correspondences* and not only this one (indeed, this reflexivity is perhaps most evident in the correspondences between Brodsky and Ortiz Monasterio [pl. 84] and between Brodsky and Vasconcellos), and indeed these images are extremely self-reflective. They are often traversed by different mirror effects: from the images cast upon reflective surfaces like water to the mirrors in which objects are reflected, to the several images that cite or replicate other images, even if at times in displaced forms, to the various modes of representation represented within the images (including, in this correspondence, writing, buildings, mirrors, and windows displaying reflections and, in the other correspondences, photographs, stones with inscriptions, posters, books, portraits within different kinds of frames, signs on windows or walls, drawings, and even plastic reproductions of body parts). These reflections operate in these photographs as a means of photographing photography itself. These are photographs, in other words, that tell us something about photography and not only because, within a photograph, *everything is representation*. They enact, in their movement across all kinds of borders—national, medial, subjective, and temporal and spatial—innumerable forms of itinerancy and thereby offer us a kind of lens through which we might begin to trace the essential instability, indeterminacy, mobility, and migratory and even serial character of all photographs. They demonstrate that what makes a photograph a photograph is its essential itinerancy.

IV. Reading Photographs

In tracing the different ways in which González Palma, Niépce, Fontcuberta, Rennó, Meiselas, Brodsky, Esclusa, and others stage and enact the itinerancies of photography, I have also wanted to suggest that the photograph's mobility extends to the concept of photography and to the word itself. Given the way in which photography—the word and the concept—condenses and encrypts a series of associations that prevent it from remaining identical to itself, that confirm its relations to other terms, mediums, and even fields, I would even say that photography's condition of possibility can only be the impossibility of its ever having a fixed semantic content. This is why there are languages of photography and why they must be itinerant.

The virtue of considering itinerancy to be the signature of photographic images is that it helps us move beyond the more common efforts to think about the relation between photography and travel and instead to focus on the itinerancy of the practices and discourses of photography themselves, and even the itinerancy inscribed within every photograph. This attention to the different modes of itinerancy that have characterized the history of photography enables a more compelling, active, transnational lens through which to understand not only the effects of the speed of globalization on contemporary techniques of vision but also the various ways in which the itinerancies already in motion from the beginnings of photography have remained with us today, even if transformed into different and new forms. If I have emphasized photographs that refuse to stay in a single place, and if I have drawn my examples primarily from Ibero-American archives, it is because I have also wanted to challenge the dominance of Europe and North America within traditional histories of photography and, in doing so, to rethink photography's beginnings and its future.[18] Indeed, from its very inception, the photographic image has been divided from itself, has been compelled to take on other forms, even as these other forms, too, continue to alter in their relation to one another, in their relation to what we have wanted to call "the itinerant languages of photography."

In 1927, in an essay titled "Photography in Advertising," László Moholy-Nagy wrote, "The illiteracy of the future will be ignorance not of reading or writing, but of photography."[19] *The Itinerant Languages of Photography* aims to help us resist this illiteracy and thereby to provide a kind of guide to the wondrous and ongoing history of this magical thing, which is never just one, that we call photography. What is at stake is our capacity to think the very future of photography, a future that was already inscribed in its earliest beginnings and that, because of the medium's endlessly itinerant lives, remains, like all futures, open.

Notes

Epigraph: Michel Foucault, "Photogenic Painting," in *Gérard Fromanger: Photogenic Painting*, trans. Dafydd Roberts (London: Black Dog, 1999), 83–85. I am grateful to Emerson Bowyer for having directed me to this text.

1 Roland Barthes, *Camera Lucida: Reflections on Photography*, trans. Richard Howard (New York: Farrar, Straus & Giroux, 1981), 4.

2 Walter Benjamin, "The Work of Art in the Age of Its Technological Reproducibility," trans. Harry Zohn and Edmund Jephcott, in *Selected Writings*, vol. 4, *1938–1940*, ed. Marcus Bullock and Michael W. Jennings (Cambridge, MA: Belknap Press of Harvard University Press, 2003), 252–54, 271. Although there would be many moments in Benjamin to support this claim, I cite these pages as the most direct indications that, for Benjamin, the "authenticity" or "originality" of a work of art—in this instance, a photograph—is already the effect of a process of reproduction.

3 On this point, see Geoffrey Batchen, "Form is henceforth divorced from matter," *Still Searching: An Online Discourse on Photography* (blog), Fotomuseum Winterthur, September 23, 2012, http://blog.fotomuseum.ch/2012/09/2-form-is-henceforth-divorced-from-matter/.

4 Barbara Brown, "The World's First Photograph," *Western Association of Art Conservation Newsletter* 22 (September 2002): 1.

5 Helmut Gernsheim, "The 150th Anniversary of Photography," *History of Photography: An International Quarterly* 1 (January 1977): 6.

6 Brown, "World's First Photograph," 1.

7 Gernsheim, "150th Anniversary," 8.

8 Brown, "World's First Photograph," 1.

9 Joan Fontcuberta, "Archive Noise," January 31, 2006, Zabriskie Gallery, http://www.zabriskiegallery.com/artist.php?artist=5&page=45. All quotations from Fontcuberta are from this artist's statement.

10 According to a recent estimate, 375 billion digital photographs were taken in 2011, more than three thousand images are uploaded to the Flickr photo-sharing website every minute, and more than 300 million photos are uploaded on Facebook each day—a visual explosion that has emerged largely because of the proliferation of camera-ready mobile phones.

11 Walter Benjamin, "Little History of Photography," trans. Edmund Jephcott and Kingsley Shorter, in *Selected Writings*, vol. 2, *1927–1934*, ed. Michael W. Jennings, Howard Eiland, and Gary Smith (Cambridge, MA: Belknap Press of Harvard University Press, 1999), 512.

12 Cuauhtémoc Medina, "A Beautiful Death: On Rosângela Rennó's *Última Foto*," *Prefix Photo*, no. 17 (Spring–Summer 2008): 30.

13 Ibid., 24.

14 Geoffrey Batchen, "Ectoplasm," in *Each Wild Idea: Writing, Photography, History* (Cambridge, MA: MIT Press, 2001), 140.

15 Here see Mia Fineman's summary of the issue in her wonderful catalogue *Faking It: Manipulated Photography before Photoshop* (New York: Metropolitan Museum of Art, 2012), 42:

> As digital photography and image processing have gradually but inexorably superseded film cameras and chemical darkrooms, dramatic pronouncements about the end of photography have become increasingly common. In the early 1990s the former *New York Times* photo editor Fred Ritchin predicted that digital editing software would bring about "the end of photography as we have known it." The media historian William J. Mitchell characterized the digital age as a "post-photographic era," declaring, "From the moment of its sesquicentennial in 1989, photography was dead—or, more precisely, radically and permanently displaced—as was painting 150 years before."
>
> While it is evident that something in our culture is changing radically, photography itself is still very much alive. Quantitatively speaking, more people are using cameras to create many more photographs than ever before.

16 See Benjamin, "Little History of Photography," 527.

17 I have been moved to think about the implications of water by Branka Arsic's reflections on water in her "Introduction: In the Mode of Water," in *On Leaving: A Reading in Emerson* (Cambridge, MA: Harvard University Press, 2010), 1–18.

18 In this, we seek to further the work already initiated by the important collection of essays edited by Christopher Pinney and published under the title *Photography's Other Histories* (Durham, NC: Duke University Press, 2003). Although our focus on itinerancy reframes the effort to extend photography beyond its Euro-American context, it shares this book's interest in viewing photography as a globally circulated yet locally appropriated medium. Also pertinent here are Martin Parr and Gerry Badger's *The Photobook: A History*, 2 vols. (London: Phaidon, 2004–6); Horacio Fernandez's more recent *The Latin American Photobook* (New York: Aperture, 2011); and Rosalind Morris's edited collection *Photographies East: The Camera and Its Histories in East and Southeast Asia* (Durham, NC: Duke University Press, 2009). By shifting the terms of the discussion to itinerancy, however, we also displace these earlier discussions by challenging the possibility that photography could belong to any single national or regional context.

19 László Moholy-Nagy, "Photography in Advertising," cited, without attribution, in Benjamin's "Little History of Photography," 527. Moholy-Nagy's essay is included in Christopher Phillips, ed., *Photography in the Modern Era: European Documents and Critical Writings, 1913–1940* (New York: Aperture, 1989), 90.

The Archival Paradox

Gabriela Nouzeilles

For the world itself has taken on a "photographic face"; it can be photographed because it strives to be absorbed into the spatial continuum which yields to snapshots.

—Siegfried Kracauer

With the irreplaceable singularity of a document to interpret, to repeat, to reproduce, but each time in its original uniqueness, an archive ought to be idiomatic, and thus at once offered and unavailable for translation, open to and shielded from technical iteration and reproduction.

—Jacques Derrida

Modern memory is consubstantially linked to the archive. "It relies entirely on the materiality of the trace, the immediacy of the recording, the visibility of the image," says Pierre Nora. Within the wide arch of an ever-unfolding modernity, what began as a translation of experience into writing ends in the feverish technological inscription of everything through cameras, audio recorders, and computers. Paradoxically, the compulsion toward archival accumulation reveals not the strengthening of memory, its mounting victory, but rather its silent vanishing. The withering away of memory is the negative outcome of a modernity obsessed with the new: "The less memory is experienced from the inside, the more it exists only through its exterior scaffolding and outward signs— hence the obsession with the archive that marks our age, attempting at once the complete conservation of the present as well as the total preservation of the past. . . . Memory has been wholly absorbed by its meticulous reconstitution. Its new vocation is to record; delegating to the archive the responsibility of remembering,

it sheds its signs upon depositing them there, as a snake sheds its skin."[1] The metaphor of the shed skin is particularly apt as a figure for the role of photography in the accelerating process of archivization that characterizes the movement of modernity. Suspended on the surface of film, printed on sheets of paper, or projected on screens of fabric or glass, photographs make visible the "skin" of memory, being both the spectral shadow of a trace and its physical materialization.[2]

The moment proper to the archive is based not on spontaneous memory but rather on a certain prosthetic experience of a technical substrate, which, like Freud's mystic writing pad, reveals what it records at the same time that it obscures it. It is under this light that we should understand Jacques Derrida's suggestion that we can no longer oppose perception and technology, since there is no perception before the possibility of prosthetic iterability.[3] The persistent fascination with prints, impressions, stains, casts, or tracks that punctuates the work of many photographers seems to point in this direction. In the Mexican photographer Graciela Iturbide's archival project *El baño de Frida Kahlo* (2007)— a photographic inventory of the personal objects found in the iconic Mexican artist's private bathroom, which had remained sealed for decades—one of the pictures in the series implicitly associates the act of recording an image on a sensitive surface with the process by which Kahlo's bodily fluids, along with paint, left imprints on the white fabric of her hospital gown (fig. 10). Here the stained gown stands for an old sculptural photograph that recorded the traces of her by now vanished suffering body. Working as photographs of photographic artifacts, Iturbide's uncanny images of Kahlo's leather corsets and artificial leg insist on linking photography and memory

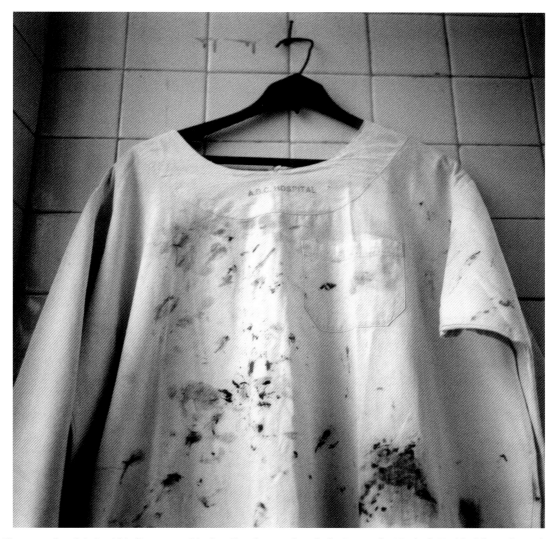

Figure 10. Graciela Iturbide (born 1942, Mexico City; lives and works in Coyoacán, Mexico), *Untitled*, from the series *El baño de Frida Kahlo* (Frida Kahlo's bathroom), 2007. Gelatin silver print, dimensions variable. Courtesy of the artist

to prosthetic experience and material inscription. With a similar conceptual approach, the Argentine photographer Bruno Dubner takes this representational logic to its very limit by reducing photography to the bare materiality of the trace, of a pure prosthetic memory beyond figuration. In *Testimonio de un contacto* (Testimony of a contact), the shapeless luminescent clouds that fill Dubner's photograms provide evidence of his minimalist encounters with light as a result of an active exploration of his darkroom, paper in hand, in search of luminosities invisible to the eye. Each photogram refers to a singular event when light made "contact" with the

surface of the sensitive paper, leaving behind a spectral impression (fig. 11, pl. 98). Iturbide's and Dubner's series seem to confirm Roland Barthes's suspicion that there is something tautological about photography. They conceive photographs as laminated objects whose two leaves cannot be separated without being destroyed. In them, the referent adheres to the signifier as a permanent trace of what no longer exists.[4]

The impossibility of separating perception, or even knowledge, from visual prosthetics is also inscribed in Michel Foucault's famous definition of the archive as both the system that governs the appearance of

statements as unique events and the organizing law that counters the endless and meaningless accumulation of material remains by organizing and grouping them into specific regularities. In order to prevent things and events from disappearing by chance into an amorphous mass or from withdrawing into anomic space, the archive itself seems to operate as a photographic machine that regulates the production of archaeological insights through the manipulation and selective recording of traveling light, so that past events shine, as it were, "like stars, some that seem close to us shining brightly from far off, while others that are in fact close to us are already growing pale."[5]

Every photograph is a priori an archival object.[6] The camera's capacity to link its act of mechanical inscription to the allegedly indisputable fact of the referent's existence at a certain point in time constitutes the basis of the dominant understanding of photography as a mode of representation. The medium's alleged capacity for precise recording, combined with its potential for

Figure 11. Bruno Dubner (born 1978, Buenos Aires; lives and works in Buenos Aires), *Untitled*, 2009, from the series *Testimonio de un contacto* (Testimony of a contact), 2007–10. Cameraless chromogenic print, 130 x 100 cm. Courtesy of the artist

replication and accumulation, has come to define archival production itself according to the language of photography and its phenomenological account of the world as a collection of images.[7]

From its inception, photography implied the capture of the largest possible number of subjects. No other prosthetic technology or figurative art had been so imperial in scope before. To photograph is a form of appropriation reminiscent of collecting through hunting and embalming. According to Susan Sontag, the insatiability of the photographing eye forever changed the terms of the confinement in Plato's allegorical cave by providing a new ethics of seeing that drastically expanded the meaning of what is worth recording. Not only did everything become a potential photograph, but it also could be recorded innumerable times and from many different angles. The result is the production of a generalized "archive effect," which gives the subject the sense that she or he can hold the whole world in her or his mind (or hands), as if it were an anthology of images: a picture-world.[8]

For more than a century, mass tourism has been one of the most powerful engines behind the commodification of experience and the transformation of the real into a flat visual spectacle. In her photographic installation *You see I am here after all* (2008), consisting of thousands of postcards of Niagara Falls, the American artist and photographer Zoe Leonard offers a critical reading of the process by which, as Siegfried Kracauer described it, the "photographic archive assembles in effigy the last elements of a nature alienated from meaning."[9] By emphasizing the techniques for representing one of the most popular subjects ever to be found in pictures, Leonard draws attention to the ways in which photography has helped reduce the world to an endless series of fairly similar archival images (fig. 12). Even nature becomes a mask in a photograph, for what is retained in the image are not the features envisaged by a free consciousness. In Kracauer's words, "The blizzard of photographs betrays the indifference toward what the things mean."[10] We are left with a mute nature without meaning.

Rather than being viewed simply as representations, photographs are treated as if they were slices of the real that can be possessed and stored at will. In being photographed, something automatically becomes part of a system of documentation, organized according to schemes of classification and storage that include

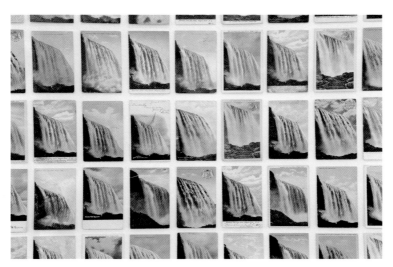

Figure 12. Zoe Leonard (born 1961, Liberty, NY; lives and works in New York City), *You see I am here after all*, 2008 (detail). 3,851 vintage postcards, 3.6 x 44.8 m. Installation view, Dia:Beacon, Beacon, NY. Courtesy of the artist

the loose chronological order of the family album or the travelogue, the erratic iconographic sequences of a personal Facebook page, and the meticulous filing and strict visual decoding that characterize the use of photography in astronomy, medical diagnosis, art history, military reconnaissance, and police work. Through photographic excising and archivization, reality as such is redefined as "an item for exhibition, as a record for scrutiny, and as a target for surveillance."[11] This also means that the image is rarely alone. Every time we look at a photograph, a whole set of framing devices comes into play, overcoding its material thinness and affecting our traffic with it, even as it is always caught up in the elaborate visual, verbal, spatial, and temporal interplay of larger machineries of staging.[12]

Archival apparatuses therefore are not stable bodies. They store information in place, even as they are always in the process of rearranging themselves (as more materials are added or erased, or as they are reorganized or reconfigured). As Marcel Duchamp so wonderfully expressed in his conceptual work *Boîte-en-valise* (1935–41)—the portable authorial museum consisting of scaled-down reproductions of his works, all neatly kept in a suitcase—*the content of the archive is always on the move*. And because it is itinerant, because it moves, there is always the chance that it will be unsettled, undermined, sabotaged, erased, or even smashed. The

archive is caught in a kind of double bind: it is simultaneously defined as an inert, rational repertoire of historical artifacts ruled by a totalizing system of knowledge and power, and as an active, porous, senseless machine, always on the verge of collapse, disrupted by contradiction and irrelevance—a Borgesian labyrinthine library "whose vertical wildernesses of books run the incessant risk of changing into others that affirm, deny, and confuse everything like a delirious god."[13]

Archives are subjected to conflicting forces: a centripetal force that painstakingly keeps and arranges records and documents, and a centrifugal force that quietly or actively erases, shifts, and expels archival matter. Indeed, the archive is both intensely conservative and potentially revolutionary. "It has the force of law, of a law that is the law of the house (*oikos*), of the house as a place, domicile, family, lineage, or institution,"[14] but at the same time that it instates some form of domiciliation, it also works against itself through oblivion and dispersion. These two conflicting forces are not necessarily at odds with each other. By undoing itself, the archive can enable new archival formations.

The paradoxical condition of the archive—the hesitation between inscription and itinerancy—is intrinsic to photography itself. Photography is both Medusan and Protean. It does congeal what it sees, but it also sets itself, and with it its referent, into motion. It both

Figure 13. Enrique Metinides (born 1934, Mexico City; lives and works in Mexico City), *Adela Legarreta Rivas Is Struck by a White Datsun on Avenida Chapultepec, Mexico City*, 1979. Chromogenic print, 24.2 x 35.5 cm. Courtesy of the artist

mummifies and sets free. Unlike its predecessor, the camera obscura, the photograph separates the viewer in time and space from the objects or subjects that generated the image. As a secondary image with the potential for endless duplication, the photograph has the capacity to bring to a multitude of potential viewers the traces of the past or a glimpse of what is not available to all, triggering endless and unexpected uses and interpretations. As Vilém Flusser puts it: "The characteristic that distinguishes photographs from other technical images is clearly evident as soon as one looks at the distribution of photographs. The photograph is an immobile and silent surface patiently waiting to be distributed by means of reproduction. For this distribution there is no need of any complicated technical apparatus: *photographs are loose leaves which can be passed from hand to hand.* There is no need for them to be stored in technically perfect data storage-systems: They can be put away in drawers."[15] Photographic images are essentially mutable and fluid artifacts, "at home" in any context while simultaneously in transit.[16] "Loose leaves" without a predetermined destination, pushed forward or around through perceptual and affective exchanges, they are circulating referents or moving signifiers that, through repeated acts of translation, become subject to multiple erasures and inscriptions through various sorts of material

assemblage.[17] As Georges Didi-Huberman reminds us: "The image *passes us by*. We have to follow its movement as far as possible, but we must also accept that we can never entirely possess it. That also means that images—doubtless not just any image, I only mean images that I would describe as fertile—are *inexhaustible*."[18]

An emphasis on photographic itinerancy rapidly discloses that all image collections, both private and institutional, have been shaped by countless flows and that all of them are embedded within wider visual economies.[19] Always already somewhere else, photographs move in and out of different and at times apparently incompatible archival formations, crossing from one categorical domain into another. This is the case with the photojournalist Enrique Metinides's powerful and incisive photographic depictions of crimes, murders, airplane crashes, and other disasters, produced between 1949 and 1979 for Mexico City's tabloids. They have migrated from the gruesome pages of the so-called Nota Roja section, for which they originally were taken, all the way to the international art gallery circuit. Once recontextualized, photographs such as the one registering the accidental death of the Mexican actress Adela Legarreta Rivas in 1979 (fig. 13) are now seen and valued through the lenses of the modernist canon and its self-referential aesthetics.

In addition to the physical and epistemological displacement across collections, there is the performative potential of every photograph as an endless series of singular iterations, within which each printing or display of an image can be compared to the performance of an intangible art object. Adopting a repertoire of poses and masks, images engage in a dance of veils, during which they intermittently unveil and conceal themselves. The Argentine photographer and collector Florencia Blanco's archival manipulation of old oil-painted photographs, which she acquired in flea markets over a period of nine years, offers a nostalgic reflection on the survival and transformation of the "same" singular image through temporal and material sedimentation and recontextualization. Blanco's photographs are not images of images but rather records of older photographic artifacts or material relics of a forgotten past—buried objects that remain in a referential limbo of perpetually abstract deixis due to a lack of context. By photographing them, she digs the oil-painted photographs out of the dead archive, thus resurrecting not the referents but the images themselves, putting them back into circulation (pls. 86, 87).

Inversely, the Mexican conceptual artist Gabriel de la Mora recycles old photographs not in order to insert them into new signifying sequences but rather to speed up the process of decay intrinsic to all photographic artifacts. The goal is to return to a zero degree of representation, or what the artist calls "white noise." For the series *Fotografías raspadas* (Scraped photographs), for example, de la Mora "peeled" off hundreds of miniscule bits of photographic images from the surfaces of their material supports, which he then collected in translucent containers or inside the glass boxes holding what remained of the ruined photographs. The result is indeterminate images whose original appearance we can only imagine (fig. 14).

Photography's historical association with travel is equally relevant to its archival condition. Not only was the invention of photography a leap in the evolution of types of image making and record keeping long associated with travel, but its mode of production also facilitated the fast flow and mass consumption of images from all over the world by lowering their cost and multiplying their numbers exponentially. If the proliferation and traffic of images achieved a spectacular global magnitude under capitalism, photography's contribution

Figure 14. Gabriel de la Mora (born 1968, Colima, Mexico; lives and works in Mexico City), *T.P.12*, 2011. Gelatin silver print, photo: 14.9 x 9 cm; framed: 37.5 x 3.5 cm. Private collection

to the elaboration of this visual economy was crucial. Beginning in the late nineteenth century, photographs came to function as a type of common currency that eventually unified all subjects within a single global archival network of valuation and desire. Picture postcards, which enjoyed widespread popularity at the turn of the twentieth century, embodied the notion of photographs as currency whose worth is defined by their exchange value.[20] Within this transnational system of visual production and reception, we find a wide variety of local and regional formations, each with its own social and historical dynamics and properties. Looking at photographic itinerancy from a transnational perspective helps us transcend and complicate the rigid opposition between a history that sees it as the mere

result of the explosion and dissemination of Western technology and a unidirectional imperial circuit of archival accumulation, and its postcolonial inversion, which seeks to de-provincialize the dominant history of photography as a Euro-American apparatus through the recovery of parallel practices and the construction of alternative archives from the periphery.[21]

If it is true, as Kracauer states, that by 1927 the world itself had taken on a "photographic face," what can thinking about specific configurations of the itinerant dynamics of photography in relation to particular regional archives bring to light? How are archives produced, affected, and transformed by the transnational production, appropriation, and circulation of technologies and images by different political and cultural agents, including local and foreign itinerant photographers and artists? What types of reality effects will be enacted by decentering the archival drive that propels modernity forward?

I would like to turn now to two strikingly heterogeneous and ambitious archival formations from Latin America, both of which take as their point of departure the fantasy of the universal archive, understood as a powerful and voracious prosthetic apparatus that incessantly keeps translating everything (objects, people, space, cities, nature) into an ever-expanding body of photographs.[22] These two formations are both paradigmatic and exceptional. They operate according to the rules of accumulation and erasure, fixation and instability, which characterize all archives, but they also offer self-referential meditations on the politics of the archive and on photography's archival drive as a contradictory and contentious process that involves fixation and ruination as well as transformation. They both channel and combine institutional and private practices that seek to make sense of the world in order to control it or modify it through image collecting, and they both came into being at turning points in the history of technological innovation: on the one hand, the birth and early stages of analog photography and its subsequent dissemination across the world in the second half of the nineteenth century and, on the other, the rapid expansion and popularization of digital photography in the past fifteen years. Both these media events triggered a succession of technological inventions and an explosion of image making and image exchange. In the first case—the voluminous photographic collection of the Brazilian emperor Dom Pedro II (1825–1891)—photography was a

way of exercising sovereign power through technological replication and symbolic accumulation but also a way of undermining imperial authority by pointing to the process of ruination that eventually overcomes all representations. In the second case—the multimedia archival projects of the Brazilian contemporary artist and photographer Rosângela Rennó—photography becomes a self-referential apparatus through which Rennó traces back the medium's violent political genealogies and promiscuous material histories in order to rethink critically photography's totalizing and authoritarian agendas as well as its prosthetic condition.

The Emperor's Itinerant Archive

To collect photographs is to collect the world.
—Susan Sontag[23]

The predatory side of photography is a marker both of its ambition and of its inherent violence. To photograph is to appropriate the thing photographed. It means putting oneself into a relation to the world that conceives knowledge as a form of power. According to this view, taking and collecting photographs turn the real into segments of information that can then be classified and filed according to universal categories. In the nineteenth century the camera's precise and expansive viewing and recording capabilities opened the possibility not only of assembling a complete inventory of nature but also of producing images of both natural and cultural worlds that had remained invisible or unnoticed until then. The archival promise of photography was total representation through the orderly arrest of the referent.

The invention and development of photography coincided with the extraordinary expansion of the modern state. Photography provided allegedly accurate and thorough records of the progress and achievements of empire and nation, which rapidly became part of an organized system of knowledge that was seen as the material embodiment of political sovereignty. Like maps, photographs reduced the world to two dimensions. Just as imperial and national geography possessed a central cartographic ambition to explore and fill in all the blank spaces on the world map, photography was soon part of an ambitious collective enterprise and played a central role within the imperial archive, which Thomas Richards has analyzed as a "collective fantasy of knowledge collected and united in the service of state and Empire."[24]

At first sight, the photographic collection of the Brazilian emperor Dom Pedro II seems to endorse the perception of photography as an epistemological and political tool for meticulous archival documentation. Both its size (it comprises more than twenty thousand photographs) and the scope of its content convey the idea of a project of gargantuan proportions, whose ultimate goal is to make world and sign coincide. Originally it was conceived as a "private" project, linked to the emperor's personal interests and pastimes, but the fact that he was its main possessor makes the collection a phantasmagoric proto-archive of an unexpected imperial nation in the making, Brazil. The collection grew under the signature of a man whose complete signature— Pedro de Alcântara Joâo Carlos Leopoldo Salvador Bibiano Francisco Xavier de Paula Leócadio Miguel Gabriela Rafael Gonzaga—was an archive in itself, in its double meaning of "system" and "law."

The collection comprises photographic images from all over the world, including remote regions of Brazil. They were produced by a large number of local and foreign photographers and are linked to many different fields of knowledge, including astronomy, engineering, anthropology, architecture, physics, and history. The extraordinary diversity of subjects seems to be based on the assumption that everything—large or small, far or close, private or public, visible or invisible, high or low—has become photographable: nature, cities, ports, African slaves, indigenous peoples, lunar eclipses, urban crowds, stars, agricultural practices, trains, plants, insects, parks, public works, buildings, and ruins, as well as the emperor and his family.[25] The list is so open and heterogeneous that at times the collection's organizing principle gets murky, as if it were the work of delirious accretion.

Itinerancy is the condition of possibility of the emperor's photographic archive. Dom Pedro II came into contact with photography through a traveler, the chaplain Louis Compte, who arrived in Rio de Janeiro on board the school ship *L'Orientale* in 1840 and gave a public demonstration of the operating system of the daguerreotype.[26] Thrilled by the possibilities of the new invention, the emperor would soon become an amateur photographer, a passionate collector of both photographs and cameras, and an active supporter of the new medium in Rio. Between 1851 and 1889 he granted the title of Imperial House Photographer to twenty-six

photographers in Brazil and six overseas, including Revert Henrique Klumb and Marc Ferrez, whose photographic works helped create a powerful and lasting iconography of Brazil and of Rio de Janeiro in particular.

The collection is the final repository of steady flows of images facilitated by new means of transportation, the new international market of images and new technologies, and the systematic exploration of Brazil's diverse landscapes and regions financed by the imperial state. The itinerant condition of the emperor himself was also a factor in the formation of the archive. Born in Brazil as a result of the forced relocation of the Portuguese crown from Europe to the colonies because of the Napoleonic invasions in the early nineteenth century, and despite the fact that he did not leave the country until later in life, Dom Pedro II was always to some extent a sovereign "out of place," a king in exile with a transnational imperial legacy. At a mature age, already politically and physically weakened, he made a series of extended trips to Europe, North America, North Africa, and the Middle East, to countries such as Italy, Greece, France, Spain, Austria, England, the United States, Canada, Egypt, and Palestine. In each case, his entourage was composed of specialists in local matters and one photographer, who was responsible for documenting the emperor's travels. The trips also provided Dom Pedro II with opportunities to enhance and expand his photography collection even further.

One of the emperor's main interests was travel photography, which became a popular genre and developed an international clientele very soon after it became possible to print photographic images on paper.[27] This type of itinerant photography circulated mostly in the form of collectible albums, of which the emperor acquired remarkable ones, including Michele Amodio's photographs of the ruins of Pompeii (1876) and Félix Bonfils's famous *Architecture antique* (1878), which includes images of Syria, Greece, Egypt, and Israel.

The wide scope of the collection, its imperial ambition, is linked at least in part to the new forms of knowledge that in the last decades of the nineteenth century helped consolidate the mutually constitutive alliance between state power and capital in Brazil. According to the new epistemological paradigm, sovereign power became identified with an optical apparatus whose visual representations of nature and history would eventually be turned into figurations of the nation.[28]

Figure 15. Joaquim Insley Pacheco (Portuguese, ca. 1830–1912), *Pedro II, Emperor of Brazil, Rio de Janeiro*, 1883. Platinum print, 37.5 x 29.2 cm. D. Thereza Christina Maria Collection, Archive of the National Library Foundation, Brazil

Samuel Boote's photograph of the Brazilian pavilion at the Continental Exhibition of 1882 in Buenos Aires clearly illustrates the identification between state and optical power (pl. 6). With the exception of a few potted plants arranged along the walls of the pavilion, "Brazil" is the result of an archive effect performed by the careful assemblage of photographs, displayed as isolated images or framed constellations, picturing local "types," from agricultural products to indigenous peoples. Although the size of the photograph does not allow us to clearly discern the content of the pictures on display, it is reasonable to presume that all or many of them belonged in fact or potentially to the emperor's collection and that Boote's photograph can therefore be read as a sort of self-referential mirror that offers us a *mise en abyme* that discloses the collection's implicit political epistemology. A closer look at other photographs in the collection, however, suggests a more complex representational dynamic at play.

At the same time that its raison d'être hesitates between the private and the public arena, the emperor's photographic collection shows a contradictory relationship with sovereign power, in both its imperial and its national dimensions. More than a homogeneous body of images, shaped by an autonomous universalizing impetus, the collection is a loose compendium of subgroupings, many of which appear in album format, organized according to diverse and at times conflicting agendas. Such incongruities perhaps echo the instability of the public image of the Brazilian emperor himself as a "monarca com muitas coroas" (a monarch with many crowns)—a hybrid sovereign who carried and displayed several public personae and political masks throughout his life, including the title of king of kings, as an embodiment of European refinement in the tropics, the cultural signs of a subaltern ruler of African or indigenous descent, and, beginning in the late 1860s, the bearings of a cosmopolitan, enlightened modern man, compatible with the idea of a modern nation.[29] When the monarchy began to lose political power as a result of the gradual but steady spread of republican and scientific ideals, the emperor would turn to photography to reinvent himself as a modern citizen. Taking advantage of the popular format of the *carte de visite*, the imperial crown flooded Brazilian society with portraits of the emperor in conventional attire.[30]

Joaquim Insley Pacheco's 1883 studio portrait of the emperor gives away the complexities of imperial self-representation in the tropics in the late nineteenth century (fig. 15, pl. 2). The photograph shows the emperor posing for yet another official picture, surrounded by a tropical background and holding a book, which stresses his reputation as an enlightened monarch, aware of scientific developments and committed to transforming Brazil into a modern nation ruled by reason and progress. At the same time, the inner composition of the portrait is marked by symbolic and referential incongruence: a king without a crown, a cosmopolitan gentleman in the tropics, nature as a selective compendium of crude signs in a country known for its exuberant nature. Instead of referential transparency and accurate documentation, we are confronted with photography's potential for political and social fiction as well as its capacity for adaptation and transformation of its conventions in transnational settings.

Political interpellation is just one of the many forking paths crossing the emperor's vast photographic archive.

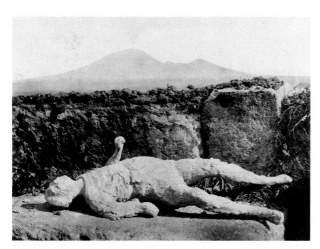

Figure 16. Michele Amodio (Italian, active ca. 1850–ca. 1880), *Pompeii (Italy): Human Cast, Pregnant Woman, Excavations*, 1868 (printed 1873). Albumen print, 19.2 x 24.1 cm. D. Thereza Christina Maria Collection, Archive of the National Library Foundation, Brazil

The collection is also punctuated by a persistent visual echolalia that keeps returning to images of death, ruins, and archival replication in history and nature, in yet another turn of photographic itinerancy. In this series, photography becomes a metalanguage through which larger philosophical, historical, aesthetic, and political questions can be brought into focus. Amodio's photograph of a pregnant woman turned into a lava cast by the volcanic eruption that destroyed Pompeii (another example of a form of inertness that suddenly "quakes") summarizes many of the emperor's implicit obsessions regarding photography and its meanings (fig. 16, pl. 4). The photograph is an image of an image of a biological camera: the woman who duplicates herself through pregnancy is in turn duplicated by the volcanic lava that makes a copy of her dead body, which is then recorded by Amodio's camera. By looking at this allegorical picture, which suggests that photography may be a means of transcending death through the creation of images, one wonders if the emperor's photographic passions also had to do with transcending his own demise.

Among the last pictures that entered the collection is one that seems to point in this direction: a photograph of the emperor and his entourage posing in front of the ruins of the Egyptian pyramids (pl. 3). While the ruinous background speaks of the inexorable passing of time and the fall of empires, ironically foreseeing the approaching disappearance of the emperor himself, by posing in front of the pyramids, Dom Pedro II locates himself "in the picture" of universal imperial history.

Dom Pedro II was overthrown and sent into permanent exile in 1889. Before he left the country, he donated his massive photographic archive to the National Library in Rio de Janeiro. He died in Paris on December 5, 1891. On December 6, Félix Nadar photographed his corpse. The photograph entered at the Instituto Moreira Salles's archival collection in 2009. Stressing once again the itinerant nature of the imperial archive, the emperor returned to Brazil from Europe as a traveling image.

Rosângela Rennó's Archival Disseminations: Recycling Photography

You imagine, as does everybody else for that matter, that our organization has for many years been preparing the greatest document centre ever conceived, an archive that will bring together and catalogue everything that is known about every person, animal and thing, by way of a general inventory not only of the present but of the past too, of everything that has ever been since time began, in short a general and simultaneous history of everything, or rather a catalogue of everything moment by moment. And that is indeed what we are working on and we can feel satisfied that the project is well advanced: not only have we already put the contents of the most important libraries of the world, and likewise the archives and museums and newspaper annals of every nation, on our punch cards, but also a great deal of documentation gathered ad hoc, person by person, place by place. . . . What we are planning to build is a centralized archive of human kind, and we are attempting to store it in the smallest possible space, along the lines of the individual memories in our brains.

—Italo Calvino[31]

All the world's photographs formed a Labyrinth. I knew that at the center of this Labyrinth I would find nothing but this sole picture, fulfilling Nietzsche's prophecy: "A labyrinthine man never seeks the truth, but only his Ariadne."

—Roland Barthes[32]

In his short story "World Memory," Italo Calvino uses the fantasy of the total archive as a setting for a thriller in which reputedly neutral practices of archival organization become not only epistemologically biased but also criminal. The Director—who narrates the story to a man who, like the reader, never responds—defies the authority of the archive and its discriminating and classificatory criteria by surreptitiously introducing discarded little things. But what appears to be the beginning of a subversive intervention to diversify the contents of the archive soon becomes a search for power and control over others. Obsessed with his wife's infidelities, the Director decides to modify the archive to erase all memory of her and her past affairs—a plan that involves, among other things, getting rid of her lovers, who include the story's addressee. Thus, the monumental promises of order and memory embodied by the total archive, which will soon be all that is left of humankind, culminates in contradiction, arbitrariness, and the erasure of the listener to the story by the Director. Calvino's text illustrates another aspect of the relationship between the two conflicting forces that rule archival formation. The centrifugal force that erases, destroys, and expels archival matter is not only the result of unavoidable oblivion and error or the impossibility of undifferentiated inclusion but also the outcome of political and ethical decisions. When it comes to society, the archive always has a dark side, which is linked to its potential for discrimination and erasure against marginal or oppressed groups.

Barthes offers a more poetic approach to the madness of the archive, its secret inconsistencies, its opacities, its lacunae. In his view, the apparent chaos of the total photographic archive—all the images in the world—is not an obstacle but rather an opportunity for creative intervention and for the construction of alternative orderings. Once inside the global labyrinth of pictures, Barthes calls for a participatory form of reception that would allow an opening and activation of the archives buried inside the images, mobilizing their potential meanings. The key is to follow Ariadne by collectively weaving new narrative threads instead of focusing on a predetermined destination.

The Brazilian artist and photographer Rosângela Rennó conceives her work at the intersection of these two fictions about the potential uses of the archive. If Barthes is right and all the images in the world form a single labyrinth, Rennó sees herself as an Ariadne who

incessantly complicates the terms of the search for the alleged monster at the center of the walled edifice of archival reason by taking unexpected directions, retracing her steps, questioning accepted filing criteria, introducing anomalous matter into the body of the archive, and incessantly and stubbornly deconstructing the dictates of sovereign power. Defying the laws of the archive, she works against the restricting and discriminating practices of the photographic archive in its different social and political configurations as police file, art museum, family album, and scientific data bank.

The focus of Rennó's interventions is in most cases the *derelicta* of the archive or the museum and everything that the recording apparatus expels or forgets: bad pictures, forgotten files, discarded or damaged photographs, wounded images—in short, visual garbage. Questioning the modernist understanding of photography in terms of authorship and aesthetic and technical innovation, Rennó considers the medium in terms of its production and reception while acknowledging its inherent reproducibility and deceptiveness. In her work, photographs are signs that acquire their meaning and value depending on the context, in relation to the place they occupy within the larger system of social and cultural coding—that is, in relation to the archive.

As is the case in the work of artists and photographers such as Tacita Dean, Joachim Schmid, Susan Meiselas, and Marcelo Brodsky, Rennó's performative and multimedia projects respond to what Hal Foster calls an archival impulse. In archival art, the figure of the artist joins that of the archivist in that his or her point of departure is the collection. The work is archival not only because it draws on formal and informal archives but also because it produces them "in a way that underscores the nature of all archival materials as found yet constructed, factual yet fictive, public yet private."[33] Furthermore, it often arranges these materials according to an archival logic and presents them in a quasi-archival architecture, usually adopting the format of the installation. According to Foster, the archival impulse assumes anomic fragmentation as "a condition not only to represent but to work through, putting forward new orders of affective association, however partial and provisional."[34]

Within this broader context, Rennó chooses to explore and scrutinize what we may call the "afterlife" of photographs—that is, the quiet existence of images

that are no longer in use or circulation. To the extent that they no longer move or signify, they are dormant pictures buried in cemeteries of images. Rennó appropriates photographs and photographic artifacts such as albums and negatives that have become obsolete and recycles them by placing them into new signifying arrangements. They come from all sorts of archival formats, including family albums, public archives, newspapers, and professional photographic studios. Once in Rennó's possession, the photographs are manipulated and altered by digital means, by the addition of a pigment, by enlarging or cropping, by altering the saturation of color or manipulating the contrast between shadows and highlights. Her ever-expanding collection is not limited to conventional visual material. Her ongoing project *O archivo universal* (1992–) comprises large numbers of narrative texts from newspapers that offer everyday stories centered on the private and public uses of particular photographs. They are seen as textual images in which photographs become material embodiments of memory, evidence, desire, or witnessing. Rennó's archival projects unfailingly produce a blurring effect that calls attention to and at the same time complicates the reading of images, stretching the definition of what photography is and what counts as photography.

Rennó's systematic and irreverent appropriation of existing images channels her critical response to the contemporary overproduction and superficial consumption of images that we can no longer see or read. Confronted with the excess of images and an overgrown transnational archive spilling over every aspect of our existences, she stopped taking photographs and decided instead to focus on awakening the optical unconscious of available but discarded images through the construction of counterarchives. Her art is a series of archival actions in which photography functions as a "workplace"—a site of anamnesiac experimentation and critical recontextualization.

Playing with the intersections between the archive and the library, Rennó frequently realizes her works in at least two formats, as installations and as artist's books. This bifurcating procedure helps make visible different forms of spatial organization according to which the archive can alternate between an architectural structure or an album, a public site or a private scene for semiotic traffic. Splitting the work into parallel formats

also opens the possibility of different forms of physical interaction and the active decoding of photographic images, which in Rennó's case remain both accessible and unreachable, always framed by layers of replication and material mediation.

Itinerancy is at the core of Rennó's archival impulse. Not only does her main modus operandi consist of putting images into motion while creating new paths for exchange and interpretation, but all her projects involve some form of movement, including flying to foreign countries and cities, visiting archival sites, trading photos with friends and collectors, and tracing particular types of photographic artifacts in flea markets around the world. More than simply obsolete coins of a common visual currency that has unified all subjects within a single global archival network of valuation and desire, her images transcend national and cultural borders, crossing over different mediums and genres and entering new visual configurations.

An archive of archives, Rennó's art not only involves a large number of visual materials from diverse archival formations but also explores their political power in the organization of private and social life by proposing an archaeology of the dominant visual discourses and apparatuses in modern society. By digging in the ruins of the archive, its hidden nooks and neglected accretions, she seeks to recover the photographic traces of the bodies of those who have been consigned to disappear within the hierarchical order of the archive— the infamous men and women whose lives are defined by their subjection to the disciplinary apparatuses of the state. By recovering the images of their obliterated bodies, her archaeological explorations question what institutional photography remembers and forgets, and for what purpose. In doing so, they destabilize the authority of the modern archive as a neutral technology of remembrance. Given the scope of her rewriting project, Rennó's archaeology is by definition a permanently incomplete task, a project always in progress.

Mimicking archival strategies of preservation and classification, Rennó treats her acquired photographic artifacts with new archival taxonomies in order to make visible the ways in which disciplinary institutions make people and their images "disappear." The archival project *Vulgo* (Alias, 1998–99; fig. 17), for example, consists of digital photographs made from reproductions of neglected glass negatives that Rennó retrieved from

Figure 17. Rosângela Rennó (born 1962, Belo Horizonte, Brazil; lives and works in Rio de Janeiro), *Number*, 1998, and *Phoenix*, 1998, from the series *Vulgo* (Alias), 1998–99. Laminated digital print or Cibachrome, from an original from the Penitentiary Museum of São Paulo, 166 x 120 cm each. Courtesy of the artist

São Paulo's Penitentiary Museum in 1998. Taken with the purpose of putting together an inventory of prisoners' innate physical features, such as cowlicks, the original photographs were supposed to record the stigmata that, according to the grammar of phrenology and physiognomy, corroborated social degeneration and a predisposition to crime. By digitally altering the negatives, blowing them up, and coloring the markers of difference that they were intended to expose, Rennó deconstructs the discriminatory logic of police records, thereby seeking to return to the photographed marginal subjects their human singularity by revealing instead their political vulnerability, even while calling attention to the violent mediation of the photographic apparatus and its blind spots. In its conspicuous iterability, the red mark opens the images of the anonymous infamous men to another reading, beyond objectification.

In *Bibliotheca* (2002–3), the rescuing and restoring of orphaned images operates in the photographic space of bourgeois self-representation and private collecting. The project grew out of another branch of Rennó's archival impulse, her long-standing interest in and persistent quest for old photo albums and private slide collections, which she began to acquire at a flea market in Brussels

in 1992. In the installation format, *Bibliotheca* treats the assembled archival objects as forgotten material artifacts of a scattered collective library. Organized as thirty-seven sealed vitrines containing one hundred albums and slide collections and covered by 1:1 scale digital color photographs of the vitrines' contents, mounted on Plexiglas, it adopts the architectural design of an archaeological exhibition, complete with a small filing cabinet with cards describing each of the objects on display and with a large world map on a wall marking the sites where they were found and gathered before they traveled to Rennó's studio in Brazil (fig. 18).

In its book format, *Bibliotheca* is organized according to a conceptual association that equates the book with the world. In dialogic opposition to the project *O archivo universal*, a collection of fragmentary visual texts without images, the artist's book *Bibliotheca* is made of visual "quotations" from photo books, whose contents have been taken apart, reshuffled, rearranged, and replicated according to a visual poetics reminiscent of the compositional technique known as the exquisite corpse, practiced by the Surrealists and the Dadaists.[35] But instead of relying on the serendipity induced by partial blindness, Rennó promotes a visual poetics that

operates according to visible correspondences between ready-made photographic bodies. Since this technique can be applied indefinitely, at least *in potentia*, Rennó's visual compendium could keep expanding forever.

As a book of books, or a photo archive made of smaller photo archives, *Bibliotheca* belongs to a genealogy of conjectural objects that, like Borges's spherical Aleph, seek to contain the totality of the universe within a single point or singular object. This genealogical connection already is alluded to in the title of the project. The anachronistic use of the Latin term *bibliotheca* refers to the Portuguese *biblioteca* (library) but above all quotes the title of an ancient work, Photius's book archive, written in the ninth century, which lists and summarizes all the books read by the patriarch of Constantinople during his brother's absence. Photius's list traces the eclectic contours of a ghostly library, most of whose contents have disappeared, leaving behind only an entry in his records.[36] In a similar way, Rennó's archival photographs constitute the shadowy remains of collections of images and the life stories they conveyed, which, detached from the affective ties that made them signify, have become anonymous and meaningless to us. Even if they have not vanished like the patriarch's books, the fact that their language has fallen into oblivion has made them unreadable. Connecting anew the

dormant photographs across time and space, Rennó mobilizes their encrypted meanings by creating new signifying threads and paths across the field of representation that run along repeating visual patterns, figures, and motifs. The results are aleatory sequences and visual correspondences that project the old images onto the screen of an anonymous collective memory: a baby sitting on a large chair looks at the camera next to the image of an old man who, by visual contagion, seems to have lived the rest of the baby's life on his behalf (fig. 19); the ruinous image of a newlywed couple posing for the camera in ceremonial attire next to another, more modern newlywed couple looking in their direction, trapped in an impossible time lag; family members unfailingly disciplined to stand for the camera around tables and family pictures; rows of picture IDs of men, women, and children, conspicuous in their seriality, their bodies dwarfed to the size of focused faces; photos of remote places and cities we would like to see; Venice framed repeatedly as a fixed set of tourist sites; bodies of water from unknown familiar places; diving swimmers frozen in midair for eternity; men in uniform forever at war; Asian women in pairs wearing traditional costumes; rainbows over modern cities that look like other modern cities; planes taking off from or landing in nonplaces; windows and mirrors framing a picture world made of reflections . . .

Figure 18. Rosângela Rennó, *Bibliotheca*, 2002. Partial installation view, Museo Tamayo, Mexico City, 2009. Courtesy of the artist

Figure 19. Rosângela Rennó, *Bibliotheca*, 2003. Artist's book, insertions in offset-printed book, hardbound, texts in Portuguese and English, open: 16 x 42 cm. Courtesy of the artist

Leafing through Rennó's album of visual quotations, we experience the foundational paradox that defines the photographic archive, suspended between the domiciliation of the law and the indeterminacy of the image, which is always on the move, protean and resistant to fixation. The camera captures the world, translating everything into a massive repertoire of frozen images and prosthetic traces of what has already been. But the stillness of the archive is just a deceiving mask. It dissimulates the slow and continuous movement and transformation of images, which, silently and actively, keep entering and exiting the archive through its revolving doors.

Notes

Epigraphs: Siegfried Kracauer, "Photography," in *The Mass Ornament: Weimar Essays*, ed. and trans. Thomas Y. Levin (Cambridge, MA: Harvard University Press, 1995), 59; Jacques Derrida, *Archive Fever: A Freudian Impression* (Chicago: University of Chicago Press, 1996), 90.

1 Pierre Nora, "Between Memory and History: The Lieux de Mémoire," in "Memory and Counter-Memory," special issue, *Representations*, no. 26 (Spring 1989): 13 (emphasis mine).

2 Opposing Nora's belief that modernity's archival drive is based on the monumentalization of history, Wolfgang Ernst argues that, on the contrary, photography liberates the past from historical discourse (which is always anthropomorphic), replacing it with the rhetoric of media and making source data accessible to unexpected configurations. Wolfgang Ernst, *Digital Memory and the Archive* (Minneapolis: University of Minnesota Press, 2013), 45–48.

3 See Derrida, *Archive Fever*, 14–15. The theorist of photography Hubertus von Amelunxen has come to a similar conclusion. In his view, the predominance of certain forms of indexical and post-indexical ways of seeing have rendered the modern subject a "homo photographicus": "Photography is the image of our history.

It has been regarded by some as a source of historical records, by others as the ruin of a historical continuum. It took the progressive digitization of the pictorial and lexical worlds, both grounded in analogy, to show us just how far we had evolved down the road towards becoming 'homo photographicus.'" Hubertus von Amelunxen, "Photography after Photography: The Terror of the Body in Digital Space," HyperArt.com, http://hyperart.com/lib/ph_after_ph.html. See also Ernst, *Digital Memory*, 37–41.

4 Roland Barthes, *Camera Lucida: Reflections on Photography*, trans. Richard Howard (New York: Hill & Wang, 1981), 6.

5 Michel Foucault, *The Archaeology of Knowledge; and, The Discourse on Language*, trans. A. M. Sheridan Smith (New York: Pantheon, 1982), 129.

6 According to Ernst, the analytical work of the media historian is challenged and undermined by the photograph's archival condition. In his view, photography is itself a media-archaeological technique of remembering the past in a way that is radically different from traditional historical discourse (*Digital Memory*, 48–49).

7 See Okwui Enwezor, "Archive Fever: Photography between History and the Monument," in *Archive Fever: Uses of the Document in Contemporary Art* (New York: International Center of Photography; Göttingen, Germany: Steidl, 2008), 11–12.

8 Susan Sontag, *On Photography* (New York: Picador, 2001), 3–4.

9 Kracauer, "Photography," 62.

10 Ibid., 58.

11 Sontag, *On Photography*, 156.

12 See John Tagg, *The Disciplinary Frame: Photographic Truth and the Capture of Meaning* (Minneapolis: University of Minnesota Press, 2009), 3–5.

13 Jorge Luis Borges, "The Total Library," trans. Eliot Weinberger, in *The Total Library: Non-Fiction, 1922–1986*, ed. Eliot Weinberger (London: Penguin, 1999), 216.

14 Derrida, *Archive Fever*, 7.

15 Vilém Flusser, *Towards a Philosophy of Photography* (London: Reaktion, 2005), 49 (emphasis mine).

16 Marcus Banks and Richard Vokes, "Introduction: Anthropology, Photography, and the Archive," *History and Anthropology* 21 (December 2010): 339.

17 The circulation of photographic images either within or between archives and collections may also alter the nature of their material relations. In this regard, it s relevant to keep in mind the distinction between the photographic *image* and the material *object* upon which it is made apparent, that is, the photograph as virtual trace and the photograph as a physical artifact. The same image can be reproduced across different objects in a process that can alter its original meaning. This process constitutes the image's material history. See Elizabeth Edwards and Janice Hart, *Photographs, Objects, Histories: On the Materiality of Images* (New York: Routledge, 2004).

18 Georges Didi-Huberman, in Mathieu Potte-Bonneville and Pierre Zaoui, "Worrying about Each Image: Interview with Georges Didi-Huberman," *Vacarme*, no. 37 (Autumn 2006), www.vacarme .org/article1352.html.

19 Elizabeth Edwards, *Raw Histories: Photographs, Anthropology, and Museums* (Oxford, UK: Berg, 2001), 7, 28–29.

20 Although traditional postcards are approaching extinction and rapidly being replaced by digital cards, for almost a century they functioned as printed money in the international market of images. Their paper bodies were formatted to enhance their potential for travel and mass circulation. In 1878 the World Congress of the Universal Postal Union set the standard size for postcards at 3½ by 5½ inches. One hundred and forty billion postcards were mailed worldwide in the period from 1894 to 1919. Their shape and ability to flow facilitated rather than undermined archivization. By providing the public with prints that could be arranged in neat piles and that could easily fit into normalized viewing artifacts such as albums, the standardized format also enabled the popularization of private image collecting. For a historical account of the circulation and collection of picture postcards portraying non-Western peoples in Europe and the United States, see Christraud M. Geary and Virginia-Lee Webb, eds., *Delivering Views: Distant Cultures in Early Postcards* (Washington, DC: Smithsonian Institution Press, 1998).

21 My take echoes the historical definition of photography as a globally disseminated and locally appropriated medium put forward in Christopher Pinney and Nicolas Peterson, eds., *Photography's Other Histories* (Durham, NC: Duke University Press, 2003). Such a view also questions the belief that photography has a fixed identity based on technical evolution, aesthetic perfection, and a short list of famous, mainly modernist photographers.

22 The figure of the archive constitutes a strong ideological concept in Latin America's cultural imagination. According to Roberto González Echeverría, Latin American classics such as Gabriel García Márquez's *One Hundred Years of Solitude* (1967) are constructed as an explicit meditation on the organization and meaning of the legal and literary archive and its contents. Roberto González Echeverría, *Myth and Archive: A Theory of Latin American Narrative* (Cambridge: Cambridge University Press, 1990), 1–42.

23 Sontag, *On Photography*, 3.

24 Thomas Richards, *The Imperial Archive: Knowledge and the Fantasy of Empire* (London: Verso, 1993), 6.

25 There have been several partial exhibitions of the emperor's photographic collection, which is housed at the National Library in Rio de Janeiro under the name of the emperor's wife, D. Thereza Christina Maria. For a general description of the collection, see Joaquim Marçal Ferreria de Andrade, *A Colecção do Imperador: Fotografia brasileira e estrangeira no século XIX* (Porto, Portugal: Centro Português de Fotografia, Ministério da Cultura, 2000).

26 According to the *Jornal do Commercio do Rio de Janeiro*, accuracy and speed were the new invention's most positive features: "One must have seen the thing with one's eyes to have an idea of the rapidity and result of the operation. *In less than nine minutes* the fountain, the Paço Square, Peixe Park, and the Monastery of São Bento and all surrounding objects were reproduced with *such fidelity, precision, and detail*, that they really seemed made by the very hand of nature, almost without the intervention of the artist." Cited in Lilia Moritz Schwarcz, *The Emperor's Beard: Dom Pedro II and the Tropical Monarchy of Brazil*, trans. John Gledson (New York: Hill & Wang, 2004), 261.

27 See Rubens Fernandes Jr., "De volta a luz: Fotografias da coleção do Imperador D. Pedro II," *De volta a luz: Fotografias nunca vistas do Imperador / Return to Light: Never Before Seen Photographs of the Emperor* (São Paulo: Instituto Cultural Banco Santos and Fundação Biblioteca Nacional, 2003), 38–49.

28 Jens Andermann, *The Optic of the State: Visuality and Power in Argentina and Brazil* (Pittsburgh: University of Pittsburgh Press, 2007), 7.

29 Schwarcz, *Emperor's Beard*, 3–12.

30 Ibid., 260–66.

31 Italo Calvino, "World Memory," in *Numbers in the Dark and Other Stories*, trans. Tim Parks (New York: Pantheon, 1995), 135–36.

32 Barthes, *Camera Lucida*, 73.

33 Hal Foster, "An Archival Impulse," *October*, no. 110 (Fall 2004): 5.

34 Ibid., 22. Foster suggests that the archival desire to connect disparate elements and objects may betray a paranoid dimension. Paranoia would be the other side of a utopian ambition, a "desire to turn belatedness into becomingness, to recoup failed visions in art, literature, philosophy, and everyday life into possible scenarios of alternative kinds of social relations, to transform the no-place of the archive into the no-place of a utopia" (ibid.).

35 Based on an old parlor game, the *cadavre exquis* (exquisite corpse) was a collective collage put together by several people, each of whom would write one or more words or draw an image on a sheet of paper, fold the paper to conceal part of it, and pass it on to the next player for his contribution. This compositional method got its name from the resulting phrase obtained in initial playing among the Surrealists: "Le cadavre / exquis / boira / le vin / nouveau" (The exquisite corpse will drink the young wine).

36 For an insightful and detailed reading of Rennó's *Bibliotheca* as an *apparatus* of memory and mnemonic strategies, see María Angélica Melendi's excellent essay "Bibliotheca; or, On the Possible Strategies of Memory," in *Rosângela Rennó: Bibliotheca* (Barcelona: Gustavo Gili, 2003), 37–49.

Photographic Itinerancy and Its Doubles

Mauricio Lissovsky

However, he did not know what he was doing himself, because at that moment he was decidedly neither dead nor alive. —Fyodor Dostoyevsky

From the moment of its invention, photography increasingly has occupied the place—necessarily and problematically—of the guardian of disparate images in a disenchanted world. It played this role until the end of the last century—not quite a bouncer (*leão-da-chácara*), more like a ballerina balancing on a tightrope that stretched from one end of our consciousness to the other. It monitored this distance—the distance between the image that verifies and another that eludes, between the transparency and opacity of the world—by making it taut, compelled to continue traversing it in order to avoid plummeting. From this incessant itinerancy we encounter doubles that come together to reflect on each other. Moving from one extreme to another along this cord, this essay brings together double images from various countries and collections. In this way, it produces its own itinerancy in its search for clues about what the modern experience of photography might have been.

I want to begin with a photograph by Adenor Gondim, who for decades has dedicated his work to the documentation of Bahian popular and religious culture (fig. 20). He searched for a background against which he might photograph two saint figurines that he had given to his son, but nothing satisfied him. He found, in a scrap heap, this portrait taken in the "studio" of a street photographer in Bom Jesus da Lapa. It was there that Cosmas and Damian finally found their place.

The joke is there along with everything that characterizes it: the sudden visualization of a comic situation, more precisely a "comic contrast," the construction of analogies between different elements (or the revelation of hidden analogies between them). A movement that Freud once described as a passage, as quick as possible, from bewilderment to enlightenment.[1] The types of contrasts, of dualities, are diverse: scale (between people and ceramic figurines), nature (between human beings and dolls), color (between monochrome and polychrome), medium (photography and sculpture), and, of course, between the sacred and the mundane (indeed the photograph *sucks* the pilgrims into the saints' "niche"). The clay saints are *humanized* as they join the pilgrim family; the latter, in turn, is *revived*, borrowing a moment that belongs to the present of Cosmas and Damian and the photographic act that unites them.

Figure 20. Adenor Gondim (born 1950, Rui Barbosa, Brazil; lives and works in Salvador, Brazil), *Cosme e Damião* (Cosmas and Damian), Bahia, n.d. Digital photograph, dimensions variable. Courtesy of the artist

Figure 21. *Untitled*, 1975. Gelatin silver print, 20.3 x 30.3 cm. Photograph taken in Ila-Orangun, Western State, Nigeria. Stephen Sprague Archive, Center for Creative Photography, The University of Arizona

Freud supposes that, in forming a joke, "a preconscious thought is given over for a moment to unconscious revision and the outcome of this is at once grasped by conscious perception."[2] What we witness here is a quick passage through the subconscious, a subtle diversion from the course to a submerged path from which thought emerges transformed into playful judgment.[3] Brought to light, the joke is nothing but a photograph, a snapshot robbed from the unconscious that rises to the surface as a deformed comic image.

Gondim's photographic joke is not resolved in a comfortable distance or difference between image and world. It is compressed in a duplicity that projects us

outside of time and throws us into an abyss that appears to be the territory specific to photography. Photography confronts these dualities each and every time it interrogates itself.

Before seeing Adenor Gondim's image-joke, I had never wondered about photography's god or patron saint. I consulted professionals in Brazil about their protector saint. The few who braved a response were almost certain that it "must be" Saint Lucy. But the correct response is Veronica, famous for having wiped Christ's face during the Passion and imprinted traces of the Holy Face onto the veil. Veronica and the shroud are the

Figure 22. Left: Hans Memling (Netherlandish, ca. 1435–1494), *Saint Veronica* [obverse], ca. 1470/1475. Oil on panel, painted surface: 30.3 x 22.8 cm. National Gallery of Art, Samuel H. Kress Collection (1952.5.46.a) Right: Advertisement for OMO laundry detergent, Brazil, ca. 1964

paradigmatic objects of the "aura," and in their condition as sacred relics, they are thus the "auratization of the trace."[4] However, beyond the analogy between these acheiropoetic images—produced without assistance from human hands—and those produced by photographers, it is suggestive that photography played an important role in the modern worship of these relics.[5] The favor was returned properly.

Veronica was therefore the first photographer—justification for the Vatican's obvious choice of making her the protector saint. The question becomes more complex when we consider that the same saint was put in charge of protecting laundry workers. The choice of Veronica originated in a liturgical gesture: the *ostension*, which consists of raising a sacred object in one's hand and exhibiting it for all to see. Veronica is always represented in ostension of the veil, and it is also in ostension that the results of well-laundered clothes are displayed (fig. 22).

We encounter under the auspices of this saint another similarity between photographers and launderers. I refer to the bath involved in photographic image making; without it, without the mediation of invisible forces of visibility at play in the dip, the image—in all its purity—would not magically surface on paper. It is likely that with the rise of digital technology this similarity is often overlooked. I am certain that today the new patron saints of photography must be Cosmas and Damian, as

has been the case in Bahia de Gondim for some time. In Bahia and in Nigeria, in the Yoruban tradition as well as in many African cultures, the birth of twins is a blessing for the family. They are called *Ibeji* ("born two").

In Nigeria, photographs of twins may serve as substitutes for the little statuettes in which Ibeji is represented.[6] There are occasions when one of the twins dies before being photographed. In these cases, it falls on the photographer to reestablish the prematurely deceased double. That is what happened with Taiwo, whom we see here holding the duplicated double of herself as a baby, representing her and her twin sister, who died before a photograph could be taken of the two together (fig. 21).

Nigerian photographic montages not only reestablish a familial memory but also reactivate the power of the double. In this way, they are able to generate as many benefits as a photograph of authentic twins. When Stephen Sprague asked little Taiwo to *ostend*, to exhibit, the Ibeji that her mother formed with two copies of the same portrait, he placed us face-to-face with the mystery and power of photography—a power always on the verge of depletion, always on the verge of becoming banal. This is the same power that Gondim attempted to evoke with his small photographic altar dedicated to the twins Cosmas and Damian.

The importance of doubles—the image's quick dip into its unconscious—was never as clear as it is now, when photographs no longer bathe.

As a double, photography faces itself. It invokes its own powers, but the results are always unclear, as in this *carte de visite* of the Brazilian emperor and his double, by Carneiro & Gaspar, from 1867 (fig. 23). There is no better allegory of the tensions present in the paradoxical configuration of nineteenth-century portraits than this montage. In the photograph, Dom Pedro II, devoted collector and photography enthusiast, lends his royal effigy to a gag, despite the sobriety of his expression. It is impossible to avoid associating this image with the thaumaturgical tradition of the double character of the king's body: a human body, mundane and transitory, and a mystical body, sovereign and permanent.[7]

But here, in this photograph, the mystical coincidence of the emperor's eternal body and Pedro's mortal body is broken. The emperor looks at Pedro. Pedro looks at the emperor. Or perhaps the emperor looks at

Figure 23. Carneiro & Gaspar, *Emperor of Brazil D. Pedro II, Rio de Janeiro*, 1867.
Albumen print (*carte de visite*), 9 x 5.5 cm. Courtesy Arquivo Nacional, Brazil

the emperor, and Pedro looks at Pedro. It's difficult to say. What does each seek in the gaze of the other? What questions does each pose? Photography was, as Lilia Moritz Schwarcz has pointed out, the main medium of the modern representation of Pedro II, and through it, the monarch attempted to participate in a progressive society embodied in a photo album.[8] Like Louis Bonaparte in France, who ordered that he be photographed like an "individual of the middle class with whom the people could identify," here the emperor also posed as "citizen-king."[9] In this surprising *carte de visite*, however, a simple photographic trick reestablishes the repressed duality of the king. More than simply exhibiting his majesty in the clothes and attitudes of the common citizen, the photograph suggests that the two bodies of the king are—in contrast to what the medieval tradition professed—of the same nature. By participating in a game of mirrors in the atelier, the emperor's double is confused with the kingdom's notables (that is, with the double of the body of all those who desired to be photographed and indeed who succeeded in being photographed).

But there is still something else at play in this portrait. Let us imagine the emperor himself holding this small photograph in his hands, observing himself as he looks at himself, unable to distinguish between body and

ghost. Who is the sovereign and who is the common citizen? The only king in the Americas, Pedro perhaps imagined that the scene of bourgeois mimeticism that he performed in the photographer's studio would demonstrate his affinity with the common man; however, in the duplication of his physical body, the photograph also reveals the monarchy's melancholic departure.

The photomontage of the Brazilian emperor short-circuits sovereignty. The same technique, this time put to use in a formal portrait of the governor of the Mexican state of Guerrero in 1915, intends to preserve, or even reestablish, a mystique at risk of fading away (fig. 24).

The governor is General Julián Blanco, seated in the middle, at the beginning of his short term in office (December 26, 1914–August 6, 1915). The portrait was taken by Amando Salmerón, known as the "photographer of the Revolution in southern Mexico."[10] General Blanco led the insurrection in the region; involved in a complex and often anarchic struggle of Mexican revolutionary factions, however, he broke with Zapata and was named interim governor of Guerrero by the "constitutionalist" president Carranza.

This photograph was probably taken at the time of his inauguration. It is a conventional portrait of a local political chief and his staff, taken with all the formalities

Figure 24. Amando Salmerón (Mexican, 1887–1951), *General Julián Blanco, Governor of Guerrero, and His Staff,* Guerrero, Mexico, 1915

Figure 25. Hans Holbein the Younger (German, 1497–1543), *The Dead Christ in the Tomb*, 1521–22.
Oil on wood, 32.4 x 202.1 cm. Kunstmuseum, Basel, Switzerland

that characterized this kind of image, with the exception of the curious figure standing at the right margin of the frame. It portrays a spectral effigy, a double of Julián Blanco himself, armed with a 30-30, pistol in holster and bandoliers crossed over his chest. The veteran general, involved in seditions and rebellions since 1893, is now a man of the constitution but skeptical that his new outfit and rank are enough to safeguard his authority. As if invoked by the assembly, the spirit of the revolution attends the new government's solemn effort to institutionalize itself through photography.

The specter of himself as revolutionary, however, was not sufficient to guarantee Blanco protection. After eight months in office, pursued by the commander of the troops that were supposedly under his authority, he took refuge in Acapulco, where he was assassinated together with his son Bonifácio. The coreligionists who betrayed him reported to President Carranza that the governor had killed his own son and committed suicide. Ironically, the motive they gave for this insane gesture is represented in the photograph. It was alleged that, despite his sworn loyalty to the president, the governor appointed to Guerrero had secretly remained faithful to *zapatismo*.

The portraits of the governor and the emperor are, in general, opposed to each other. The double of the emperor invokes the common man; the double of the general, the extraordinary. Pedro attempted to blend in; Julián, to stand out. The king-citizen divests himself of his mystique; the governor-revolutionary flaunts it. However, a chilling similarity runs through these images. In both, the photographed becomes dissociated from himself in order to watch himself. Pedro II holds on to the present in the reciprocity of his own gaze; Julián Blanco reveres

the shadow of his past. What each of these doubles ends up inscribing in the photographs, however, is the destiny of their respective governments. Both were trampled by their doubles: the double of Emperor Pedro II declared the republic; the double of Julián Blanco carried on the revolution.

Hans Belting calls attention to the fact that ancient Christology was a somatology "in the sense that it needed to involve itself in a dispute with respect to the reality of Jesus's body." In addition to wounds and thorns, Veronica and the shroud were crucial images for a body without a tomb. The body of Christ, however, was not "simply a human body but an image in itself."[11] This fundamental corporal-image wholeness, which the emperor and the governor lacked—as all of us do—is a Christly privilege.

In 1867 Dostoyevsky visited the Kunstmuseum in Basel, Switzerland. The writer *froze* in front of a painting by Holbein the younger (fig. 25), unable to avert his gaze. The face of the writer maintained the same expression—a mixture of ecstasy and panic—that he was used to having during an epileptic seizure.[12] In the museum's painting, Christ, at a lifelike scale, lies in a tomb.

The painter included the martyr's marks in his image, as was the custom. But he also introduced something new that had never been seen before. This body, which had still not begun to decompose—three days later it would rise from the tomb unscathed—was there as if in a fermata between life and death.[13] Holbein's Jesus did not rest in his fair share of eternity: with semi-open eyes and a contracted abdomen, the pain of the cross infinitely prolonged, he indefinitely retained his

last breath. The open mouth did not emit a sound, but the finger of his right hand spoke for his entire body and pointed us to the shroud.

What did Dostoyevsky see in Holbein's painting if not his own double? His own body as a living double of Christ's dead immortality. The body of Christ as a dead double of his own living mortality. And yet, all this in suspense, like a photograph.[14] Jesus Ibeji, born together in body and image, as alive as dead in his crystal tomb.

Centuries later, in another transparent tomb, a Mexican maiden also contemplates her destiny (fig. 26). Just like Emperor Pedro II, Adela Fonseca gazed at her own image—in this case, encapsulated in a glass pitcher. And just like Dostoyevsky, she was captured by a harbinger of the future: her shoulders are already naked and the shoe has escaped from her left foot.

The vessel in which the image of the maiden was imprisoned is not only an open window to the future. It is a staging of the transparency of the photographic medium that simulates the sacrifice of its own corpore-ality to the perpetual association between bodies and images. As such, the hidden desire of every image that has another image inside it is to free itself from its materiality, to move away from itself. The question of the double is therefore always the question of the image's soul, such that even the most static photographs are animated. And if the jar is now filled with water? For how long will the gentle Adela be able to hold her breath? For all the time in the world? Or only enough time for her exposure? To turn one's gaze to the jar is to let its ghosts leak, drop by drop. Through a double, a photograph asks about its destiny and about its reasons for living.

In this photograph by Bibi Calderaro (fig. 27), water fills a jar to its rim. We are no longer waiting for the photographer to return to the surface to reveal what he collected on his last dive. The double here does not need any staging or representatives. We are face-to-face with it. If photographs have a soul, I believe that this could very well be its portrait. Like children suspended in water, holding their breath and staring at us, photographs are dammed duration and dreams, always on the verge of breaking the levees of the imagination. This locked-up soul is the fuel of photography's itinerancy.

Translated by Nathaniel Wolfson

Figure 26. Amando Salmerón, *Adela Fonseca,* Chilapa, Mexico, ca. 1930

Figure 27. Bibi Calderaro (born 1965, United States, raised in Argentina; lives and works in Brooklyn), *Untitled*, from *Underwater Portraits Series*, 1991–95, Buenos Aires, Argentina. Chromogenic print, dimensions variable. Courtesy of the artist

Notes

Epigraph: Fyodor Dostoyevsky, *The Double*, in *The Double and The Gambler*, trans. Richard Pevear and Larissa Volokhonsky (New York: Vintage, 2007), 25.

1 Sigmund Freud, *Jokes and Their Relation to the Unconscious* (New York: Norton, 1963), 11.

2 Ibid., 205.

3 Ibid., 23.

4 Georges Didi-Huberman, *La ressemblance par contact: Archéologie, anachronisme et modernité de l'empreinte* (Paris: Éditions de Minuit, 2008), 80.

5 Georges Didi-Huberman, "Photography—Scientific and Pseudo-Scientific," in *A History of Photography: Social and Cultural Perspectives*, ed. Jean-Claude Lemagny and André Rouillé, trans. Janet Lloyd (Cambridge: Cambridge University Press, 1987), 75.

6 Stephen Sprague, "Yoruba Photography: How the Yoruba See Themselves," in *Photography's Other Histories*, ed. Christopher Pinney and Nicolas Peterson (Durham, NC: Duke University Press, 2003), 240–60.

7 Ernst Kantorowicz, *Les deux corps du roi* (Paris: Gallimard, 1989), 30–38.

8 Lilia Moritz Schwarcz, *The Emperor's Beard: Dom Pedro II and the Tropical Monarchy of Brazil*, trans. John Gledson (New York: Hill & Wang, 2004), 254.

9 Pedro Vasquez, *O Brasil na fotografia oitocentista* (São Paulo: Metalivros, 2003), 40. Also interesting is the monarch's adoption of the bourgeois portrait and his renunciation of arms in his effigy in favor of the commercial photographer's "coat of arms," a sign of belonging to a vast clientele.

10 Blanca Jiménez and Samuel Villela, *Los Salmerón: Un siglo de fotografía en Guerrero* (Mexico City: Instituto Nacional de Antropologia, 1998), 31.

11 Hans Belting, *Bild-Anthropologie: Entwürfe für eine Bildwissenschaft* (Munich: Fink, 2001), 95, 96.

12 Andrea Rosseti and Julien Bogousslavsky, "Dostoevsky and Epilepsy: An Attempt to Look through the Frame," in *Neurological Disorders in Famous Artists*, ed. Julien Bogousslavsky and François Boller (Basel: Karger, 2005), 65–75.

13 Belting, *Bild-Anthropologie*, 100; Julia Kristeva, "Holbein's Dead Christ," in *Black Sun: Depression and Melancholia* (New York: Columbia University Press, 1989), 105–38.

14 The photograph of a corpse is "horrible," Barthes writes, "because it certifies, so to speak, that the corpse is alive, as *corpse*." Roland Barthes, *Camera Lucida: Reflections on Photography*, trans. Richard Howard (New York: Farrar, Straus & Giroux, 1981), 78–79. With regard to Holbein's Christ, we may consider what Barthes said about the young man condemned to death who was photographed by Alexander Gardner ("He is dead and he is going to die") and, to paraphrase, "he is dead and will not die" (ibid., 95, 96).

Itinerant Mexican Icons

John Mraz

Mexico is an eminently visual culture, in which icons surface and resurface in a constant stream of connotations and re-connotations that are generated within the particular contexts of their appearances and reappearances. This process didn't begin with the Mexican Revolution of 1910–20, but some of the photographs produced during that struggle have acquired the status of icons, including two images that continue to make their visual presence felt: that of Emiliano Zapata standing stolidly in *charro* raiment, a sash across his chest, one hand holding a carbine and the other on a sword (fig. 28, pl. 31), and that of "Adelita the *soldadera*" peering intently from a train.[1] Other key itinerant icons from the Mexican past (and present) are a 1934 photograph by Manuel Alvarez Bravo, *Obrero en huelga, asesinado* (Striking worker, assassinated), and one by the Hermanos Mayo of a mother grieving over her son, killed during a 1952 May Day march.

The picture of Emiliano Zapata in Cuernavaca during the summer of 1911 has become an international revolutionary icon and one of the most reproduced Latin American photographs. It was probably taken by a foreigner (Hugo Brehme? Fred Miller?), and the fact that an outsider could get close to the fearsome warrior reinforces the idea of Zapata's interest in constructing his own image; he probably felt that someone from another country would be more neutral than the capital's photojournalists, who worked for a reactionary press; he may also have hoped that the image would reach eyes outside Mexico. Zapata had little trust in the metropolitan press, and rightly so, considering the eventual use it made of this picture. The photograph is intriguing in its complexity and may represent a startlingly graphic depiction of triumph. Zapata is draped with crossed cartridge belts—a visual trope of the revolt led by Francisco Madero—and dressed with a general's sash and sword as a symbol of his status as the authority in Cuernavaca, capital of Morelos state. It may also be part of an effort to legitimate his movement on a national level: he and his *campesinos* were portrayed in the Mexico City press as cruel and ferocious savages, so Zapata may have been attempting to counteract that mind-set, presenting himself as a professional soldier, with the rank of general, and thus a man deserving of political recognition.

Before it was published in a periodical, the legendary Mexican lithographer José Guadalupe Posada made a print based on the image, which he almost certainly saw on a postcard; after Posada's death in 1913, the lithograph circulated on broadsheets with texts that both praised and excoriated Zapata. The icon itself appeared in the press two years after it had been made, when it served as a newspaper's front-page illustration for an attack on Zapata as "Attila of the South." It has been reproduced many times, usually as an illustration with a one-dimensionally positive or neutral connotation, including recurrent publications in U.S. magazines. One exception is its incorporation into a painting by Arnold Belkin, in which the artist showed the leader as if his body were dissected into geometric forms that are at the same time his skeleton.

Another noteworthy use of the icon is that devised by the photojournalist Elsa Medina, who integrated it into a photograph in such a way as to offer a dense reading, which is also a critique of the party dictatorship that has been a persistent legacy of the revolution (fig. 29). President Carlos Salinas de Gortari (1988–94) frequently employed the figure of Zapata, both visually and verbally, in pushing his programs, and the "collaboration"

Figure 28. Hugo Brehme (?) (1882–1954, born in Germany, active in Mexico), *Emiliano Zapata with Rifle, Sash, and Saber, Cuernavaca*, June 1911. Inkjet print from a digital file, exhibition copy, 25.4 x 17.8 cm. Fondo Casasola, SINAFO-Fototeca Nacional del INAH (Inv. #63464)

Figure 29. Elsa Medina (born 1952, Mexico City; lives and works in Mexico City), *Presidente Carlos Salinas and Secretary of Agrarian Reform Víctor Cervera Pacheco at the Presidential Residence, "Los Pinos," in a Meeting with Campesino Organizations to Reform Article 27 of the Constitution*, Mexico City, 1991. Inkjet print from a digital file, exhibition copy, 17.8 x 11.7 cm. Courtesy of the artist

between Medina and Salinas produced an image in which he makes a grotesque gesture in front of a painting based on Zapata's icon during a meeting about doing away with agrarian reform. Medina's image is a penetrating critique of the use that the Partido Revolucionario Institucional (PRI) has made of the revolutionary heritage that has served to legitimize its rule but that it has not respected. This is the Mexican icon that most often appears on Internet sites, generally linked to leftist

causes, but it has also been used to promote karaoke music, U.S. gun culture, the Costa Alegre Travel Agency, and the rock group La Revolución de Emiliano Zapata, whose biggest hit appears to have been "Nasty Sex."

Zapata's icon circulated as a postcard prior to its appearance in the press; another postcard was made at the same time of the Zapata brothers with their wives (fig. 30). (In fact, Emiliano appears to have borrowed Eufemio's cartridge belt in order to create the Maderista

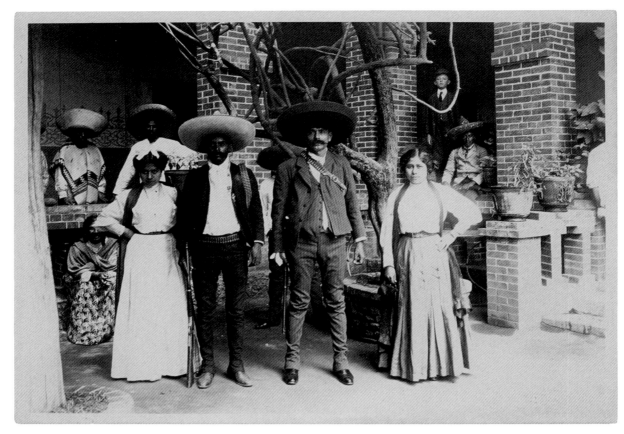

Figure 30. Hugo Brehme (1882–1954, born in Germany, active in Mexico), *Zapata Cuernavaca*, 1911. Gelatin silver print, 12.5 x 17.5 cm. Hugo Brehme views of the Mexican Revolution, The Getty Research Institute, Los Angeles (98.R.5)

trope.) The Mexican Revolution took place in the middle of the international postcard boom, and it was extensively covered by photographers who sold their images through this medium. The majority of the photographs taken during the revolution may have been made in the five-by-seven-inch format, which is designed for postcards. Moreover, images filtered between the mediums of photojournalism, studio photography, and postcards constantly, being copied and recopied to meet a demand so great that the U.S. producer on the border, Walter Horne, was printing as many as five thousand postcards a day.

One image that does not appear to have circulated as a postcard is that of a woman—known today as "Adelita"—who grips the handrails of a train car and leans forward, looking up the tracks (pl. 30). She has been recruited to serve as the personification of the *soldaderas*,

the camp followers who lived from the soldiers' pay (*la soldada*), fed them, treated their wounds, took care of their children, provided social lubrication and entertainment, and sometimes grabbed weapons to defend themselves. The photograph was probably taken by Gerónimo Hernández in April 1912 in Buenavista station, where the woman was standing on the stairs of a military train headed north to put down the rebellion of Pascual Orozco, who had risen against President Francisco Madero (1911–13). Its iconic history began on the front page of the Maderista newspaper, *Nueva Era*, and from her first appearance the woman was designated a *soldadera*, because the cutline proclaimed, "I will defend my Juan."

The image disappeared for some thirty years before it reappeared in *Historia gráfica de la Revolución*, published by Gustavo Casasola in 1942. There the author affirmed, "This *soldadera* has seen all of Mexico,

crossing from border to border."[2] In its subsequent appearances, the young woman has always been a camp follower, for example, on the cover of *Las soldaderas*, the book about these women by Elena Poniatowska. For one author this woman offers the "paradigmatic image of the *soldadera*, the Mexican soldier's faithful companion."[3] Her picture has circulated throughout the Americas, Europe, and Asia.

The usual practice has been to crop the negative in which "Adelita" appears, removing the right half of the image. That part of the glass plate is broken in the original negative, but we can still see a group of women standing on the platform of the train car. When we ask who she was, her location on the train may provide an important clue. *Soldaderas* of the rank and file usually traveled on top of or underneath the cars. The women who were inside the cars were probably the privileged followers of federal officers. In an early attempt to demystify the image and contextualize it, I ventured the hypothesis that they may have been prostitutes.[4]

Perhaps inspired by my irreverent remark, independent sex workers made one of the most interesting uses of this image in their posters for the celebration of Independence Day on September 15, 2008 (fig. 31).

At this point, I believe that the women were not prostitutes or *soldaderas* but Mexico City food vendors who attended the soldiers while the train was stopped. In spite of the efforts to demystify this image—and the myth of the *soldadera* that it incarnates—new versions continue to appear. I would bet that every researcher working with Mexican photography has, at one time or another, heard of a little old lady living in a far-off and often inaccessible town who insists that she is "Adelita": the *viejitas* offer as evidence a copy of the photo on their wall—amplified, blurry, and contrasty from being rephotographed by the Bazar Casasola. It is, in the end, an image with profound roots in the national consciousness, as can be seen in the photograph by José Hernández-Claire, which he titles *La mirada* (The look; fig. 32) but which could be called "Adelita aged."[5]

Figure 31. Independent sex workers, September 15, 2008. Poster, 43.2 x 55.9 cm. Collection of John Mraz

Figure 32. José Hernández-Claire (born 1949, Guadalajara, Mexico; lives and works in Guadalajara), *La mirada* (The look), 1990. Inkjet print from a digital file, exhibition copy, 17.8 x 12 cm. Courtesy of the artist

Figure 33. Manuel Alvarez Bravo (Mexican, 1902–2002),
Obrero en huelga, asesinado (Striking worker, assassinated) (portfolio #13), 1934.
Gelatin silver print, 18.8 x 24.5 cm. Princeton University Art Museum,
Gift of Mr. and Mrs. Gerald Levine (x1991-257.10)

Manuel Alvarez Bravo was in Tehuantepec in 1934 in search of a picturesque locale to make a short film-essay when he suddenly heard what he thought were fireworks. Arriving at what he expected to be a celebration, he found himself in the middle of a battle between strikers who were demanding a minimum wage and the scabs who had taken the workers' jobs in a sugar mill. As the strikers circled back around in front of the workplace under contention, they were received with more shots, and Alvarez Bravo photographed a man stretched out on the ground. Warned that the authorities were in league with the mill owner, he fled but not before having made what would become his best-known image, *Obrero en huelga, asesinado* (Striking worker, assassinated; fig. 33, pl. 43).

The photograph is somewhat of an anomaly in Alvarez Bravo's oeuvre, which is made up almost entirely of art photography. In the early 1930s, however, he had moved toward a realist aesthetic, pulled away from his earlier interest in visual poetics by the influence of the documentary style. Emphasizing images of daily life, this style had developed in the United States and Europe in response to the Great Depression. Other important influences in his realist shift were the German photographer Albert Renger-Patzsch and Soviet aesthetics. Of

course, in this period many Mexican intellectuals were leftist, including Alvarez Bravo, who never joined the Mexican Communist Party but was a member of LEAR (League of Revolutionary Writers and Artists). One place the photo of the assassinated worker appeared was on the cover of the May Day issue of LEAR's magazine, *Frente a frente*, in 1936; there a photomontage was constructed that placed the dead striker under the portraits of Adolf Hitler, Benito Mussolini, and Plutarco Elías Calles, president of Mexico from 1924 to 1928 and the controlling power in the country for many years. Later the image appeared in magazines dedicated to news and culture, such as *Estampa* (1945), and it has continued to circulate in leftist and especially art publications.

In 1989 the celebration of photography's 150th anniversary took place, and among the works produced was a photomontage by Riza Niru (fig. 35) for COCEI (Coalition of Workers, Peasants and Students in the Isthmus of Tehuantepec), who combined Alvarez Bravo's photograph with an image taken in 1979 by Víctor León, *No habrá huelga general* (There will be no general strike; fig. 34). One of the pioneers of the New Photojournalism in Mexico, León had joined with other photographers in an effort to develop ways to infuse their visual statements with irony and to develop a photography that departed

Figure 34. Víctor León (born 1953, Mexico City; lives and works in Xalapa, Mexico),
No habrá huelga general (There will be no general strike), 1979.
Inkjet print from a digital file, exhibition copy, 11.7 x 17.8 cm. Courtesy of the artist

from the official line. León had a particular interest in making what he called "irreversible images," photographs whose absolute clarity of intention would make it impossible to change their meanings with cutlines when published. He felt that *There Will Be No General Strike* was an example of an image whose visual force would not admit a different reading than that intended by the photographer.

Published by the magazine *Proceso* in 1979, this photograph shows Mexico's most powerful union leaders, the men who have been instrumental in keeping the working class underpaid, underfed, and under control; in the middle is Fidel Velázquez, who directed the umbrella group of Mexican unions, the CTM (Confederation of Mexican Workers), for more than fifty years. León shot the millionaire bosses of the Mexican workers from a low angle, something that would ordinarily confer on them visual power. However, the foreground objects—the elegant table setting with cut-glass goblets and gold-rimmed plates—mediate the viewer's perception of the leaders. The table is nicely set for those who have betrayed their comrades, but the *bolillo* on the shining plate and the sparkling liquid serve as a metaphor for the respective "bread and water" of which the different classes partake. By combining the photos,

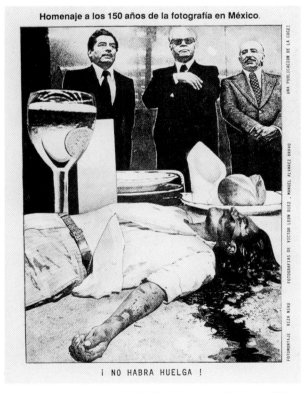

Figure 35. Riza Niru, *No habrá huelga general* (There will be no general strike), 1989. Photomontage, 20.3 x 15.2 cm.
Collection of John Mraz

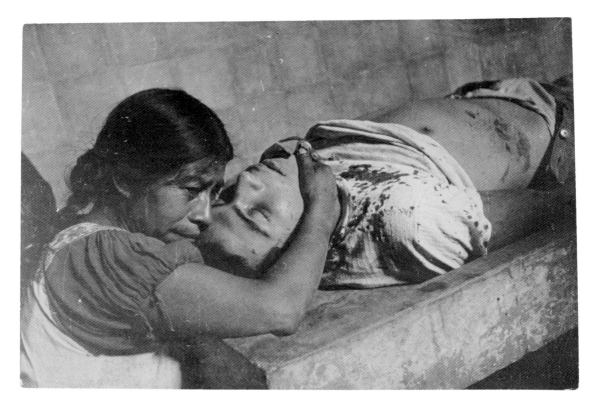

Figure 36. Julio Mayo (Julio Souza Fernández, born 1917, La Coruña, Spain; lives in Mexico),
Untitled (Mother and Dead Son), 1952. Gelatin silver print, 12.7 x 17.8 cm. Collection of John Mraz

Niru insists that the men who were elected to protect the workers have used their position to enrich themselves and to co-opt or destroy any labor group not totally controlled by the government; it is a message that runs through modern Mexican history.

The photograph of the mother crying over the body of her dead son (fig. 36) is arguably the most powerful of the five million images taken by the Hermanos Mayo, the May Day Brothers, a photojournalist collective formed by five men who fought on the Republican side in the Spanish Civil War and were given political asylum in Mexico in 1939. The victim was a young communist killed by an undercover policeman when he attempted to join the official May Day march, from which independent and leftist workers were barred during much of the twentieth century. The year 1952 saw an exceptionally bloody struggle between CTM goons and the independent workers who tried to participate. Attempting to recover May Day was a yearly custom among the

unaffiliated, but in 1952, the last year to protest against Miguel Alemán, the president who had institutionalized official unionism, it resulted in a particularly brutal confrontation.

The melee was covered by two of the Hermanos Mayo, Faustino and Julio. One of Faustino's images was given a full page in the photo-reportage on the battle: it shows a young girl, probably overcome by tear gas, being treated by a nurse; the cutline describes her as an "innocent victim" of "red provocation."[6] Another published Mayo photo shows a badly beaten man surrounded by workers; some appear to be protecting him from further abuse while others seem to wish to continue beating him. This victim was the undercover policeman, whom the workers had identified, pummeled, and taken in front of the president, crying out that they had captured the assassin. Notwithstanding the fact that this man was a murderer, the cutline assured a reactionary reading of the image by identifying the undercover cop

as a "communist gunfighter" receiving his comeuppance from the workers, while characterizing the protestors as "crazy anti-patriotic agitators."

Although *Mañana* published three Mayo images of this conflict, they did not include that taken by Julio Mayo of the mother grieving over her dead son; its power is such that it spoke too much for itself to permit its meaning to be transformed through an extraneous conceptual framework—in that moment. The photograph so impressed the great muralist David Alfaro Siqueiros that he reproduced it in a mural (fig. 37). Although it could not enter the reportage on May Day 1952, this photo was recontextualized thanks to the amnesia cultivated by the mass media. Thus tamed, it appeared in a 1955 photo-essay on the "most journalistic Mayo photos," in which the cutline asserted: "Who is she? Who is he? Their simple names, of the *pueblo*, are condensed in this brief eloquence: mother and son. The mother destroyed by pain, the son knocked down by death. The scene: the *Cruz Verde* some day in 1950. Any day in which drama can occur."[7] Ripped out of its real matrix—and with a cynicism that relied on the ambiguity of even the most powerful photos—it was assigned a fabricated significance, transforming a historical instance of the struggle against official unionism into a timeless and recurrent phenomenon of daily life.

In Mexico, images are circulated and recirculated, adding ever more complex levels of significance.

Because photographs are ambiguous, polysemous, and semantically weak, they float and can be made to say whatever the context dictates. Thus at times the meanings assigned to them contradict one another while at other times they reinforce the original message. Nonetheless, all Mexico's itinerant images acquire their particular meanings only upon being anchored to the specific contexts that create their connotations. It is solely by understanding the various contexts in which images circulate that we can trace their shifting meanings.

Notes

1 For a more extensive discussion of these icons, see John Mraz, *Photographing the Mexican Revolution: Commitments, Testimonies, Icons* (Austin: University of Texas Press, 2012). I am grateful to the University of Texas Press for permission to include this material.

2 Gustavo Casasola, *Historia gráfica de la Revolución, 1900–1940* (Mexico City: Gustavo Casasola, 1942), 664.

3 Manuel Rodríguez Lapuente, *Breve historia gráfica de la Revolución Mexicana* (Mexico City: G. Gili, 1987), 74.

4 John Mraz, "El Archivo Casasola: Historia de un mito," in *El siglo de la Revolución Mexicana*, ed. Moisés Jaime Bailón Corres, Carlos Martínez Assad, and Pablo Serrano Álvarez (Mexico City: Instituto Nacional de Estudios Históricos de la Revolución Mexicana, 2000), 213.

5 The photograph is reproduced in Mraz, *Photographing the Mexican Revolution*, 245.

6 *Mañana*, May 10, 1952.

7 "13 instantáneas," *Mañana*, September 3, 1955.

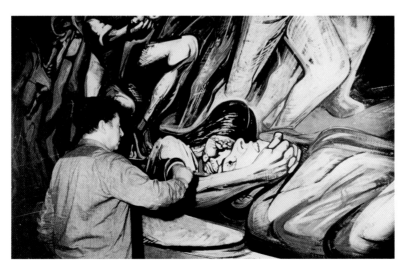

Figure 37. Hermanos Mayo (active in Spain and Mexico 1931–82), *Untitled (David Alfaro Siqueiros Painting a Mural from a Mayo Photo)*, 1959. Gelatin silver print, 12.7 x 17.8 cm. Collection of John Mraz

The Scene of the Crime: Photography's Unconscious

Valeria González

1.

The sheer number of fragments from "Little History of Photography" (1931) that Walter Benjamin copied verbatim in "The Work of Art in the Age of Its Techno-logical Reproducibility" (1936)—with citation itself being another mode of reproduction—helps us to perceive the major discursive shift that took place in the few but decisive years separating the two texts. The clarity of the argumentative structure of the second text has contributed to the widespread diffusion of a notion concerning the relationship between photogra-phy and the loss of the aura, one that links visual reproduction with the dissolution of the image's unicity, as if the capacity of the image to be reproduced, displaced, and circulated itself corresponds to this process of dissolution.

In the middle of the nineteenth century, Sir Oliver Wendell Holmes had already remarked on the devalua-tion of the material object in favor of photographic reproducibility and on the parallel between this process and the technical revolution in the production and systematization of monetary exchange.[1] Precisely at the end of the century in which, according to Michel Foucault, the heterogeneity of objects and desires had been erased, making human time into the first universal paradigm,[2] Sigmund Freud's concept of the uncon-scious provided a place to resituate the unchangeable unicity of the individual. In his 1931 text, Benjamin inaugurated a shift from positivist paradigms of obser-vation toward scientific models of scratching and penetration, such as surgery and psychoanalysis. The "optical unconscious," the distinctive trait of photogra-phy as an automatic register, corresponds to another type of loss of the aura, not the unicity but the unity of the image. If singularity was a key synonym for originality in the marketplace of value, unity would have the same role for the status of the image. In psychoanalysis, the functioning of the imaginary is determined by the fact that the foundation of the "I" of the conscience as a unitary entity arises from the psychic act of assuming a specular image. The projection of this constitutive fiction delimits at once the field of the visible and the sense of beauty, to which contemporary art often has opposed operations of fragmentation or the dissolution of the image into formless materialities.[3]

Holmes described photography as a mirror of reality. Benjamin (by means different from, but con-temporaneous with, the *trahison* of Magritte's pipe) would say that the image that the mirror gives back is, in any case, profoundly strange to the human being. If photographic reproducibility liquidated the singularity of the artistic image, it is the irreducible singularity of the photographic trace (its unconscious) that transcends its deceitful unity, the projection of the artistic will of the photographer, of his gaze, of that "eye" in which we can locate, in counterpoint, the optical conscious: in Benjamin's words, "For it is another nature that speaks to the camera rather than to the eye; other above all in the sense that a space informed by human conscious-ness gives way to one informed by the unconscious."[4]

The automatism of the apparatus (and here we should recall the "registering apparatus" of the first Surrealist manifesto) serves as an equivalent to the split or *schizo* that the Freudian concept of the unconscious effects on the false unity of the subject. Benjamin's notion of a "nature" that "speaks" to the camera does not entail an undue reliance of the unconscious on

Figure 38. RES (born 1957, Córdoba, Argentina; lives and works in Buenos Aires), *¿Dónde están? Paseo Colón y AU 25 de mayo, 10:35 PM–11:35 PM, 05/21/1985, Buenos Aires*, 1985, from the series *¿Dónde están?* (Where are they?), 1984–89. Gelatin silver print, 50 x 50 cm. Courtesy of the artist

reality or the world, as Rosalind Krauss has surmised, but rather a recognition of the way in which this automatic register interpellates the subject.[5] The "new vision" proposed by László Moholy-Nagy remained limited to the idea that reality is transformed historically according to modifications of the shared codes that regulate perception. For Moholy-Nagy, photography was

a new "alphabet."[6] Benjamin goes beyond this. Comparable to the way in which Jacques Lacan would later distinguish between the common notion of reality and what he denominated the register of the real, Benjamin asserts that the unconscious material made visible by photography resembles the traces of a crime because it requires an interpretation and because, at its core, its

Figure 39. RES, *Punta de Abajo, Choele Choel (1879–1996) Argentina*, 1996, from the series *NECAH 1879*, 1996–2008. Photo at left by Antonio Pozzo (1829–1910, born in Italy, active in Argentina). Chromogenic prints (diptych), 63 x 45 cm each. Courtesy of the artist

mystery is death. This is the spark beneath the image, threatening to burn it beyond recognition. The allusion to death in the context of Benjamin's analysis of a photograph of Karl Dauthendey with a woman immediately precedes the introduction of the concept of the optical unconscious in the 1931 text. It matters little that Benjamin made a mistake in identifying the woman in the photograph,[7] precisely because the question here is not the relationship between photography and reality (the status of representation) but how the real seeps into the photographic image from beyond the optical conscious circumscribed by the photographer's gaze. Indeed, the initial definition of the famous concept of the aura is preceded by the mention of Eugène Atget as the photographer who "initiates the emancipation of object from aura." Atget's urban vistas had been compared to those of a scene of a crime; Benjamin assigns this parallel to the very condition of photography. Without the mediation of the "associative mechanism" that allows one to "point out the guilty"—that is, to interpret the signs of the absent—photography would be reduced to a fleeting "shock effect." Without mentioning his name, Benjamin cites Moholy-Nagy's analogy between photography and writing, as if he were presenting a kind of photograph of it, but again only to separate the terms. Isn't the truly illiterate person the one who is incapable of reading his own images, he suggests, the one who is unable to identify in the image what transcends its limits, who has yet to find a language with which he can approach the capacity of the image to exceed itself?[8]

There is nothing resembling an original meaning in the photographic register without the mediating factor—"necessary," according to Benjamin—of the caption, the inscription of an act of interpretation that is not necessarily linguistic and whose situational truth, always subject to transformations, goes beyond the criterion of the image's referentiality. What imparts an itinerant capacity to the languages of photography is not only the ubiquitous potentiality of reproduction but also the designation of a meaning that constitutes again and again a new original, wrenching the image from its illusory identity and resituating it in the transitory and specific space of a signifying chain. According to Boris Groys, the contemporary artist can "reauratize" a copy whenever she extracts it from a deterritorializing circuit of circulation and anchors it to a specific context. "The infinite is, on the contrary, not open because it has no outside. Being open is not the same thing as being all-inclusive. The artwork that is conceived as a machine of infinite expansion and inclusion is not an open artwork but an artistic counterpart of an imperial hubris."[9] Contrary to the Benjaminian utopia, what we can designate in topological terms as an itinerant capacity shows itself wherever a sort of relative fixity is possible, not in those spaces where the demand for reproduction is endlessly driven by a vocation "for all that is the same in the world."[10]

2.

The capacity for reassigning meaning that Groys attributes to art not only exists in the realm of mass media but also has been exercised in the appropriation of historical archives of photography. In contemporary art from Argentina, there are a number of different examples of the re-signification of these kinds of records, of their recirculation in different contexts and across different mediums. An examination of the series *NECAH 1879*, the work of the artist and photographer RES (Raúl Stolkiner), is particularly illustrative of the itinerant capacities of the terms that we have proposed.

In Argentine history, the phrase "the conquest of the desert" is used to designate the military campaign that extended the borders of the Argentine nation-state up to the present-day province of Río Negro. The very designation of the "desert" entails an ideological perspective, since these territories were inhabited by indigenous peoples who, though depleted, continued to occupy the land when General Julio A. Roca arrived with his army in 1879. Roca was accompanied on his campaign by Antonio Pozzo (1829–1910), a photographer whose images from the expedition have been preserved.

In 1996 RES retraced the itinerary of the campaign and was able to find the exact points of view from which Pozzo had operated his camera. Wherever it was possible, he repeated in situ, more than a century later, the shots of this pioneer. *NECAH 1879* is a series of diptychs in which the artist juxtaposed Pozzo's images with his own. In certain cases, such as *Punta de Abajo* (fig. 39), the similarity of the two photographs (the persistence of the desolate landscape) belies the very civilizing argument of that bellicose campaign. Two additional pieces allude to what was excluded from Pozzo's register. One is a cross section of a Remington rifle (fig. 40), whose importation to Argentina was a decisive factor in the military victory, and the other is a series of photographs that evoke the motto of the indigenous resistance: "Don't give Carhué to the white man."[11] Hanging in the foreground of each shot, the letters that form these words appear to levitate like fearless ghosts over the silence of the southern landscape (fig. 41). Unlike much of the indigenous photography developed in the Americas, RES's work incorporates the invisible subject by evoking the voice rather than the image.

Figure 40. RES, *Mecanismo del fusil Remington, corte transversal* (Remington rifle's firing mechanism, cross section), 1996, from the series *NECAH 1879*, 1996–2008. Chromogenic prints (diptych), 125 x 125 cm each. Courtesy of the artist

Figure 41. RES, *NECAH* ("*No entregar Carhué al huinca,*" *sentence pronounced by the Indian chief Calfucurá in 1873. In English: Don't give up Carhué—a strategic place—to the white man*), *1996, from the series NECAH 1879, 1996–2008. 24 gelatin silver prints, 18 x 24 cm each. Courtesy of the artist*

The attentive "listening" manifest in the way that RES reinscribed the documentary archive of the campaign of 1879 argues for an interpretation of these photographs that considers the concept of the unconscious. This unconscious, it must be stressed, should not be ascribed to reality itself but emerges, thanks to the indexical genetics of the apparatus, from what was *not* seen by the subject (Antonio Pozzo, in this case), even though he was looking. The disclosure of this unconscious signals precisely the limits, individual and social, of representation. A conspicuous example of this kind of displacement can be observed in the image titled *El cacique Linares y su gente* (Cacique Linares and his people; fig. 42). As we see, the horse on the far left side of the visual field moved during the time of exposure, though not anarchically. As a domesticated animal, he focused his gaze on the two relevant points that organize the shot (or, rather, that organize any arranged portrait): the group that poses and the photographer. The distribution of power in the interior of the photographic mechanism was, in this context, contiguous to the relationship of military domination. The immobility of the indigenous people required by the technique of wet collodion was guaranteed beforehand by the instantaneous firing capacities of the repeat rifle for moving targets. If any of Linares's men

fled, they would be shot by the gun rather than the camera, a fact that only the animal does not know. From the margins of the image, the strange two-headed horse reveals the repressed violence of the official discourse of the "campaign of the desert."

As we have mentioned, many Argentine artists have appropriated historical documents. What interests us particularly about this work is the desire that motivated the artist to return in person, not to the place of the crime against the indigenous people but to the place of the photographic shot, understood in Benjaminian terms as the scene of a crime, that is, as the *locus* of a contact that cannot be reproduced or reduced to mere information. A scene that becomes the origin of meaning only when the artist, with a detective's acumen, constructs a story from traces hitherto elusive and dispersed.

3.

Antonio Pozzo's photographic archive, like so many others, reveals to us a field in which interpretation—the mobilization of the implicit meanings of an image—can be exercised. If something was repressed, it *did happen*; this is why Freud speaks of the "return." Psychoanalytic theory distinguishes the return of the repressed from a traumatic experience. The trauma signals what could not

happen. This is an important distinction to keep in mind in discussing another series by the same artist, titled *¿Dónde están?* (Where are they?; fig. 38). This project was initiated in 1984, shortly after RES returned to Argentina after a period of exile in Mexico at the conclusion of the brutal military dictatorship (1976–83) that was responsible for the deaths and disappearance of thousands of people.[12] As we will see, the question of the so-called *desaparecidos* must be formulated in a space where those who are gone have disappeared without a trace.

The demand by human rights organizations for the "aparición con vida" (return alive) of those assassinated by the dictatorship makes explicit the inherent perversity of the figure of the "disappeared." "He isn't an entity, he isn't here, neither dead or alive, he's a disappeared [es un desaparecido]" is the infamous definition employed by the dictator Jorge Rafael Videla in 1979. The logic of this definition therefore does not entail the physical destruction of bodies but rather the total erasure of their existence, the cancellation of their significance in the symbolic common space that we call "reality." In Lacanian terms, they are a foreclosed signifier (the legal origin of the word *forclos* refers to a material clue that has been established as nonexistent).

Psychoanalysis designates the Name-of-the-Father as the signifier that constitutes, regulates, and guarantees social relations, and it distinguishes structurally between psychosis, in which the Name-of-the-Father is absent, and perversion, in which this signifier has been repudiated. The consequences in the social realm of state terrorism as an apparatus of instrumentalization for the repudiation or subversion of the law are multiple. The strategies carried out by the Mothers of the Plaza de Mayo and human rights organizations to make the disappeared visible focused on adamantly demanding the reinscription of the foreclosed signifier, the condition of possibility of its restitution as evidence for a legal case.[13]

In his work on the extermination of the indigenous population of Argentina, RES resolved to return in person to the scene of the crime. Yet in the concentration camp

Figure 42. RES, *El cacique Linares y su gente* (Cacique Linares and his people), *Choele Choel, Argentina, 1879*, from the series *NECAH 1879*, 1996–2008. Photo by Antonio Pozzo. Chromogenic print, 63 x 45 cm. Courtesy of the artist

state, the scene of the crime is exactly what has been negated. In Pozzo's photographs, a surface of contact between the "conquerors" and the "conquered," the exclusionary violence of representation had left its mark. During the military dictatorship, censorship of the means of communication was aimed particularly at photography. Where there is no photograph, there has been no event, as Julio Menajovsky affirms.[14] The Mothers and other human rights organizations flooded the public sphere with photographs from private albums. The singular remnants of those faces became the collective sign of all the disappeared. This was achieved through a specific itinerary, a circular route around the Plaza de Mayo, which simultaneously indicated the impossibility of circumscribing the limits of the scene of the crime.

Under a thoroughfare, using mobile flashes and exposures of more than an hour, RES generated the irruption of phantasmagoric elements. *Where are they?* The topological complexity of the image shows the public space of memory as an arduous palimpsest. In the midst of an imposing architectural structure and the silence of the night, as a revelation of the obscene that lurks behind the scenery of all those "public" works of the dictatorship, the repetition of a tapir fetus alludes to systematic extermination, the erasure of names, and the singularities of the concentration camps. Undoubtedly, in selecting the Paseo Colón and the thoroughfare 25 de Mayo as photographic sites, RES alludes to the unfinished construction of these structures as a sign of the rupture of impunity and silence. What the artist did not know at the time was that one of the secret detention and torture camps, "El Club Atlético," was located in this place. Ignorance and exactitude coexist in the structure of trauma. Unlike the repressed signifier, which can be disentangled through the chains of metaphoric substitution, this real that has not been inscribed compulsively returns and appears before the subject

"*as if by chance.*"[15] In equal degrees from its conscious project and its unconscious trauma, the image takes into account the elaboration of collective memory as an itinerary in the territory of the symbolic, an impulse to open up a space for the effaced: the space, undoubtedly, of the rule of law that guarantees common life in a democratic state.

I have wanted to suggest that the itinerant capacity of photography, distinct from the technical possibility of ubiquitous reproduction (often exploited by the mass media), is exercised through an act of localization. This does not depend, however, on a physical space, but rather on an identification (in Benjamin's words, "point[ing] out the guilty") that allows for the deciphering of what actually took place. The works by RES present us with two different difficulties: the place where the repressed (the expulsed) has left a trace when leaving the scene and the place where something from beyond the scene imposes a demand for a (blind) path toward lucidity and elucidation. It is between this Scylla and Charybdis that the issue of photography's itinerancy touches on photography's unconscious.

Translated by Jeffrey Lawrence

Notes

1 Oliver Wendell Holmes, "The Stereoscope and the Stereograph," *Atlantic Monthly*, June 1859, reprinted in Vicki Goldberg, ed., *Photography in Print* (New York: Simon & Schuster, 1981), 100–114.
2 Michel Foucault, "The Measure of Labour," in *The Order of Things* (New York: Vintage, 1966), 221–26.
3 Sigmund Freud used the specular love scene from the myth of Narcissus to designate a new psychic mechanism in which the unity of the "I" was constituted for the individual ("On Narcissism," 1914). Jacques Lacan would later connect this hypothesis with the etiological concept of the "mirror stage" ("The Mirror Stage as Formative of the Function of the I as Revealed in Psychoanalytic

Experience," 1949). Unlike animal species, for which the imago unleashes a series of behaviors useful to conservation, the "I" as an imaginary fiction installs itself as a "discordance with [the individual's] own reality." At the same time, "in an ambiguous relation," the "mirror-image would seem to be the threshold of the visible world." Moreover, "Such facts are inscribed in an order of homeomorphic identification which would itself fall within the larger question of the meaning of beauty as formative and erotogenic." Jacques Lacan, "The Mirror-Phase as Formative of the Function of the I," in *Mapping Ideology*, ed. Slavoj Žižek (London: Verso, 1994), 94–95.

4 Walter Benjamin, "Little History of Photography," trans. Edmund Jephcott and Kingsley Shorter, in *Selected Writings*, vol. 2, pt. 2, *1931–1934*, ed. Michael W. Jennings, Howard Eiland, and Gary Smith (Cambridge, MA: Belknap Press of Harvard University Press, 2005), 510.

5 Rosalind Krauss's debt to Walter Benjamin in her work lies not only in her appropriation of the phrase "optical unconscious" but also in the very idea of projecting the scission of the subject proposed by psychoanalysis into the field of human vision. Nevertheless, insofar as the author understands that Benjamin wanted to ascribe an unconscious to the "world of visual phenomena: clouds, sea, sky, forest," she must declare her use of the term as "at an angle" to that of the German author. Rosalind Krauss, *The Optical Unconscious* (Cambridge, MA: MIT Press, 1997), 179.

6 László Moholy-Nagy, "From Pigment to Light," *Telehor* 1, no. 2 (1936), reprinted in Goldberg, *Photography in Print*, 339–48.

7 Benjamin misidentified the woman in the photograph as Dauthenday's first wife, who committed suicide. She is actually his second wife. This detail has been taken from the French translation by André Gunthert in *Revue d'études photographiques*, no. 1 (November 1996): 6–39 (revised and corrected in 1998). With almost one hundred notes and a systematic bibliographic index, this is at present the most important edition of Benjamin's article.

8 Benjamin, "Little History," 518, 527.

9 In this sense, such a capacity encodes the political dimension of art, insofar as it is revealed as a space for making decisions. Boris Groys, "The Topology of Contemporary Art," in *Antinomies of Art and Culture: Modernity, Postmodernity, Contemporaneity*, ed. Terry Smith, Okwui Enwezor, and Nancy Condee (Durham, NC: Duke University Press, 2008), 80.

10 Walter Benjamin, "The Work of Art in the Age of Its Technological Reproducibility," trans. Edmund Jephcott and Harry Zohn, in *The Work of Art in the Age of Its Technological Reproducibility and Other Writings on Media*, ed. Michael W. Jennings, Brigid Doherty, and Thomas Y. Levin (Cambridge, MA: Belknap Press of Harvard University Press, 2008), 23–24.

11 "No entregar Carhué al Huinca." "Carhué" refers to the territory that was "conquered" and "Huinca" to the white man. RES's work takes its title from this slogan.

12 On March 24, 1976, the military coup led by General Jorge Rafael Videla suspended constitutional guarantees in Argentina. According to the report "Nunca más" (Never again), presented by the Comisión Nacional sobre la Desaparición de Personas (CONADEP) in 1984, thirty thousand people were killed in secret detention and torture facilities.

13 Human rights organizations played a decisive role. In August 1983 a commission was formed for the purpose of compiling and systematizing information regarding the secret facilities. This information was then turned over to the new democratic authorities. Both the report "Nunca más" (CONADEP, 1984) and the judicial process known as the "Juicio a las Juntas" (1985), which converted the testimonies of victims of and witnesses to grave violations of human rights into legal evidence, relied on this contribution.

14 Julio Menajovsky, "Terrorismo de estado y fotografía, entre el documento y la intervención," Segunda Bienal Argentina de Fotografía Documental, Universidad Nacional de Tucumán, August 2006, http://www.fotobienal.com.ar/Bienal_2006/Relatoria_Menajovsky.html.

15 Lacan writes, "What is repeated, in fact, is always something that occurs—the expression tells us quite a lot about its relation to the *tuché—as if by chance.*" Jacques Lacan, "Tuché and Automaton," in *The Four Fundamental Concepts of Psychoanalysis*, vol. 11 of *The Seminar of Jacques Lacan*, ed. Jacques-Alain Miller, trans. Alan Sheridan (New York: Norton, 1978), 54. In the repetitive plots of Andy Warhol, Hal Foster found a visual equivalent to the return of the traumatic real in what we could call the failures of the technical. Hal Foster, "The Return of the Real," in *The Return of the Real: The Avant-garde at the End of the Century* (Cambridge, MA: MIT Press, 1996), 134.

I decided to take a look, again

Thomas Keenan

What need does photography have of the archive? Why should one be required at all? Of course, some photographs are worth saving, for the sake of history or beauty or sentiment, but isn't it the image itself that matters, not the archive? Decisive moment, close enough, punctum—for an entire history of thinking about photography, the archive is an afterthought.

So suppose someone said to you, "Because the camera is literally an archival machine, every photograph is a priori an archival object."[1]

You might answer, "Well, an archival object as opposed to what?" Or, "What sort of archival object?" The camera is a recording machine, but in what sense is recording the same as archiving? What does *literally* mean, exactly? Implicit in the *a priori* is the claim that the photograph, as soon as it is recorded, or even in advance of its inscription, is something archival, something stored away and thus retrievable. Which is to say, *not* the sort of thing that needs to be assembled or collected into an archive, even if, empirically speaking, this often happens. From the beginning, without any extra intervention, it is claimed, the photo belongs to the realm of the depository.

You might wonder whether this means that the photograph is securely placed, even trapped, in the historical moment that it has, as one sometimes says, "captured." Does every photograph thus belong, in a settled way, to a given archive from its very inception? Is this an argument for an "original context," for the power of an originating present or an organizing interpretation to fix and file the image?

No, the thesis is more radical than that. Not only is the archive born with the photograph itself, coeval and inseparable, but—strangely—this condition is an invitation to mobility. Eduardo Cadava and Gabriela Nouzeilles, who made this claim about the archive, extend it in an unexpected direction. They draw our attention to "the mobilization of images drawn from the visual aesthetics and archive of the Holocaust in discussions of human rights in Latin America," and ask us to appreciate—or rather, confront—"the re-appropriation and re-contextualization of images."

The provocation is bracing: far from the ritual privilege of the "original context," we are here called upon to rethink history on the basis of mobilization, recontextualization, instability. So the archive, and the archivality of the photographic image, would be tied not to its stability or fixity but to its detachability, its capacity to move and be moved, its tendency, even, to abandon the circumstances of its creation in view of unanticipated futures. In this sense, the archive is not a place where images are deposited but a place where they are found . . . and possibly lost.

Bringing together the archive and the image in this way is not an argument for contextual determination but something rather different, an insistence on the weak hold of context, the failure of any context or any archive to capture the photographic image. The "re-appropriation and re-contextualization of images" has to imply, in fact, *dis*-appropriation and *de*-contextualization as the very structure of the interpretation and the action of images. Becoming archival, for an image, does not mean being placed in an archive; on the contrary, it means not staying put, exiting, being taken out or taken over by some force other than the ones organizing the moment of its inscription. Photographs are archival objects insofar as they can be ripped out of some archives and placed in other ones, insofar as they migrate from one archive to another . . . which they always already do.

Figure 43. Walid Raad (born 1967, Chbanieh, Lebanon; lives and works in New York City) / The Atlas Group, *We decided to let them say, "we are convinced," twice _Onlookers*, 1982–2006. One of 15 archival digital prints, 111.8 x 170.2 cm. Courtesy of the artist and Paula Cooper Gallery, New York

Figure 44. Walid Raad / The Atlas Group, *We decided to let them say, "we are convinced," twice _ Artillery I*, 1982–2006. One of 15 archival digital prints, 111.8 x 170.2 cm. Courtesy of the artist and Paula Cooper Gallery, New York

This becomes very clear when we confront what Cadava and Nouzeilles call "memory, history, justice" or, in their other shorthand, "human rights." Although it is not the only feature of human rights discourse, this movement of decontextualization, of abstraction, of removal from one frame and transfer to another, does seem to be essential to the notion that what one claims as a right for oneself must of necessity belong to others, regardless of who or where or when they are.

This is one way to understand what is meant by the "universality" of human rights. It is the universality not of everyone, as if we were in possession, once and for all, of a definition of the human status. No, it is the universality of the anyone, of the if-me-then-others-as-well. The generality of claims for human rights is essentially related to this capacity for mobilization, for taking leave of the point of origin in order to extend, unpredictably, to anyone else at all. My suffering is my own, my injuries harm only me, and my needs are personal. But as soon as I claim redress for such wounds as wrongs, as soon as I demand a response to them as unjust, then they are not just mine any longer: if they are violations of something I claim as a right, then that protection cannot belong only to me. We see this most forcefully when photographs are exhibited to document injustice: the image can function only to the extent that it breaks the absolute hold of its origins, migrates, provokes equivalences and parallels. No matter how singular the image and what it represents might be, this movement of abstraction and separation is essential to its operation.

In this sense, an archive, particularly a photographic one, is a laboratory for experimentation with unanticipated possibilities. The archive, which bears the imprint of history and is so often entrusted with the solemn task of memory, is also fundamentally oriented toward the future.

I believe that this is in fact a pretty good definition of *itinerancy*, which is not simply a synonym for wandering around, aimlessness, or indeterminacy but in fact names a structural orientation of the photograph toward the future. I would not hesitate to assimilate it to the general structure that Jacques Derrida long ago called the *dérive*, or "drift"—an "essential drift bearing on writing as an iterative structure, cut off from all absolute responsibility, from consciousness as the ultimate authority."[2] What goes for writing, the grapheme, holds for photography as well (in this case if not in every case). The detachability of the image from its origins, its structural reproducibility and hence its belonging-to-no-one, its built-in force of decontextualization, all are ways of characterizing a certain itinerant behavior—as long as we appreciate that this does not refer to some utopian condition of freedom, unbounded autonomy, or self-propelled liberatory force but simply identifies what makes the future—different futures—possible, for better or for worse.

A future, and not just one long extended present, is possible because no mark or image can appear without a context, but that context is never absolutely given in advance. It is this movement that makes the thing what it is or, rather, what it can be: "One can perhaps come to recognize other possibilities in it by inscribing it or *grafting* it into other chains. No context can entirely enclose it."[3]

In other words, if a word or an image made sense or functioned only by reference to or in one context— say, the original intention or the original situation of its production—it would not be a sign, a communication, a signifying mark. It must be able to function outside that context—which is to say, in the future or in a time and place utterly distinct from those of its origin—or else we would not call it a sign. But this is not just a possibility waiting to be realized by a clever editor or a thief, not just something that might befall the word or image on a bad (or a good) day. On the contrary, it is already happening "within," as it were, every image. The drift or the itinerancy of the image is structural: right here, right now, it is on the move. Derrida reminds us that this latent possibility is an active one, "a force of rupture," he calls it.[4] One can perhaps come to recognize other possibilities *in the image* by grafting it into other chains.

What is so often thoughtlessly referred to as the "universality of human rights," or of photography, cannot be thought without reference to this experience of itinerancy.

It is in this sense that I borrowed my title—"I decided to take a look, again"—from a project by Walid Raad called *We decided to let them say "we are convinced," twice*.[5] The image is always asking for another look, and we owe it the decision to take one, and another one. This requires tearing open the archive and may not leave the "image itself" unscathed either. Raad has someone—he names him Marwan Hanna—tell us a story about some photographs he took in the summer of 1982, when the Israeli military attacked West Beirut. From the security

Figure 45. Walid Raad / The Atlas Group, *We decided to let them say, "we are convinced,"*
twice_Soldiers II, 1982–2006. One of 15 archival digital prints, 111.8 x 170.2 cm.
Courtesy of the artist and Paula Cooper Gallery, New York

of the eastern side of the city, he watched and took photographs (figs. 43–45):

> In the summer of 1982, I stood along with others in a parking lot across from my mother's apartment in East Beirut, and watched the Israeli land, air and sea assault on West Beirut. The PLO along with their Lebanese and Syrian allies retaliated, as best they could.
>
> East Beirut welcomed the invasion, or so it seemed. West Beirut resisted it, or so it seemed.
>
> In 1982, I was thirteen, and wanted to get as close as possible to the events, or as close as my newly acquired telephoto lens permitted me that summer. Clearly not close enough.
>
> This past year, I came upon the negatives from that time, all scratched up and deteriorating. I decided to take a look, again.[6]

What he watched, it seems, was not what the camera saw. Or rather, not what came to be visible in the photographs. The camera saw something the boy did not. As the events unfolded, he did not know what was happening, even though he watched it with his own eyes. The play of the "or so it seemed" shadows the narration.

And it affects others, too, for the images are not just evidence of the photographer's act of watching. The camera watches the watchers—sometimes by showing them, sometimes simply by following their gazes, sometimes by showing us others returning the gaze of the camera—in order to open the question of what it is that they saw, and what they made of it.

In any case, things were not as they seemed, it seems. "As close as possible," he says, echoing Robert Capa, was "clearly not close enough." It never is. That is why a second look is required.

A second look lets us see something else in the image, other photographs in the photograph; it opens the photograph as an archive, a set of unexpected possibilities and unpredicted futures.

From the security of their vantage point in the east, the watchers watch the assault on the west. The camera moves comfortably among them and among the Israeli troops stationed on that side of the city. There is almost an intimacy, an easy exchange of looks between the camera and the soldiers. The soldiers and their weapons—even the jets overhead—present themselves, acknowledge the camera, relax before it, welcome their welcomers.

Twenty years later, in Beirut, this must have seemed incomprehensible. How was it possible? To have gotten so close and not seen so much. The images record that not-seeing, that susceptibility to an unanticipated turn of events. The images testify to their own incapacity to know what might come next (and think of what did: retreat of the PLO forces, Sabra and Shatila, the bombing of the marine barracks, another decade of civil war, hostages, car bombs, occupation, among many other things). This future, stored in the image, is marked in the "or so it seemed." And its violence, its sheer defiance of comprehension, is registered in the scratches, blurs, tears, and streaks that scar the images—not just a matter of deterioration or the passage of time, but the inscription, in the images themselves, of their non-self-evidence, of their own failure to coincide with themselves.

The images are subjected to a rhythm of proximity and disappearance, countered by chance rediscovery, which suggests a decidedly different notion of history: the images are always available for another look. Stored, lost, in whatever condition, in some forgotten archive, they reappear. And the familiarity of the scenes, marked by discoloration and stains, produces an unusual time-lapse effect: neither the events nor the photographs can be securely locked in the archive, in the past, but both seem somehow not entirely finished yet. The decision must be taken to look again, as a matter of responsibility.

Perhaps this is why Raad begins the series with an image of the spectators. So often challenged, derogated, criticized—"How can you just stand there and watch?"—the spectator seems to name here the very possibility of agency and activity.

Precisely because, to recall the phrase from Derrida, the images are orphaned, cut off from all absolute responsibility, they are open to a second look, but it must be *taken*. One could talk about this in terms of "memory"—both voluntary, because you need to decide to look back and see what's there, and involuntary, because the images, reencountered after a long lapse, remember something that you don't.

But although memory is often held up as the urgent, if not also guaranteed, ethical or political responsibility of the photograph, there are other political gestures that, however related they may be to this function of recording, are not simply coincident with it. And these future-oriented tasks are not reducible either to the earnest repetition of the slogan "never again." Remembering something offers no protection against repeating it; on the contrary, memory and repetition are often locked together more tightly than memory and resistance.

That is one thing that "looking again" means, in fact. The photograph announces, among other things, that no image is clear or close enough, sufficient to tell us what to do, let alone to do it for us. The perfect image, the one that lets us see clearly and that directs us toward the appropriate action, is permanently unavailable. These images tell us not only that the apparently desirable transparency is impossible, as Ariella Azoulay puts it in another context, "but that the passion for such visibility is precisely what thwarts the eye from seeing what is visible on the surface."[7] They remind us that many other images *are* available though, that there is a vast lab of image creation, and that it offers us material for deliberation, and for action. The images demand that we construct a future. They remind us of the necessity not just of reading them (in the sense of decoding their meanings) but of rereading them.

They announce that what is there is there to be seen and that indeed the conditions for seeing it are extensively deployed and regularly in action and that if we are failing it is not necessarily or simply to see but to respond adequately. It is not just a matter of memory, however crucial it is and will always be. The photographer has already taken the second look, observed and recorded the very construction of the archive itself. But he cannot take *our* second look for us.

Notes

1 Eduardo Cadava and Gabriela Nouzeilles, "Princeton Global Collaborative Research Fund. Project: The Itinerant Languages of Photography; Images, Media, and Archives in an International Context," n.d., www.princeton.edu/international/doc/ NouzeillesCadavaFinalProposal_PR.pdf. All subsequent quotations attributed to Cadava and Nouzeilles are from this proposal.

2 Jacques Derrida, "Signature Event Context," trans. Samuel Weber and Jeffrey Mehlman, in *Limited Inc* (Evanston, IL: Northwestern University Press, 1988), 8.

3 Ibid., 9.

4 Ibid.

5 Anthony Reynolds Gallery, "We are a fair people. We never speak well of one another. An exhibition of documents from the Atlas Group archive, 18 November–22 December 2005," http:// www.anthonyreynolds.com/past/05_atlas/pr.htm. The project dates, I believe, from 2005–6. Another version of this text, with some differences, appears in the Atlas Group's online archive, at http://www.theatlasgroup.org/data/TypeA.html. Carles Guerra and I included this series of images from Walid Raad in our exhibition *Antiphotojournalism* at La Virreina in Barcelona (2010) and FOAM Amsterdam (2011).

6 Anthony Reynolds Gallery, "We are a fair people."

7 Ariella Azoulay, *The Civil Contract of Photography*, trans. Rela Mazali and Ruvik Danieli (New York: Zone, 2008), 287.

The Fury of Images

Joan Fontcuberta

In the spring of 2011 the heart of Barcelona became the site of an extraordinary outburst of popular protests against the political system. There, as in many other European cities, thousands of protestors took to the streets to manifest their indignation at the pantomime of Spanish parliamentary democracy and the greed of the financial sector, which had made their lives precarious. During several weeks, the so-called *indignados*, or "angry ones," concentrated in a peaceful encampment in the Plaça de Catalunya, the most central spot in the city, where they debated the situation in popular assemblies and articulated alternative proposals.

On Sunday, May 22, municipal elections were held across the country. Up to the day of the elections, political spokespeople claimed to respect the *indignados'* right of association and their right to demonstrate and even paid lip service to their complaints. As was to be expected, the tone changed once the votes were cast. Where before there had been solidarity with the legitimate demands of the protestors, politicians as well as the mainstream media turned to criticizing the "tiresome" occupation of public space. The stance of the *indignados* began to be dubbed nihilistic, sterile, or utopic. In addition, the local soccer team FC Barcelona was scheduled to play in the European Champions League final only a few days later, and since the tradition after a win was for an enthusiastic crowd of fans to head toward the city center in celebration, it was thought that an uncontrolled confrontation with the participants in the encampment could present a serious risk.

On the morning of May 27, the day before the game, the authorities ordered that the Plaça de Catalunya be vacated by force for sanitation reasons. A contingent of 450 police officers participated in the operation.

Reporters and television cameras captured the action, whose violence and cruelty against people who did not offer the slightest resistance was difficult to justify. All in all, more than 120 people were injured in the operation. The images of security forces hitting demonstrators with batons and dragging them out of the plaza were seen around the world; for many, these scenes seemed like a historical flashback, calling up memories of Francoist repression.

These images forced Felip Puig, the interior minister of the region of Catalonia and the person ultimately responsible for the operation, to provide an explanation. Following a predictable script, in his first statement he accused the media of offering a biased account of what actually happened. The decision to cover the forceful response of the agents while omitting the provocations to which they were subjected represented, in his view, a flagrant distortion of the facts. According to Puig, the police limited their actions to defending themselves against previous acts of aggression. But many journalists refused to accept this version of things and submitted video footage to the minister of the entire sequence of events during the eviction, which allowed the images that were shown on the news to be put into context through the inclusion of what happened before and after. They insisted that the minister offer a new version of events once he had seen this footage, asking him to reconsider his accusations against the media and his defense of police actions.

In the minister's subsequent appearance, the polemic continued in the question-and-answer session. What was his version of events after analyzing the images? The minister evaded the issue: "I'm a very busy person. How can you expect me to spend my time

Figure 46. Erik Kessels (born 1966, Roermond, the Netherlands; lives and works in Amsterdam), *24hrs in Photography*, 2011. More than one million printed photographs. Installation view, Foam, Amsterdam. Courtesy of the artist

looking at two hours of film when I already know what I'm going to see?" He immediately went on the offensive: "But this situation has made me think of something that will allow us to avoid in the future any suspicion about the activities of our security forces. From now on the officers will wear cameras inside their helmets that will record every move they make and will verify the integrity of their conduct and their adherence to established protocol."

Intoxicated by his own enthusiasm, the minister did not even realize that if he had applied this measure in the eviction of the Plaça de Catalunya, he would have been faced with a pile of tapes with almost two thousand hours' worth of footage. If no one in his department could spare two measly hours to spend in front of the screen

looking at a video, how realistic could the minister's proposal possibly be? It was a proposal, it should be added, that anticipated a counterproposal: that the demonstrators also wear cameras on their heads that would provide a sustained countershot of the police aggression. Thus we would have the same actions from the point of view of the attackers and from that of the attacked, framed perfectly by their two opposing subjective cameras.

This shocking episode had several consequences. It inspired caricatures of Felip Puig: from that point on, political satires showed him wielding a baseball bat like the menacing thugs in Hollywood films. But it also introduced the paradox of the watchful eye, which moved from the speculations of Orwellian fiction to

actual implementation in the real world. It became clear that it was not enough to have thousands of webcams installed in public spaces to scrutinize our every movement for "our own security." The minister took the scopophilic ecstasy of Dziga Vertov to the Foucauldian territory of discipline and punishment. Above all, Puig's proposal imagined a magnificent contribution to the saturation of the world with redundant images, an ambition to create and fill completely useless archives so that worthwhile information would collapse under the mass of contaminated images. The intended effect of his proposal was in fact dramatized artistically in Erik Kessels's 2011 installation (fig. 46) at Foam in Amsterdam. The installation consisted of more than one million photographs that, having been downloaded and printed, were scattered throughout the different rooms of the building. The number of photographs corresponded to the sum of archives loaded through the Internet portal Flickr during one twenty-four-hour period.

The project of the police officer turned man-camera (or *homo photographicus*) that animated press debates for a while slowly arrived at a dead end. The images captured by the police webcams could have a dissuasive effect, but they would hardly have been effective. Additionally, legal authorities advised that the project might fall afoul of privacy laws and the right to one's own images. But for scholars of visual culture, two character-istics of the digital era were revealed that could be extrapolated and applied to many aspects of daily life. First, we invest much more time in taking pictures than in viewing them. We take so many pictures that we can't find time to look at them; we continually postpone while accumulating more and more photos. Our hard drives are increasingly filled with waiting images, unseen images, "invisible" images. Second, there is still a gap between digital methods of image production and analogous methods for reading these images. The proposed videos that would be taken by the officers in the course of their operations would be unusable because they would require an army of viewers to comb through them and find their precise points of interest. This is most likely the system of inspection that the Barcelona police force would use. But it is hard to doubt the feasibility of designing some mode of processing and analyzing images that would focus on a particular characteristic: the presence of a violent gesture, the use of a weapon, an expression of pain. It is very plausible

that these elements could be codified and traced. It's only a matter of time.[1]

In any case, it makes sense to characterize Felip Puig as visionary at least for having the distinction of attempting to put into practice what had already been anticipated in the realm of art technology and science-fiction films. For example, Wafaa Bilal, an Iraqi artist and New York University professor of photography, had a microcamera with a USB connection surgically inserted into the posterior part of his skull in order to take pictures of what was going on behind him.[2] The project was commissioned by the government of Qatar for the exhibition *Told/Untold/Retold* at Mathaf (Arab Museum of Modern Art) in Doha in 2010–11 (fig. 47). Bilal's encephalocamera would snap photos at a regular interval of one per minute so that the images could be seen streaming in real time on the museum's monitors. Bilal's work concentrates on the interaction between technology and concepts of storytelling and travel. Placing the camera so as to capture one's rear view, however, entails focusing on a blind spot, the opposite of what we see directly in front of us with our eyes. For a police officer it would be a way to protect his back, but for Bilal it symbolized what has been left behind: to travel is to leave behind experiences that have already been lived. How to explain these photos? How can these disjointed cuts that are randomly chosen reconstruct an intelligent narrative? Nietzsche maintained that there are no facts, only interpretations, and Bilal transferred the demiurgic responsibility of that interpretive impulse to the spectator. In his own words:

> The webcam implant converts part of my body into a technical device that distributes the taped contents through the Internet. The arbitrarily captured images will retain unconnected registers and will facilitate a narrative that must be filled in by the spectator like a bodily space, at the same time as the presentation determines a certain composition. In *Illuminations* Benjamin has described the storyteller as someone "who can let the wick of his life be consumed com-pletely by the slow fire of his story." In this sense, I find myself tied to a story like Benjamin's storyteller, transferring the interpretive frame to an audience that lacks the necessary context and thus transforming the story according to the subjective interactions and subsequent expressions. Using this narrative triangle, the work formulates commentaries on the ways in

Figure 47. Wafaa Bilal (born 1966, Najaf, Iraq; lives and works in New York City), *3rdi***, 2010–11. Project documentation. Courtesy of the artist**

which images are used to tell and retell stories, both those that belong to us and those that we make our own.[3]

Although conceptually very different, the cyborg nature of the man-camera has a long tradition in futuristic films, one of the most exemplary of which is Bertrand Tavernier's *Death Watch* (1980). Conceived as an homage to Michael Powell's *Peeping Tom*, Tavernier's film is based on the story of David G. Compton's novel *The Unsleeping Eye* (1973), published in Great Britain with the title *The Continuous Katherine Mortenhoe*. The film is a bitter moral parable about death as spectacle and the manipulation of the individual by mass media. Roddy (Harvey Keitel), a young reporter for a sensationalist television network, has a microcamera inserted into his brain that allows him to film through his eyes the death of the writer Katherine Mortenhoe (Romy Schneider). The action is set in a future in which natural diseases have been almost entirely eradicated and death by illness has become extremely rare. When Katherine is diagnosed with an incurable illness, she

becomes a celebrity and is mobbed by the media. A television network offers her an enormous amount of money to consent to being filmed during her final days. Katherine pretends to agree to the terms, but she then takes flight with Roddy's help. She is unaware that Roddy is actually a cameraman who is transmitting everything he sees, his every perception forming the material for a reality show that she herself stars in without realizing it. A secondary effect of the surgical procedure is that Roddy can go blind if he experiences even a short exposure to darkness; he therefore takes drugs to stay awake, has learned to sleep during brief periods with his eyes open, and carries with him a small lantern to light up his eyes at night.

The fantastic register of the film can be glimpsed in the details that Tavernier incorporates into this ultra-technological world—computers that write their own stories, a televised professor for each student—and an ambiguous social reality in which the police continue to react forcefully to demonstrators. Some traditions are never lost: the future appears to perpetuate the troglodyte gesture of harassing those who protest, a vision that the events of the Plaça de Catalunya confirmed. In fact, reality often surpasses the forecasts generated by the feeble imaginations of screenwriters. We have only to recall the reality shows that record live executions. True pornography has no limits. For better or for worse, "the possible," as Gaston Bachelard warned, "is a temptation that reality always ends up accepting."[4]

Jumping ahead three decades, we find in a contemporary cult classic a return to the man-camera. *Black Mirror* is a miniseries that extracts the essence of technoparanoia. Besides the reference to obsidian mirrors that were thought to have the power to visualize the future, it alludes to the idea of a mirror in which we do not want to see ourselves reflected. Charlie Brooker, who created the series, explains, "The 'black mirror' of the title is the one you'll find on every wall, on every desk, in the palm of every hand: the cold, shiny screen of a TV, a monitor, a smartphone."[5] We are addicted to technology; we are voyeurs of lives that are not our own, and we wind up feeling as if we were the coproducers of those lives. In each house, at each workstation, there is a flat screen, an Internet connection, a smartphone. Google, Twitter, and Facebook are the new paradigms.

The final episode of the 2011 season of *Black Mirror*, "The Entire History of You," was written by Jesse

Armstrong and directed by Brian Welsh. It is a story of love, mistrust, and jealousy; the technological special effects are a mere pretext for the typical plot of the problematic relationship that ends in tragedy because of obsession and jealousy. All of this takes place, however, in a future society in which a technology has been invented that allows people to reexamine their existence time and again. A chip implanted behind the ear records the audio and visual experience of every individual; each and every word and gesture of our lives can be rewound on demand and projected onto a screen.[6] Here we become walking hard drives capable of entertaining, torturing, or fixating ourselves by revisiting a thousand times over what we have already lived. We cannot change the past, but we can relive it—in slow motion or fast motion—on a constant video loop. Are these technological advances healthy for a relationship? For Walter Benjamin, "There is no document of culture which is not at the same time a document of barbarism."[7] Culture and knowledge are pillars of technology and progress, which, in their turn, encourage the occurrence of catastrophe. Neither progress nor technology appears to better the human condition. As Benjamin notes: "The concept of progress must be grounded in the idea of catastrophe. That things are 'status quo' *is* the catastrophe."[8]

The plot centers on the roller-coaster relationship between the young lawyer Liam Foxwell and his wife, Ffion, who are ensconced in a comfortable life of bourgeois happiness. Soon, however, Liam finds evidence that leads him to suspect that Ffion has had a relationship with Jonas. Drunk and full of rage, Liam goes to Jonas's house and, threatening him with a broken bottle, demands that he project his archive of memories, in which Jonas and Ffion appear tumbling around in Liam's bed. Liam immediately forces Jonas to erase the archive so as to leave no trace of these painful experiences, but upon returning to his house, he makes his wife view his own memories that correspond to these scenes. The situation takes a turn for the worse when Liam discovers that the affair took place when he was away, during the period in which the couple's child was conceived. Ffion claims that she had already detached that part of her memory, but since the erasure of an archive creates a gap in the temporal string of memories that can be detected, Liam realizes that his wife is still lying to him. In the last scenes the house is empty. Liam evokes the happy memories of his wife and child, but since they torment him, he impulsively removes the chip from his skull with a knife. The death throes of the memories are unleashed, as when one's life flashes before one's eyes in the moment before death. The mutilation enables a settling of scores with the past; tranquillity requires the annulment of access to this unlimited repertoire of images.

Thus, in its conclusion, "The Entire History of You" transcends the plane of sentimental conflict to refer to an unprecedented phenomenon of total access to and excess of images. We witness a fundamental rupture in the means by which the extraordinary flow of images is made available to everyone. The critic Clément Chéroux writes: "From the point of view of usage, this is a revolution comparable to the installation of running water in the household in the nineteenth century. Today we have access in our homes to a faucet of images that implies a new hygiene of vision."[9] For a certain brand of artistic activism, this iconographic contamination demands "ecological" strategies of containment that contemporary creators translate through the institutionalization of appropriationist and recycling practices. The work of Penelope Umbrico is a prime example of this position. The artist explains that she began the process of creating her ongoing series *Sunsets from Flickr* in 2006, when she felt the impulse one day to take a photograph of a romantic sunset (fig. 48).[10] She decided to check how many photos corresponded to the tag "sunset" on Flickr and discovered that there were 541,795 glorious sunsets; in September 2007 there were 2,303,057, and in March 2008, 3,221,717. (On May 10, 2013, there were 12,234,242.) Just on Flickr and with a single search term, the faucet floods us with millions of sunsets. Does it make sense to expend the effort to take one more photo? Will the one we take add anything to that which is already out there? Is it worthwhile to increase the existing visual pollution? Umbrico thinks that the time has come to stop taking pictures and start using or repurposing those that already exist.

In a world in which objects dominated images, Arman had already begun to practice the strategy of accumulation by the late 1950s. In an essay on Arman, Umberto Eco characterized this as a "poetics of enumeration or cataloguing" that was opposed to the "poetics of the finished form." For Eco, "the poetics of the catalogue is a characteristic of the periods of doubt about the shape and nature of the world, as opposed to

Figure 48. Penelope Umbrico (born 1957, Philadelphia; lives and works in New York City), *541,795 Suns, from Sunsets from Flickr (Partial) 1/23/06*, 2006. Detail of 2,000 Kodak EasyShare machine chromogenic prints, 10.6 x 15.2 cm each. Courtesy of the artist

the poetics of the finished form, typical of the moments of certainty about our identity."[11] The criticism that Arman launched against the society of consumption and the serial production of objects demonstrated a crisis that our postindustrial and hypertechnical society has only aggravated. The inflation of images can be considered a symptom of a social and political pathology of which the mass of *indignados* constitutes only one of the visible victims. To act upon images entails therefore a gesture of ideological signification that exceeds the arena of the artistic and intervenes in new forms of political activism.

Umbrico elaborates, in fact, an integration of the poetics of accumulation and finished form: in *Sunsets from Flickr*, the method demands superabundance and surplus, but the result is one of outstanding aesthetic force. The sober counterpoint to Umbrico's work is Joachim Schmid's *Other People's Photographs* (2008–11),

a collection of almost one hundred self-published books in which images found online are grouped under a title according to predetermined criteria of classification (fig. 49). Schmid suggests that when images lose the thread of their origin, their unrestrained production leads us to absolute chaos; his mission is therefore to restore order. Or at least to restore a possible order, an order accompanied by a malicious wink that elicits confusion in the naive public and complicity in the public that is in the know.

According to Umberto Eco, "We have enough elements to affirm that there are two types of catalogues: some tell us that the world is repetitive; others that it is always surprisingly different."[12] The metaphysics of images again alludes to the forms of categorizing the world: each volume of *Other People's Photographs* simulates the contents of an archivist's folder, that is, the assemblage of the multiple through a principle of unity,

Figure 49. Joachim Schmid (born 1955, Balingen, Germany; lives and works in Berlin),
Other People's Photographs, 2008–11. 96 print-on-demand books, 18 x 18 cm each.
Installation view, Le Bal, Paris 2012. Courtesy of the artist

however arbitrary and absurd it might seem. Thus every volume scores a hit against the coherence of a theory of the catalogue and the archive. In the end, Schmid recuperates for postphotographic culture the encyclopedic will of d'Alembert and Diderot, fertilized, however, with the pedagogical paradoxes of Borges. For example, Borges's invention of a quotation from a supposed Chinese encyclopedia titled *Celestial Emporium of Benevolent Knowledge*: "On those remote pages it is written that animals are divided into (a) those that belong to the Emperor, (b) embalmed ones, (c) those that are trained, (d) suckling pigs, (e) mermaids, (f) fabulous ones, (g) stray dogs, (h) those that are included in this classification, (i) those that tremble as if they were mad, (j) innumerable ones, (k) those drawn with a very fine camel's hair brush, (l) others, (m) those that have just broken a flower vase, (n) those that resemble flies from a distance."[13] Schmid's typologies for interweaving

images according to their common content are suggestive of an irrational and senseless thesaurus that, in a further pirouette of Borgesian ontology, gives the exact measure of the crazy life of images that swirl around us. In this atmosphere of furious and frenetic images, it is obvious that Schmid belongs to the group of artists who intend to tame them and keep them at bay.

But the fact that there are too many images in today's world forces us to reflect on the images that we don't have: images that have never existed, images that have existed but that are no longer available, images that have faced insurmountable obstacles to come into existence, images that our collective memory has not conserved, and images that have been prohibited or censored. . . . In any case, excess and access continue to mark the agenda of postphotographic visual culture and put us on the path to new reformulations of the laws that structure the nature of the image in its multifarious

modes: aesthetic, epistemological, ontological, anthropological. Newtonian physics explained the behavior of nature in a plausible way, but when we acquired instruments to explore deep space and play with subatomic particles, we discovered that there were phenomena that refused to be governed by those laws. Then we invented quantum physics, and Einstein formulated the theory of relativity. Surely we are on the cusp of a quantum theory of images.

Translated by Jeffrey Lawrence

Notes

1 As an index of the possibility of this codification, I'll offer an illustrative example: I bought a simple camera to take underwater pictures, a small Olympus Tough. To my surprise, the camera has an operational setting that recognizes dogs and another that recognizes cats. (Weirdly, the camera lacks a setting that recognizes fish, which would be logical in this case.) Nowadays many camera models have "firmware" that recognizes faces and smiles, but these dog and cat settings disconcerted me, and while I appreciate the abilities of the programmers, I wonder at the same time what kind of coordinates or algorithms allow us to identify a graphic configuration of "dog" or "cat." Soon we will be able to use cameras to identify races.

2 See Bilal's description of the *3rdi* project on his website, http://wafaabilal.com/thirdi/.

3 Ibid.

4 "Le possible est une tentation que le réel finit toujours par accepter." Gaston Bachelard, *L'intuition de l'instant* (Paris: Gonthier, 1966), 55.

5 Charlie Brooker, "The Dark Side of Our Gadget Addiction," *Guardian* (UK), December 1, 2011.

6 According to the parameters of this argument, if a second of video is composed of twenty-five frames, a simple calculation establishes that each individual would produce 1,440,000 images per day (deducting the eight hours of inactivity during sleep).

7 Walter Benjamin, "On the Concept of History," trans. Harry Zohn, in *Selected Writings*, vol. 4, *1938–1940*, ed. Howard Eiland and Michael W. Jennings (Cambridge, MA: Belknap Press of Harvard University Press, 2003), 392.

8 Walter Benjamin, "Central Park," trans. Edmund Jephcott and Howard Eiland, ibid., 184.

9 Clément Chéroux, in *From Here On*, curated by Clément Chéroux, Joan Fontcuberta, Erik Kessels, Martin Parr, and Joachim Schmid (Arles, France: Rencontres Internationales de la Photographie, 2011), unpaged.

10 Statement on the artist's website, http://www.penelopeumbrico.net/Suns/Suns_Index.html.

11 Umberto Eco, "Sobre Arman," in *Arman* (Barcelona: Fundació la Caixa, 2001), 17.

12 Ibid., 18.

13 Jorge Luis Borges, "The Analytical Language of John Wilkins," trans. Ruth L. C. Simms, in *Other Inquisitions, 1937–1952* (Austin: University of Texas Press, 1964), 103. Surely Borges would have been pleased with the string of quotations that his false quotation induced. As far as I'm concerned, I have not been able to resist the temptation to evoke it again, even though I included it in an earlier essay on the work of Joachim Schmid.

PLATES

Joan Fontcuberta,
Googlegram: Niépce

Joan Fontcuberta's *Googlegram: Niépce* (2005) is based on the earliest known photograph, Joseph Nicéphore Niépce's *View from the Window at Le Gras* (ca. 1826). By processing the results of a Google image search for the words *photo* and *foto* through photo-mosaic software, Fontcuberta re-created Niépce's photograph as a composite of ten thousand images, what he calls "archive noise." The work therefore evokes the first photograph only in order to suggest its movement across time and across different contexts and to suggest that the surface of every image is already a kind of archive, the trace of multiple memories. A meditation on the circulation and itinerancy of images, Fontcuberta's photograph points to the potential for transformation inscribed within every photograph—from the very "first" photograph to all those produced today—made possible by innumerable and ever-changing technologies.

OVERLEAF: Plate 1. Joan Fontcuberta (born 1955, Barcelona; lives and works in Barcelona), *Googlegram: Niépce*, 2005. Inkjet print from a digital file, exhibition copy, 120 x 160 cm. Courtesy of the artist

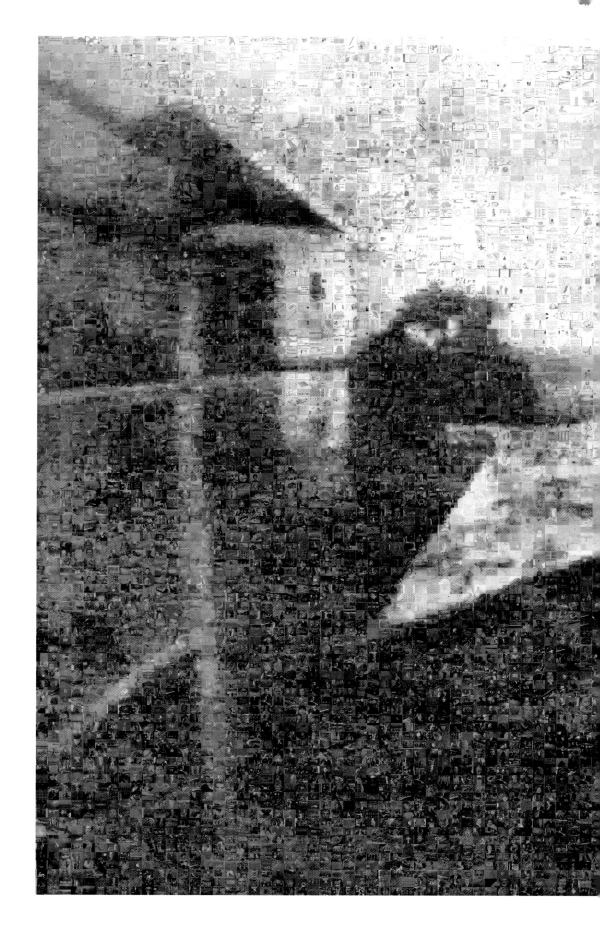

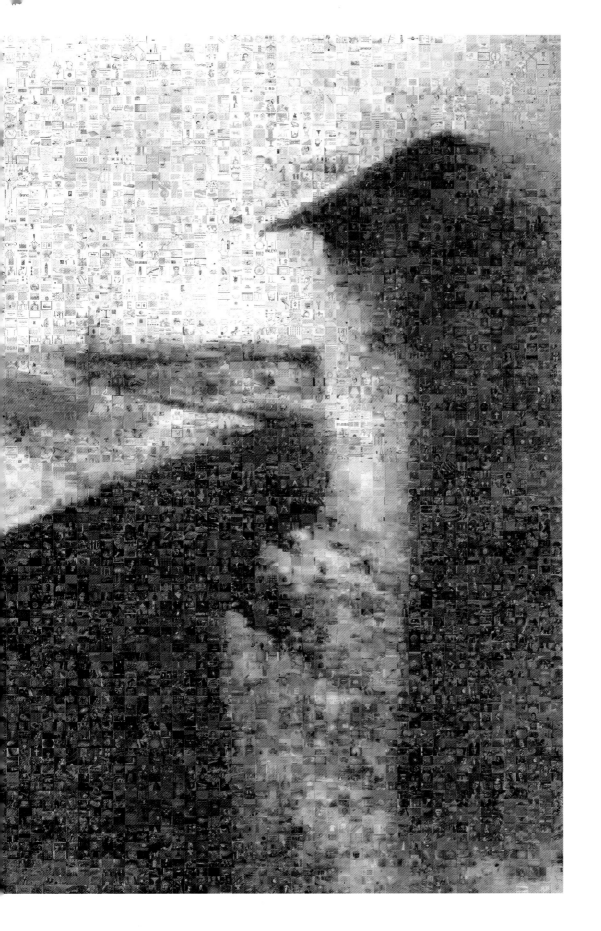

I.
Itinerant Photographs

The Emperor's Collection

In the nineteenth century, pictures and cameras started to circulate across borders, first slowly and then in waves, and everything became photographable. Taking and acquiring photographs began to be viewed as a way of collecting the world. The photographic collection of the Brazilian emperor Dom Pedro II (1825–1891), with more than twenty thousand photographs now housed in the National Library in Rio de Janeiro, illustrates the scope and power of such an imperial view. The emperor became interested in photography in 1840, when the ship *L'Orientale* brought the first camera to the continent. He supported more than two dozen photographers between 1851 and 1889, and through international agents he acquired works by the most important European and American photographers of the time. The photographs presented here illustrate the emperor's wide-ranging interests—including astronomical and scientific photography, natural "photographic" phenomena, travel photography, and portraits—and they make clear that this "Brazilian" collection was never just Brazilian.

Plate 2. Joaquim Insley Pacheco (Portuguese, ca. 1830–1912), *Pedro II, Emperor of Brazil, Rio de Janeiro*, 1883. Platinum print, 37.5 x 29.2 cm. D. Thereza Christina Maria Collection, Archive of the National Library Foundation, Brazil

LL. MM. L'Empereur et l'Impératrice du Brésil

aux Pyramides.

**Plate 3. H. Delie and E. Bechard (French, active 1870s), *Brazilian Emperor D. Pedro II, Empress D. Thereza Christina,
and the Emperor's Retinue next to the Pyramids, Cairo, Egypt*, 1871. Albumen print, 19.8 x 26.3 cm.
D. Thereza Christina Maria Collection, Archive of the National Library Foundation, Brazil**

Nº 4230. Pompei : empreinte humaine une femme enceinte fouilles 1868.

Plate 4. Michele Amodio (Italian, active ca. 1850–ca. 1880), *Pompeii (Italy): Human Cast, Pregnant Woman, Excavations*, 1868 (printed 1873). Albumen print, 19.2 x 24.1 cm. D. Thereza Christina Maria Collection, Archive of the National Library Foundation, Brazil

Dado pelo Dr Warren professor substituto de operações do Dr Bigelow
na Medical School de Boston quando visitei o Museu d'Elle onde existe este
mastodonte mto grande restaurado. As pernas são artificiaes; mas existem as peças das
restantes que se desfazem. 12 de Julho de 1876

EXPOSIÇÃO CONTINENTAL DE 1882

SECÇÃO BRASILEIRA

Esmaltes photographicos e photographias diversas

Plate 6. Samuel Boote (Argentine, 1844–1921), *South American Continental Exhibition, Brazilian Section, Buenos Aires, Argentina*, 1882. Albumen print, 27.9 x 36 cm. D. Thereza Christina Maria Collection, Archive of the National Library Foundation, Brazil

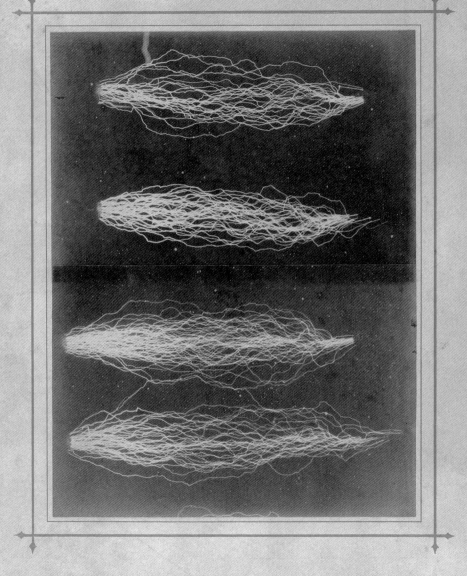

Quatre séries d'étincelles explosives d'une machine électrique de Holtz

Plate 7. Charles Moussette, *Four Series of High-Voltage Sparks from a Holtz Electric Machine*, **Paris, 19th century. Albumen print, 18.2 x 13.1 cm. D. Thereza Christina Maria Collection, Archive of the National Library Foundation, Brazil.**

Photographie d'une portion de la Voie lactée

AR = 20h. 4m.
D = +35°. 30'

Observatoire de Paris

Épreuve obtenue le 10 Juin 1885
par M.M. Henry

Plate 8. Prosper-Mathieu Henry (French, 1849–1903) and Paul-Pierre Henry (French, 1848–1905),
Part of the Milky Way, **Paris Observatory, June 10, 1885. Albumen print, 26.3 x 22 cm.**

The Invention of Brazil

Photography was instrumental in the creation of a set of images that helped define modern Brazil as a tropical landscape and a multiethnic society. It served to represent its nature and its peoples, and it also offered a visual narrative of national modernization through images of new buildings and roads, public parks, and busy ports. Revert Henrique Klumb's photographs of Petrópolis—the modern city that was built for the emperor though he never lived there—and Marc Ferrez's gorgeous archival images of wider Brazil belong to the collective enterprise of capturing a nation in images. An itinerant photographer and inventor, Ferrez joined the Imperial Geographic and Geological Commission in 1875 and traveled extensively around the country. He received wide recognition for his photographs of Brazilian landscapes and social types, many of which circulated as postcards. His panoramic views of Rio de Janeiro helped consolidate Brazil's foundational fictions of self-representation.

Plate 9. Revert Henrique Klumb (ca. 1830s–ca. 1886, born in Germany, active in Brazil), *Petrópolis's Mountain Range (Night View), Petrópolis, Rio de Janeiro*, ca. 1870. Albumen print, 24 x 30 cm. Gilberto Ferrez Collection, Instituto Moreira Salles Archive, Brazil

Plate 10. Revert Henrique Klumb, *Cascatinha, Petrópolis, Rio de Janeiro*, ca. 1870.
Albumen print, 28 x 24 cm. Gilberto Ferrez Collection, Instituto Moreira Salles Archive, Brazil.

Plate 11. Revert Henrique Klumb, *Cascatinha Waterfall Retreat, Petrópolis, Rio de Janeiro*, 1865.
Albumen print, 20 x 24 cm. Gilberto Ferrez Collection, Instituto Moreira Salles Archive, Brazil.

Plate 12. Revert Henrique Klumb, *Quitandinha River, Petrópolis, Rio de Janeiro*, ca. 1870.
Albumen print, 24 x 30 cm. Gilberto Ferrez Collection, Instituto Moreira Salles Archive, Brazil

Plate 13. Revert Henrique Klumb, *Petrópolis's Cemetery, Petrópolis, Rio de Janeiro*, 1870.
Albumen print, 24 x 30 cm. Gilberto Ferrez Collection, Instituto Moreira Salles Archive, Brazil

ENTREÉ DE RIO

Plate 14. Marc Ferrez (Brazilian, 1843–1923), *Entrance to Guanabara Bay*, ca. 1885. Albumen print, 18 x 25 cm. Gilberto Ferrez Collection, Instituto Moreira Salles Archive, Brazil.

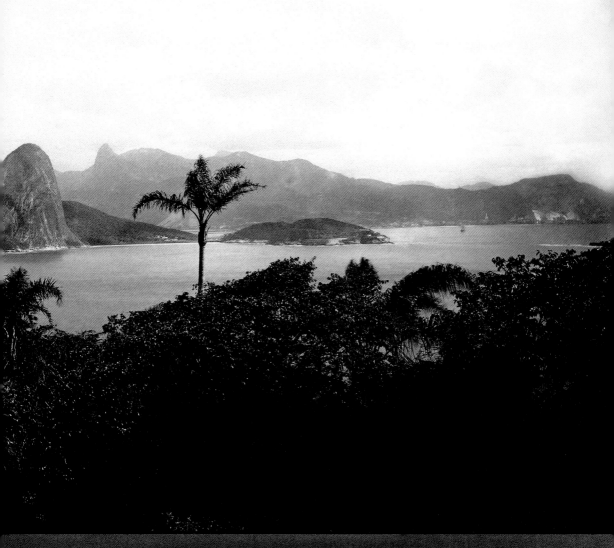

LA BAIE.

Plate 15. Marc Ferrez, *Itapuca Rock, Rio de Janeiro*, ca. 1876. Albumen print, 20 x 27 cm.
Gilberto Ferrez Collection, Instituto Moreira Salles Archive, Brazil

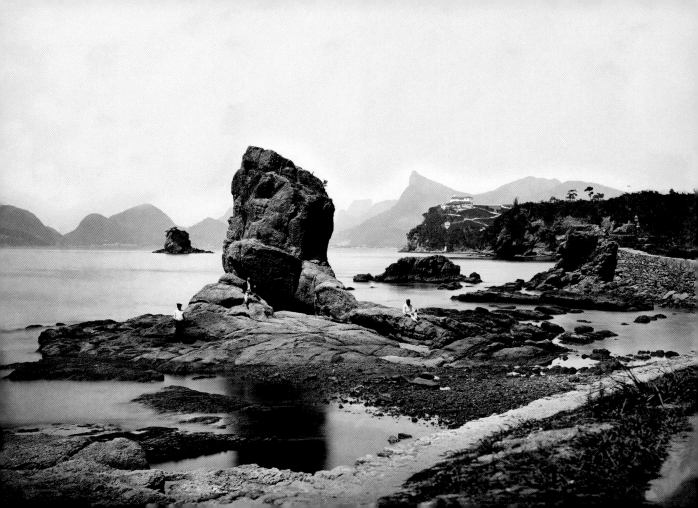

Plate 16. Marc Ferrez, *Araucárias, Paraná*, ca. 1884 (printed later). Gelatin silver print, 29 x 39 cm. Gilberto Ferrez Collection, Instituto Moreira Salles Archive, Brazil

**Plate 17. Marc Ferrez, *Naturalist and Mining
Engineer Paul Ferrand in the Itacolomy Mountains,
Ouro Preto*, ca. 1886 (printed later).
Gelatin silver print, 18 x 24 cm. Gilberto Ferrez
Collection, Instituto Moreira Salles Archive, Brazil**

Plate 18. Marc Ferrez, *Botanical Gardens, Rio de Janeiro*,
ca. 1890 (printed later). Gelatin silver print, 17 x 23 cm. Gilberto Ferrez Collection,
Instituto Moreira Salles Archive, Brazil

Plate 19. Marc Ferrez, *The Market and Saint Francis Church by the Brazilian Colonial Sculptor and Architect Aleijadinho, Ouro Preto*, ca. 1880 (printed later). Gelatin silver print, 18 x 23 cm. Gilberto Ferrez Collection, Instituto Moreira Salles Archive, Brazil

Plate 20. Marc Ferrez, *Soil Preparation for the Construction of the Railroad Tracks, Paranaguá-Curitiba Railroad, Paraná*, ca. 1882 (printed later). Gelatin silver print, 23 x 29 cm. Gilberto Ferrez Collection, Instituto Moreira Salles Archive, Brazil

Plate 21. Marc Ferrez, *View of the Peak Pão de Açúcar, Rio de Janeiro,* ca. 1915.
Autochrome, exhibition copy, 10 x 12 cm. Gilberto Ferrez Collection,
Instituto Moreira Salles Archive, Brazil

Plate 22. Vincenzo Pastore (1865–1918, born in Italy, active in Brazil),
Group of People around a Peddler Playing a Barrel Organ in the Square of the Republic, São Paulo,
ca. 1910. Gelatin silver print, 9 x 12 cm. Instituto Moreira Salles Collection, Brazil

II.
Itinerant Revolutions

The Mexican Revolution

The Mexican Revolution (1910–20) is among the world's most photographed armed revolutions. Coinciding with the dawn of photography as a popular medium, it received extraordinary coverage by professional photographers and photojournalists, whose work was facilitated by lower costs, the standardization of the printing process, and the mobility offered by new portable cameras. One of the largest photographic archives of the revolution was assembled by the photographer Agustín Víctor Casasola. Countless images of the revolution traveled from provincial studios to Mexico City's newspapers, from there to Europe, and from northern Mexico to the United States. In addition, images were often appropriated by different photographers and studios, enabling them to be recirculated and reinterpreted through cropping, editing, and recaptioning. Many iconic photographs of the revolution became what the historian John Mraz calls floating images as they traveled through different media, acquiring new meanings and connotations along the way.

Plate 23. Hugo Brehme (1882–1954, born in Germany, active in Mexico), *Xochimilco, D.F.*, ca. 1920. Gelatin silver print (postcard), 8.3 x 13.3 cm. Princeton University Art Museum, Gift of Forrest D. Colburn (2006-445)

8214 XOCHIMILCO D.F.

Plate 24. Miguel Casasola (?), *Government Minister José Ives Limantour (Shaded by Umbrella) in Mexico City for the Opening of the Works to Bring Drinking Water from Xochimilco*, March 18, 1910. Inkjet print from a digital file, exhibition copy, 14.3 x 20.3 cm. Fondo Casasola, SINAFO-Fototeca Nacional del INAH (Inv. #35001)

Plate 25. *General Jesús Carranza and Men Looking at the Destroyed Rail Tracks*, ca. 1913. Inkjet print from a digital file, exhibition copy, 20.3 x 14.3 cm. Fondo Casasola, SINAFO-Fototeca Nacional del INAH (Inv. #32942)

Destrucción de la vía al sur de "Bocatoche"

Plate 26. *Rurales under Carlos Rincón Gallardo's Command Boarding Their Horses on Their Way to Aguascalientes*, n.d. Inkjet print from a digital file, exhibition copy, 14.6 x 20.3 cm. Fondo Casasola, SINAFO-Fototeca Nacional del INAH (Inv. #6345)

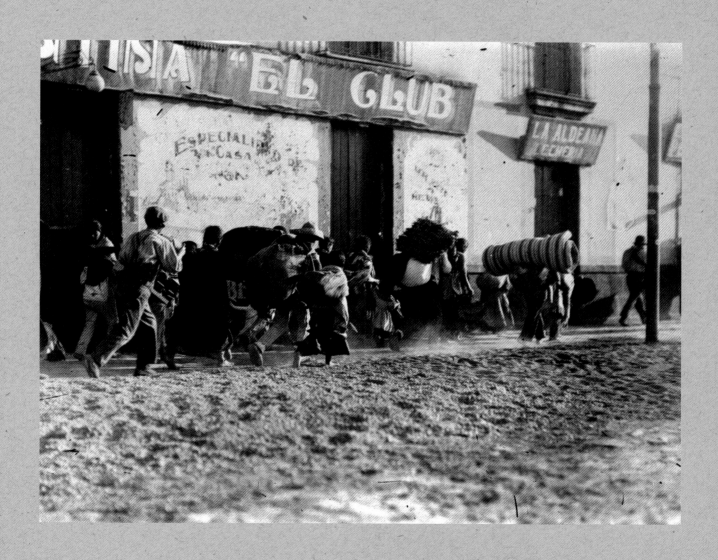

Plate 27. *People Fleeing from the Combat Zone during the Truce during the Tragic Ten Days (Decena Trágica), Mexico City*, February 16, 1913. Inkjet print from a digital file, exhibition copy, 16.1 x 20.3 cm. Fondo Casasola, SINAFO-Fototeca Nacional del INAH (Inv. #37311)

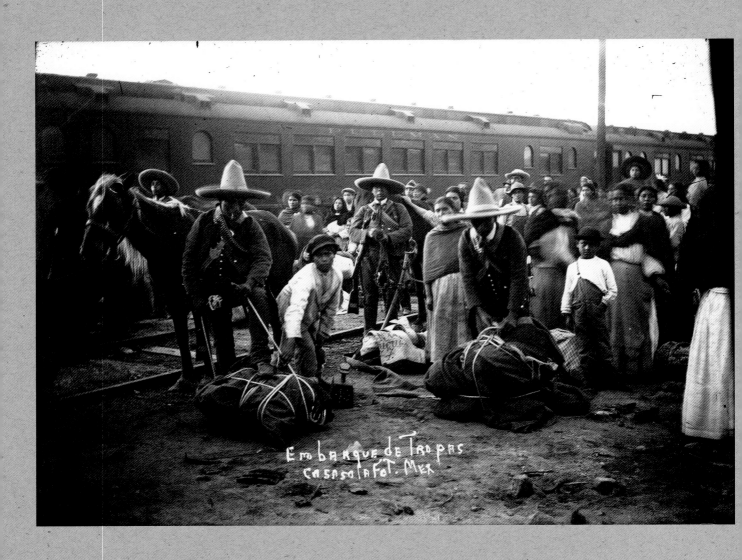

Plate 28. *Troops Boarding a Train*, n.d. Inkjet print from a digital file, exhibition copy, 14.6 x 20.3 cm.
Fondo Casasola, SINAFO-Fototeca Nacional del INAH (Inv. #5291)

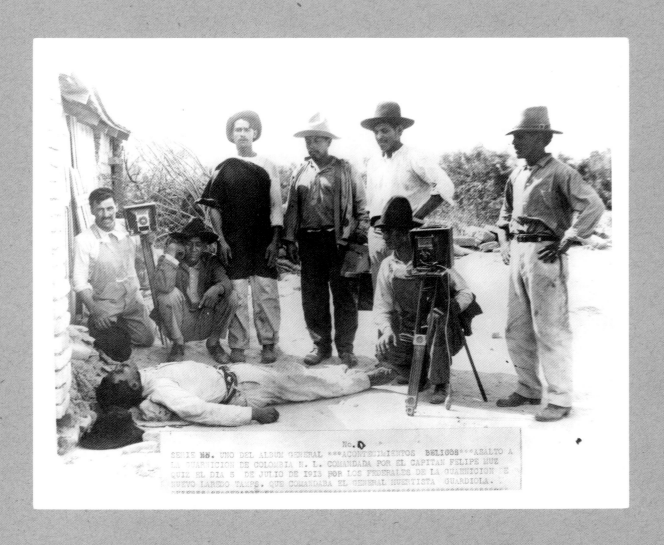

Plate 29. Eustasio Montoya (Mexican, active early 20th century), *Photographers and a Dead Man in Nuevo León after Being Attacked by Huertistas*, July 5, 1913. Inkjet print from a digital file, exhibition copy, 16.5 x 20.3 cm. Archive González Garza, Universidad Panamericana

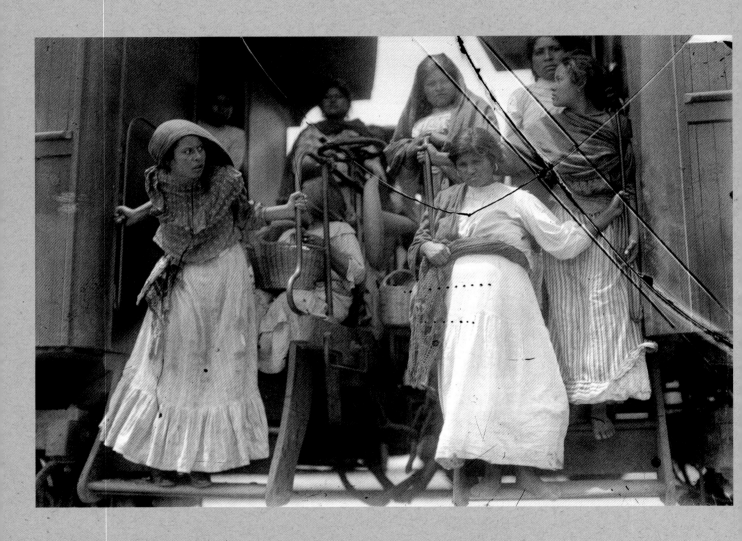

Plate 30. Gerónimo Hernández (?) (Mexican, 1878–1955), *Soldaderas on a Train Platform in the Buenavista Station, Mexico City*, April 1912. Inkjet print from a digital file, exhibition copy, 14.3 x 20.3 cm. Fondo Casasola, SINAFO-Fototeca Nacional del INAH (Inv. #5670)

Plate 31. Hugo Brehme (?), *Emiliano Zapata with Rifle, Sash, and Saber, Cuernavaca*, June 1911. Inkjet print from a digital file, exhibition copy, 25.4 x 17.8 cm. Fondo Casasola, SINAFO-Fototeca Nacional del INAH (Inv. #63464)

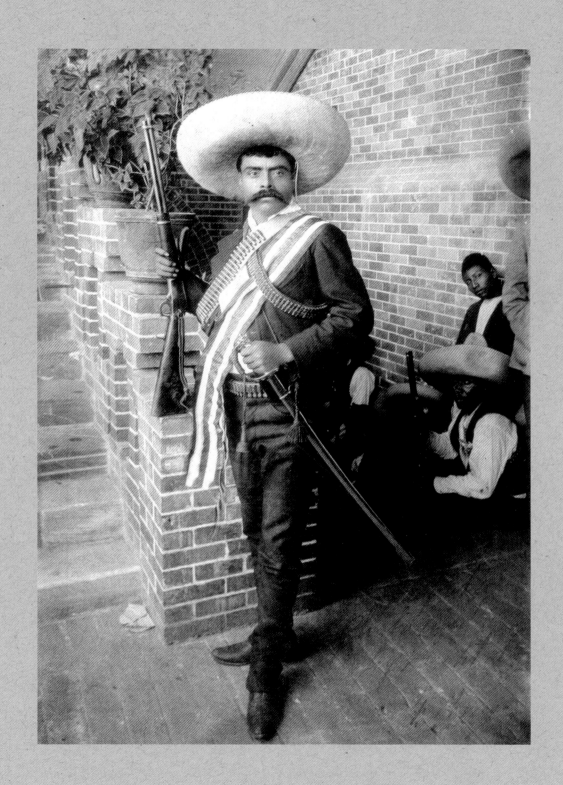

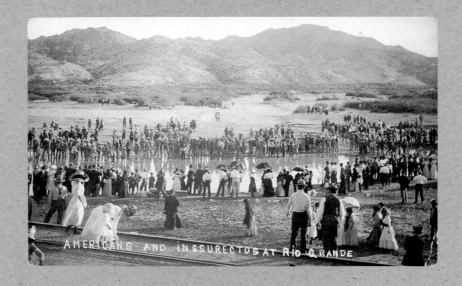

AMERICANS AND INSURRECTOS AT RIO GRANDE

Postcards from the Revolution

The Mexican Revolution became visible mostly through the itinerant power of postcards, tens of thousands of which were produced during the war's first decade. Photographic negatives were rapidly turned into picture postcards that were sold to soldiers and the general public on both sides of the Mexican-U.S. border. They presented corpses, executions, soldiers, revolutionary heroes, and the mass displacement of civilians. Many of the shots were clearly staged, while others portrayed the death and destruction wrought by a prolonged civil war, and still others the fervor of the revolution itself. Americans—who had once embraced images like Hugo Brehme's picturesque vistas of Mexican landscapes and local types, which circulated widely before the revolution—were among the most avid producers and consumers of postcards depicting the morbid and daily scenes of the Mexican Revolution. Written on by the photographers or by the people sending them, the postcards were framed and reframed and, circulating at the intersection of text and image, became one of the first examples of war as an international spectacle.

Plate 32. *Americans and Insurrectos at Rio Grande*, 1911.
Gelatin silver print (postcard), 8.7 x 13.7 cm. Andreas Brown American Photographic Postcard Collection, The Getty Research Institute, Los Angeles (89.R.46)

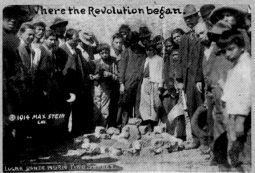

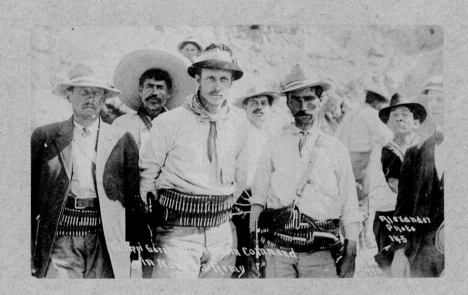

Plate 33. *Where the Revolution Began*, 1913. Photomechanical print (postcard), 14 x 8.8 cm. Signed: ©1914 Max Stein Chi[cago]. Mexican Postcard Collection, Graphic Arts, Department of Rare Books and Special Collections, Princeton University Library

Plate 34. Jim A. Alexander (American, 1863–1926), *Giuseppi Garibaldi Second in Command in Madero's Army*, ca. 1911. Gelatin silver print (postcard), 8.7 x 13.7 cm. Andreas Brown American Photographic Postcard Collection, The Getty Research Institute, Los Angeles (89.R.46)

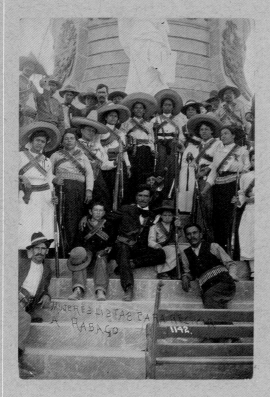

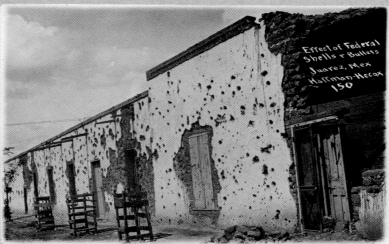

Plate 35. Walter H. Horne (American, 1883–1921), *Women Ready to Greet General Rábago*, 1911. Gelatin silver print (postcard), 13.7 x 8.7 cm. Andreas Brown American Photographic Postcard Collection, The Getty Research Institute, Los Angeles (89.R.46)

Plate 36. *La serpiente maldita* (The cursed serpent), 1913. Gelatin silver print (postcard), 13.7 x 8.7 cm. Images of the Decena Trágica, The Getty Research Institute, Los Angeles (2000.R.15)

Plate 37. *Effect of Federal Shells & Bullets, Juárez, Mexico*, 1911. Gelatin silver print (postcard), 8.8 x 13.9 cm. Signed: Hoffman-Hecox. Mexican Postcard Collection, Graphic Arts, Department of Rare Books and Special Collections, Princeton University Library

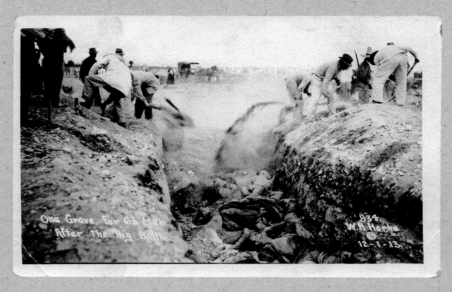

Plate 38. Walter H. Horne, *One Grave for 63 Men after the Big Battle*, 1913.
Gelatin silver print (postcard), 8.8 x 13.8 cm. Signed: W.H. Horne ©12-1-13. Mexican Postcard Collection,
Graphic Arts, Department of Rare Books and Special Collections, Princeton University Library

The Modernist Revolution

Revolutionary politics fed an ensuing revolution in artistic and cultural forms and practices in Mexico. The international and local avant-gardes came together to challenge and transform photography's realist conventions. Rather than simply the product of a recording apparatus, photographs became a site of formal experimentation that gave birth to a politically engaged modernist aesthetic whose traces are still visible today. Renowned Mexican photographers and foreign art photographers who traveled to Mexico—including Lola and Manuel Alvarez Bravo, Henri Cartier-Bresson, Tina Modotti, and Paul Strand—helped create a transnational "Mexican" visual palimpsest characterized by a strong interest in the popular classes, a taste for the surreal, and an effort to transform the photographic medium itself. This experimental project continues in the work of Graciela Iturbide, Elsa Medina, Enrique Metinides, Pedro Meyer, and Pablo Ortiz Monasterio, each of whom has brought a revolutionary vision to the practice of photography.

Plate 39. Tina Modotti (1896–1942, born in Italy, active in Mexico), printed by Richard Benson (American, born 1943), *Untitled*, 1923–30 (printed 1976). Palladium print, 24 x 18.9 cm. The Museum of Modern Art, Courtesy of Isabel Carbajal Bolandi (SC 1976.252)

Plate 40. Tina Modotti, *Workers' Parade*, 1926. Gelatin silver print, 21.5 x 18.6 cm.
The Museum of Modern Art, New York, Anonymous gift (95.1964)

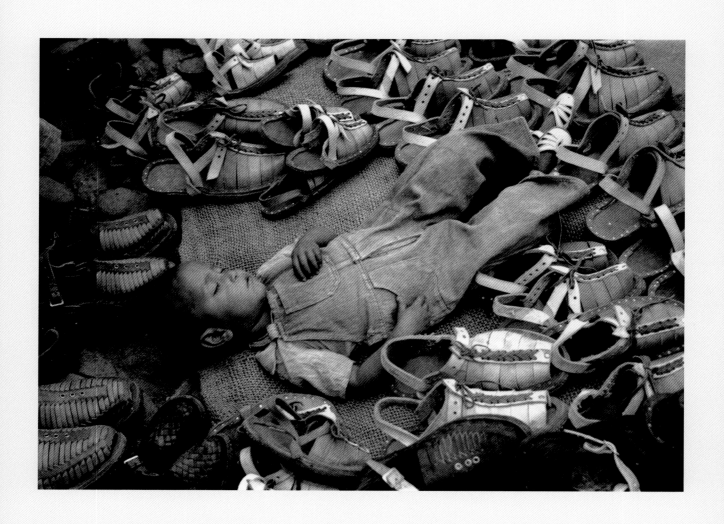

Plate 41. Lola Alvarez Bravo (Mexican, 1907–1993), *El sueño de los pobres 1*
(The sleep of the poor; or, The poor people's dream 1), 1949. Gelatin silver print, 17.1 x 23.6 cm.
Lola Alvarez Bravo Archive, Center for Creative Photography, University of Arizona (93.6.33)

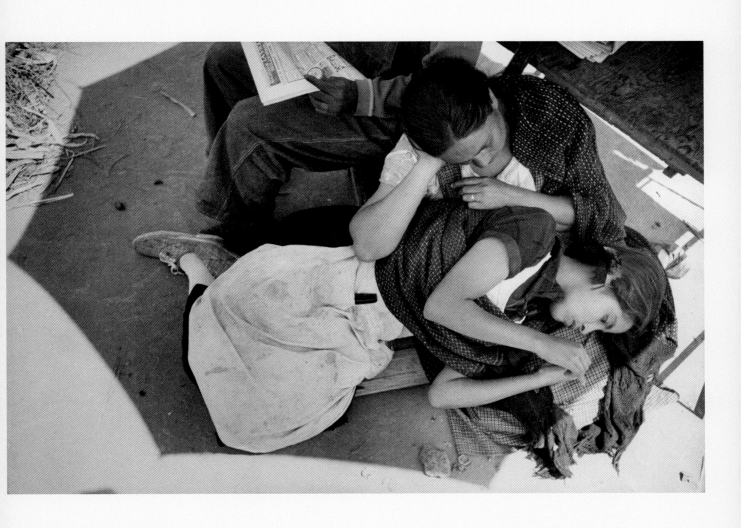

Plate 42. Henri Cartier-Bresson (French, 1908–2004), *Mexico City*, 1934.
Gelatin silver print, 26.5 x 39.5 cm. Princeton University Art Museum,
Gift of Elliott J. Berv, Portland, Maine (x1977-94)

Plate 43. Manuel Alvarez Bravo (Mexican, 1902–2002),
Obrero en huelga, asesinado (Striking worker,
assassinated) (portfolio #13), 1934. Gelatin silver print,
18.8 x 24.5 cm. Princeton University Art Museum,
Gift of Mr. and Mrs. Gerald Levine (x1991-257.10)

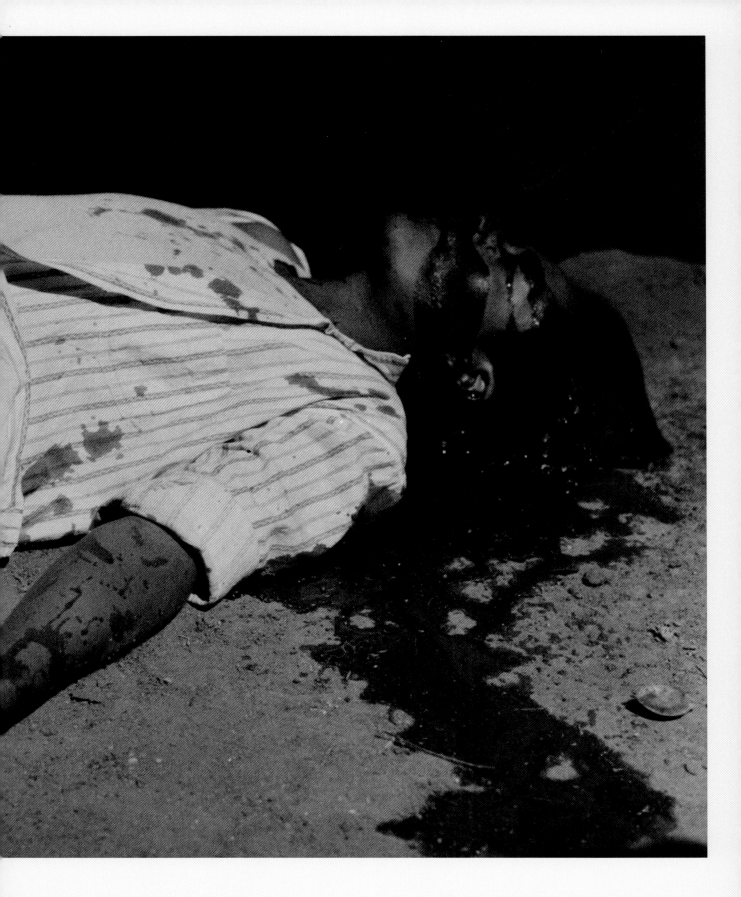

Plate 44. Enrique Metinides (born 1934, Mexico City; lives and works in Mexico City), *Rescate de un ahogado en Xochimilco con público reflejado en el agua* (Retrieval of a drowned person in Lake Xochimilco with the public reflected in the water), 1960 (printed 2006). Gelatin silver print, 35 x 52.8 cm. Princeton University Art Museum, Museum purchase, David L. Meginnity, Class of 1958, Fund (2007-92)

Plate 45. Manuel Alvarez Bravo, *Luz restirada* (Lengthened light), 1944 (printed 1977). Gelatin silver print, 24.1 x 17.6 cm. Princeton University Art Museum, Gift of Frederick M. and Elizabeth Myers (x1979-133)

Plate 46. Manuel Alvarez Bravo, *El umbral* (Threshold), 1947. Gelatin silver print, 24.3 x 19.4 cm.
Princeton University Art Museum, Gift of Frederick M. and Elizabeth Myers (x1981-82)

Plate 47. Manuel Alvarez Bravo, *Dos pares de piernas* (Two pairs of legs), 1928–29. Gelatin silver print, 23.2 x 18.3 cm.
Princeton University Art Museum, Gift of Frederick M. and Elizabeth Myers (x1981-78)

Plate 48. Manuel Alvarez Bravo, *Señor de Papantla* (The man from Papantla), 1934–35. Gelatin silver print, 18.2 x 13.6 cm. Princeton University Art Museum, Gift of Frederick M. and Elizabeth Myers (x1979-137)

Plate 49. Graciela Iturbide (born 1942, Mexico City; lives and works in Coyoacán, Mexico),
Jano (Janus), *Ocumichu, Michoacán*, 1981. Gelatin silver print, 32.1 x 20.9 cm.
Princeton University Art Museum, Gift of Douglas C. James, Class of 1962 (1999-185)

Plate 50. Paul Strand (American, 1890–1976), *Boy, Hidalgo*, 1933 (printed 1967). Photogravure, 16 x 12.4 cm. Princeton University Art Museum, Gift of David H. McAlpin, Class of 1920 (x1971-335 n)

Plate 51. Paul Strand, *Church—Coapiaxtla*, 1933 (printed 1967). Photogravure, 16.1 x 12.4 cm.
Princeton University Art Museum, Gift of David H. McAlpin, Class of 1920 (x1971-335 b)

Plate 52. Graciela Iturbide, *Cementerio* (Cemetery), *Juchitán, Oaxaca*, 1988. Gelatin silver print, 32.2 x 22 cm.
Princeton University Art Museum, Gift of Douglas C. James, Class of 1962 (1999-3)

Plate 53. Graciela Iturbide, *Pájaros en el poste de luz, Carretera a Guanajuato* (Birds on light pole,
Road to Guanajuato), Mexico, 1990 (printed 2013). Gelatin silver print, 40.6 x 50.8 cm. Courtesy of the artist

Plate 54. Pablo Ortiz Monasterio (born 1952,
Mexico City; lives and works in Mexico City),
D.F., 1987. Gelatin silver print, 30.5 x 45.7 cm.
Courtesy of the artist

III.
Itinerant Subjects

This section is devoted to the ways in which photography approaches moving subjects through a variety of strategies, including abstract composition, repetition and duplication, and the construction of a narrative series. Concerned with itinerant social and political subjects—among them streetwalkers, pedestrians, migrants, and those trying to cross various borders—it comprises works by some of the most powerful and original street photographers in Spain and Latin America, including Joan Colom, Nacho López, and Pablo Ortiz Monasterio, who have sought to register everyday life in popular enclaves and the impact of urban modernization. This section also examines photography as a political instrument and as a means of producing an aesthetics of memory. It emphasizes recurring motifs such as the silhouettes that move across the sociopolitical works of Eduardo Gil, Graciela Iturbide, Susan Meiselas, and Pedro Meyer. The images convey a relation between the ambulatory subjects that they depict and their own itinerancy.

Plate 55. José Medeiros (Brazilian, 1921–1990), *Pátio do Palácio Gustavo Capanema, antigo Ministério da Educação* (Courtyard of the Gustavo Capanema Palace, former Ministry of Education), *Rio de Janeiro, Brasil*, 1960. Gelatin silver print, 30 x 40 cm. Instituto Moreira Salles Collection, Brazil

Plate 56. Xavier Miserachs (Spanish, 1937–1998), *Via Laietana, Barcelona*, 1962.
Gelatin silver print, 24 x 30 cm. Collection Foto Colectania Foundation, Barcelona (Núm reg. 192)

Plate 57. Joan Colom (born 1921, Barcelona; lives in Barcelona),
Gente de la calle (People on the street), 1958–64. Gelatin silver print, 23 x 17 cm.
Collection Foto Colectania Foundation, Barcelona (Núm reg. 185)

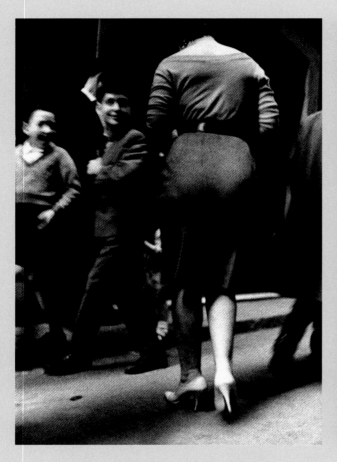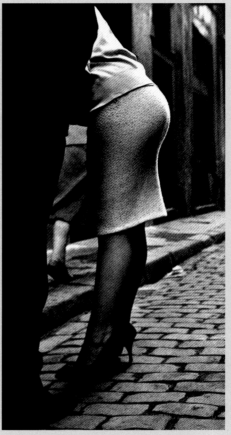

Plate 58. Joan Colom, *Gente de la calle* (People on the street), 1958–64. Gelatin silver print, 26 x 18 cm. Collection Foto Colectania Foundation, Barcelona (Núm reg. 187)

Plate 59. Joan Colom, *Gente de la calle* (People on the street), 1958–64. Gelatin silver print, 23.3 x 11.9 cm. Collection Foto Colectania Foundation, Barcelona (Núm reg. 1536)

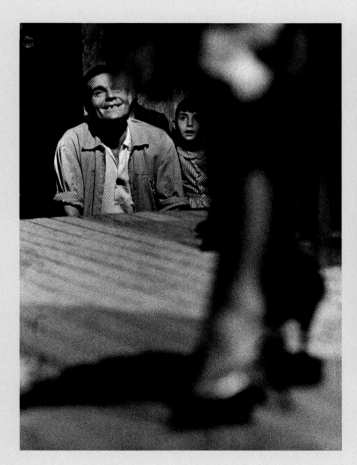

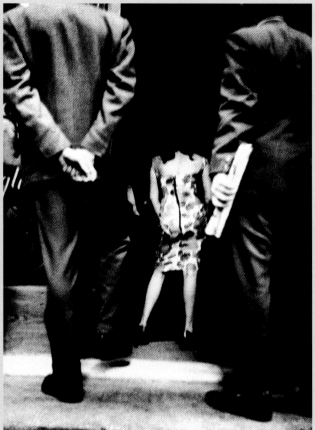

Plate 60. Joan Colom, *Fiesta Mayor*, 1960. Gelatin silver print, 40 x 30 cm.
Collection Foto Colectania Foundation, Barcelona (Núm reg. 189)

Plate 61. Joan Colom, *Gente de Raval* (People of the Raval), ca. 1958 (printed later). Gelatin silver print,
43 x 33 cm. Collection Foto Colectania Foundation, Barcelona (Núm reg. 2011)

Plate 62. Joan Colom, *Gente de la calle* (People on the street), 1958–64. Gelatin silver print, 24 x 18.5 cm. Collection Foto Colectania Foundation, Barcelona (Núm reg. 179)

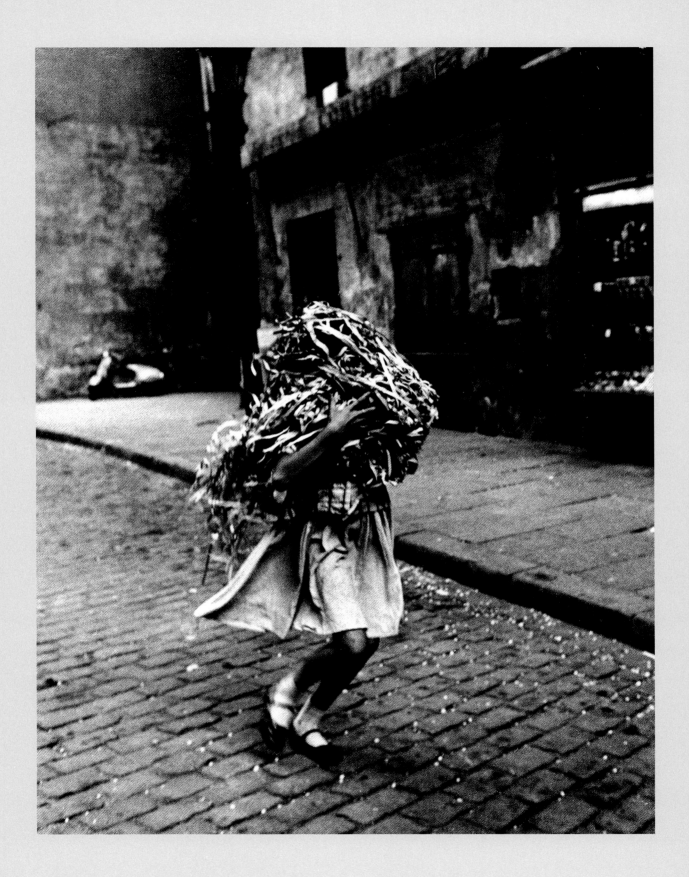

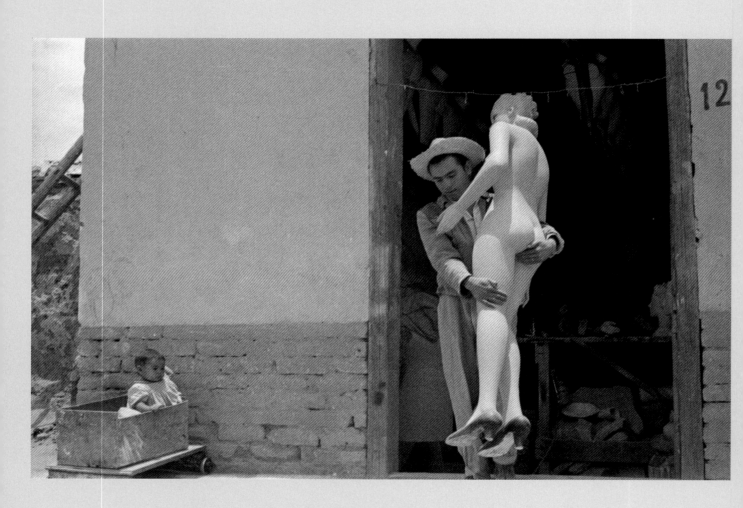

Plates 63 and 64. Nacho López (Mexican, 1923–1986), *La Venus se fue de juerga por los barrios bajos*
(Venus went partying in the poor neighborhoods), 1953. Inkjet prints from digital files, exhibition copies,
16.5 x 24.4 cm each. SINAFO-Fototeca Nacional del INAH (Inv. #405623 and #405641)

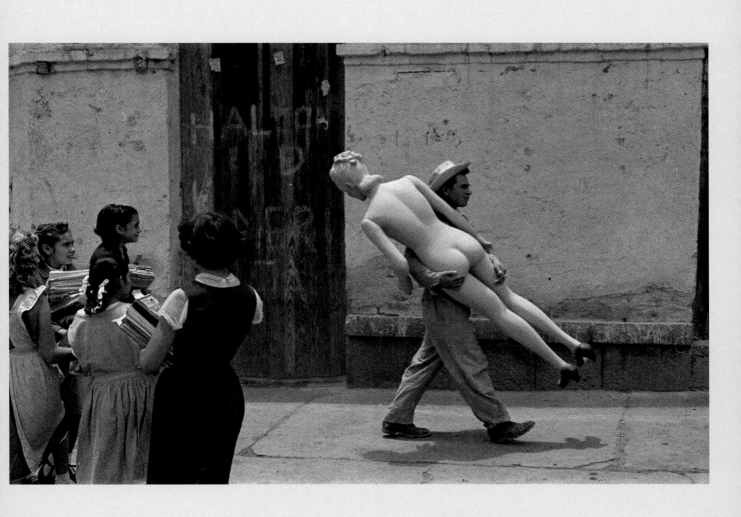

Plate 65. Juan Manuel Castro Prieto (born 1958, Madrid; lives and works in Madrid), *Sombras a cuchillo* (Shadows made with a knife), *Sipán, Perú*, 1999. Gelatin silver print, 46 x 57 cm. Collection Foto Colectania Foundation, Barcelona (Núm reg. 103)

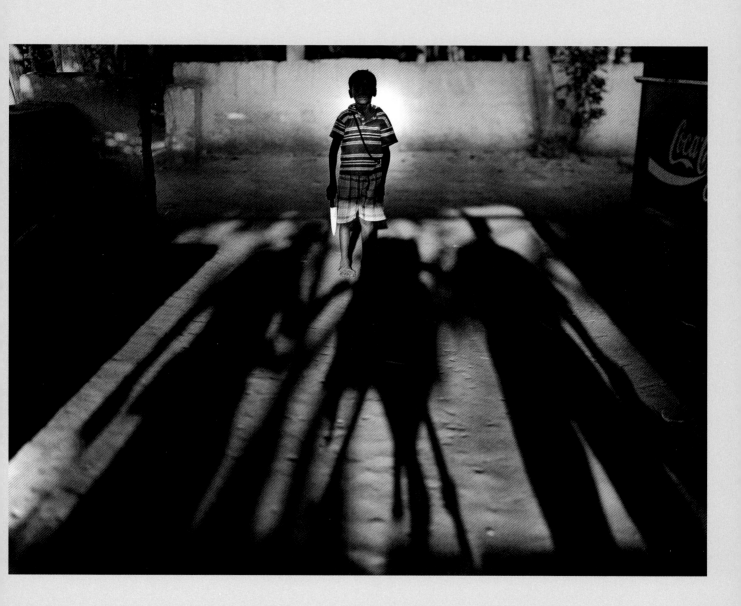

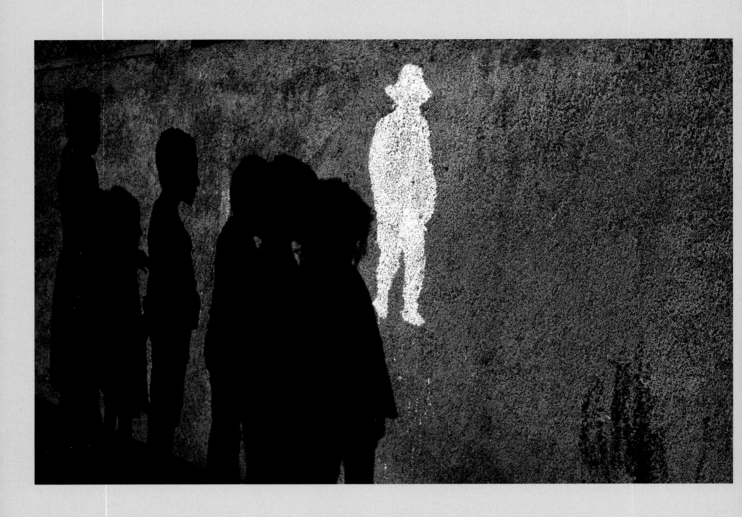

Plate 66. Pedro Meyer (born 1935, Madrid; lives and works in Mexico City), *Sandino,
Estelí, Nicaragua*, 1984. Inkjet print on cotton paper, 31.9 x 48.1 cm. Courtesy of the artist

Plate 67. Susan Meiselas (born 1948, Baltimore; lives and works in New York City),
Soldiers Searching Bus Passengers along the Northern Highway, El Salvador, 1980
(printed 2013). Gelatin silver print, 20 x 30 cm. Courtesy of the artist

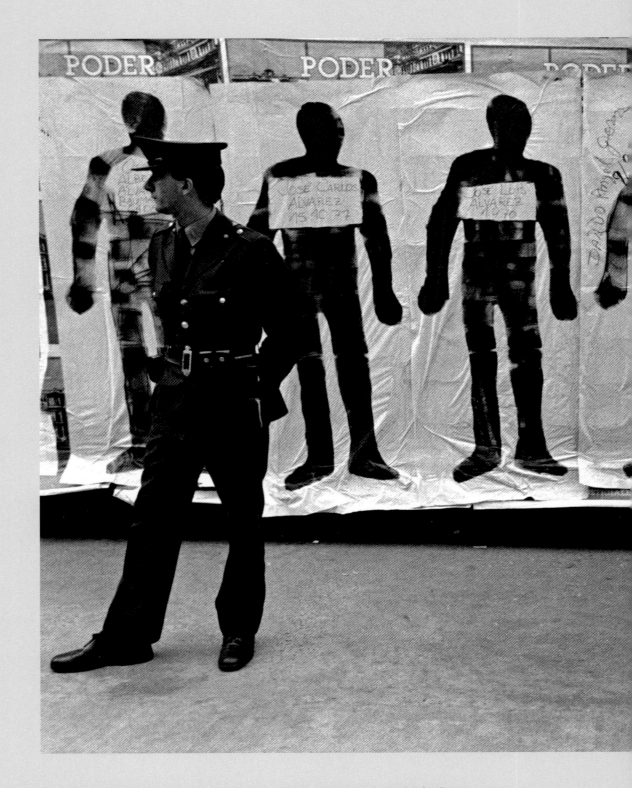

Plate 68. Eduardo Gil (born 1948, Buenos Aires; lives and works in Buenos Aires), *Siluetas y cana*
(Silhouettes and cops), September 21–22, 1983, from the series *El siluetazo* (The silhouette action),
Buenos Aires, 1982–83. Gelatin silver print, 31 x 50 cm. Courtesy of the artist

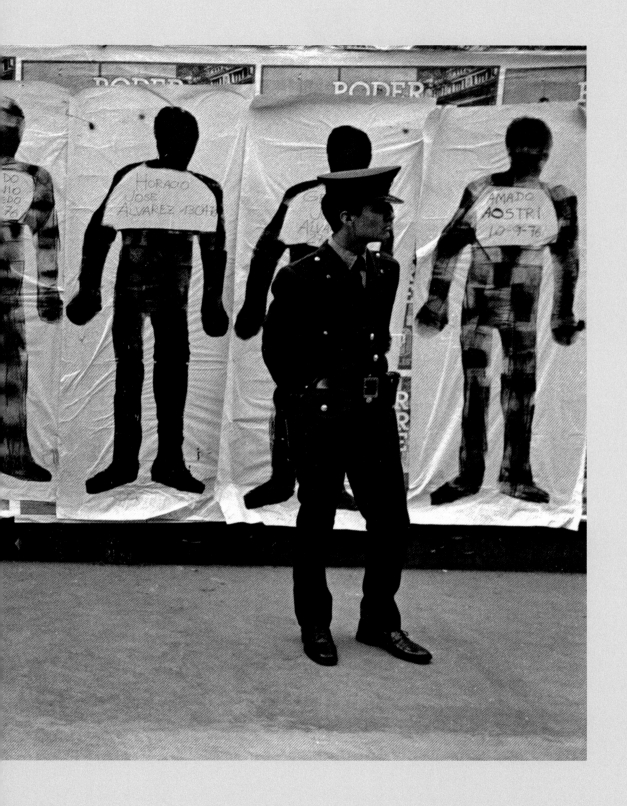

Plate 69. Graciela Iturbide, *Cholos, Harpys, East L.A.*, 1986 (printed 1990). Gelatin silver print, 40.6 x 50.8 cm. Courtesy of the artist

Plate 70. Graciela Iturbide, *Mujer ángel, Desierto de Sonora, México* (Angel woman, Sonoran Desert, Mexico), 1979 (printed later). Gelatin silver print, 24.8 x 33 cm. Private collection

Plate 71. Elsa Medina (born 1952, Mexico City; lives and works in Mexico City), *El migrante* (The migrant),
Cañon Zapata, Tijuana, Baja California, México, 1987 (printed 2011). Gelatin silver print, 21.2 x 32 cm.
Princeton University Art Museum, Museum purchase, David L. Meginnity, Class of 1958, Acquisition Fund (2012-97)

Plate 72. Pablo Ortiz Monasterio, *Y es plata, cemento o brisa* (And it is silver, cement, or breeze), ca. 1985. Gelatin silver print, 27.9 x 35.6 cm. Courtesy of the artist

IV.
Itinerant Archives

Latin American Photo Books

Within the world of photography, books are printed vessels, which is why photography has always been closely related to the world of bookmaking. The dissemination of photographs in book form has been more far-reaching than their display in galleries and museums. Unlike exhibitions, photo books can circulate as convenient and portable archives of a photographer's work, moving across social and national boundaries with great ease. Since the 1920s some of the most significant Latin American photographers—Horacio Coppola, Enrique Bostelmann, Paolo Gasparini, Pablo Ortiz Monasterio, and many others—have produced a rich and diverse group of photo books. Presenting narrative-like or cinematic series of images, these books are hybrid objects usually combining images and writing. They require forms of reception that can be both private and political. Their curated repertoire of images serves as a lens through which we can view the multiply intertwined social, political, and artistic histories of the region.

Plate 73. Pierre Verger (French, 1902–1996, active in Brazil), *Fiestas y danzas en el Cuzco y en los Andes* (Festivities and dances in Cuzco and the Andes, Peru), 1945. Buenos Aires: Sudamericana; photo book, open: 25.5 x 41 cm. Collection of Marcelo Brodsky

20. Ilave (Puno, Perú) 21. Ilave (Puno, Perú)

the women spinning like tops, displaying layer upon layer of brightly coloured petticoats, las mujeres que giran como trompos poniendo a la vista sus sobrepuestas faldas de llamativos colores les femmes qui tournent comme des toupies, montrant leurs jupes superposées aux couleurs vives

2. Rosaspata (Puno, Perú) 3. Rosaspata (Puno, Perú)

It comes forth like the dawn, into the uncertain light of day veiled by the smoke and vapours of the early morning booths, where food and hot drinks are sold. Cold stalks on the high mountain and shoulders are wrapped in long ponchos, Brota como el alba, a la indecisa luz del día velada por comidas y bebidas calientes, el frío en la alta montaña los humos y vapores de los tempraneros puestos con sus hombres embozados de largos "ponchos", s'étendant comme l'aube, à la lumière indécise du jour, voilée par les fumées et les vapeurs matinales des postes où l'on distribue nourriture et boissons chaudes, le froid, en haute montagne, avec les hommes emmitouflés dans de longs "ponchos",

172

173

CALLE BERNARDO DE IRIGOYEN AL 300. (OESTE)

CALLE VICTORIA, ESQUINA SAN JOSÉ. (SUD)

Plate 74. Horacio Coppola (Argentine, 1906–2012), *Buenos Aires 1936: Cuarto centenario de su fundación* (Buenos Aires 1936: Fourth centennial of its foundation), 1936. Buenos Aires: Edición de la Municipalidad de Buenos Aires; photo book, open: 32 x 46 cm; closed: 32 x 24 x 1.3 cm. Collection of Marcelo Brodsky

Plate 75. Enrique Bostelmann (Mexican, 1939–2003), *América: Un viaje a través de la injusticia* (America: A journey through injustice), 1970 (2nd ed., 2007). Mexico: Siglo XXI Editores; photo book, open: 20 x 55 cm; closed: 20 x 27 x 1.4 cm. Private collection

II Al principio fue el Alarife, el hombre de la plomada y del mortero, de cuyo temprano paso al Nuevo Mundo queda constancia en los asientos de Pasajeros a Indias de la Casa de la Contratación de Sevilla. (Seis habían pasado ya a la Isla Española, antes de que se iniciara la colonización de Cuba.) De ahí que, independientemente de aquella Habana anterior a La Habana que —según se dice— alzaron unos cuantos colonos en las orillas del río Almendares, hemos de buscar el verdadero núcleo generador de la ciudad en aquellos humildes y graciosos vestigios que aún perduran en uno de los patios del antiguo Convento de Santa Clara, cerca de las clá-

Plate 76. Photos by Paolo Gasparini (born 1934, Gorizia, Italy; lives and works in Caracas, Venezuela); text by Alejo Carpentier (Cuban, 1904–1980), *La ciudad de las columnas* (City of columns), 1970. Barcelona: Editorial Lumen; photo book, open: 22.4 x 43.5 cm.

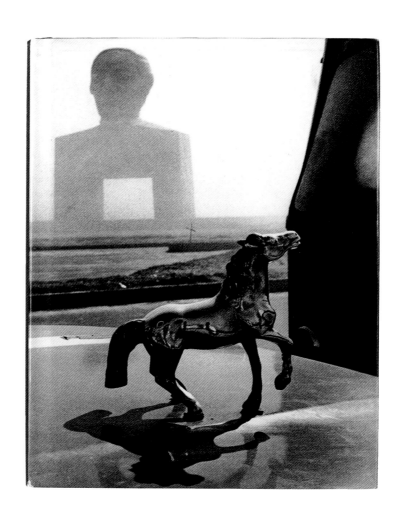

Plate 77. Pablo Ortiz Monasterio, *La última ciudad* (The last city), 1996. Mexico City: Casa de las Imágenes; photo book, open: 25 x 38.5 cm; closed: 25 x 18.4 x 1.7 cm. Collection of Marcelo Brodsky

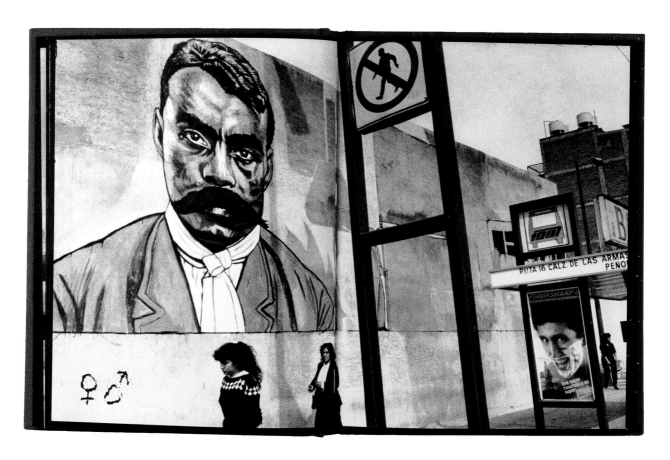

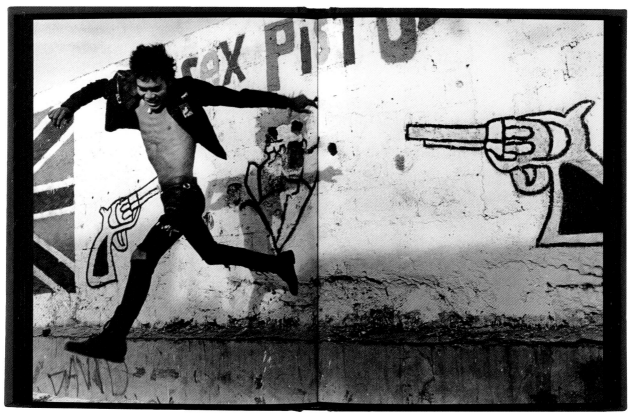

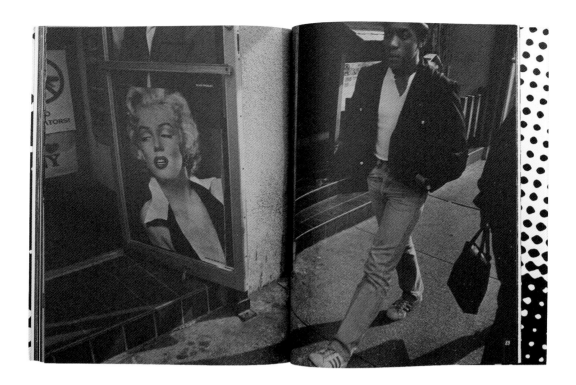

Plate 78. Paolo Gasparini, *Retromundo* (Retro world), 1986. Caracas, Venezuela:
Grupo Ed. Alter Ego; photo book, open: 35 x 52.5 cm.
Collection of Marcelo Brodsky

Plate 79. Bob Wolfenson (born 1954, São Paulo; lives and works in São Paulo), *Encadernação dourada / antifachada* (Golden binding / anti-facade), 2004. São Paulo: Cosac & Naify; photo book, open: 30.2 x 48 cm. Collection of Marcelo Brodsky

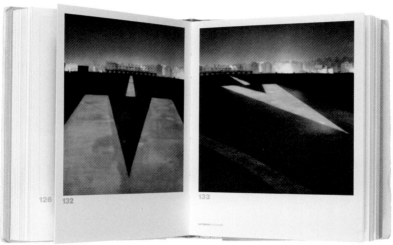

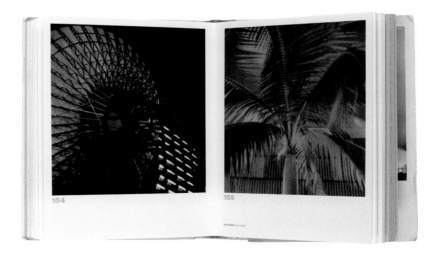

Plate 80. Cássio Vasconcellos (born 1965, São Paulo; lives and works in São Paulo), *Noturnos* (Nocturnes) *São Paulo*, 2002. São Paulo: Bookmark; photo book, open: 17.5 x 30.5 cm; closed: 17.5 x 14 x 3.2 cm. Collection of Marcelo Brodsky

Plate 81. Facundo de Zuviría (born 1954, Buenos Aires; lives and works in Buenos Aires), *Siesta argentina* (Argentine siesta), 2003. Buenos Aires: Ediciones Larivière; photo book, open: 18.5 x 612 cm; closed: 18.5 x 24.9 x 1.6 cm. Collection of Marcelo Brodsky

Visual Correspondences

What is a dialogue or correspondence? What happens when a dialogue or correspondence involves the exchange of images? What happens, in other words, when the ritual of sending images is superimposed onto that of the epistolary exchange? Marcelo Brodsky's *Visual Correspondences* project (2006–10) includes exchanges between Brodsky and the Catalonian photographer Manel Esclusa, the Mexican photographer Pablo Ortiz Monasterio, the Brazilian photographer Cássio Vasconcellos, the English photographer Martin Parr, and the German artist Horst Hoheisel. Each correspondence consisted of a series of images e-mailed between Brodsky and his interlocutors, in which each photographer and artist would reply to the image he received, often in terms of the figures, forms, colors, or other elements of the image. Together, the correspondences raise timely questions about the possibilities of cultural and visual exchange in our digital age, the nature of communication and correspondence, and the circulation of images in general.

Esclusa

Brodsky

Plate 82. Manel Esclusa (born 1952, Vic, Spain; lives and works in Barcelona) and Marcelo Brodsky (born 1954, Buenos Aires; lives and works in Buenos Aires), Photographs 6 and 7 of 40 in *Visual Correspondences /* *Correspondencias visuales: Manel Esclusa–Marcelo Brodsky,* **2006–10. Courtesy of the artists**

Parr

Brodsky

Parr

Brodsky Parr Brodsky

Plate 83. Martin Parr (born 1952, Epsom, UK; lives and works in Bristol, UK) and
Marcelo Brodsky, Photographs 12 to 17 of 30 in *Visual Correspondences / Correspondencias visuales:
Martin Parr–Marcelo Brodsky*, 2007–8. Courtesy of the artists

Ortiz Monasterio

Brodsky

Ortiz Monasterio

Brodsky

Ortiz Monasterio

Brodsky

Ortiz Monasterio

Plate 84. Pablo Ortiz Monasterio and Marcelo Brodsky, Photographs 24 to 30 of 30 in *Visual Correspondences /
Correspondencias visuales: Pablo Ortiz Monasterio–Marcelo Brodsky*, 2007–8. Courtesy of the artists

Itinerant Archives

This sequence comprises photographs that reappropriate archival images or technologies, including older photographic processes, or reference or cite other photographs or mediums, as when Toni Catany produces an homage to Paul Strand, when RES evokes Borges's story "The Aleph," when Florencia Blanco takes photographs of domestic painted photographs, or when Bruno Dubner turns to the photogram in order to record his explorations of the darkroom. Citation is at times a way of mobilizing the dormant political meanings inhabiting the recycled photograph, resurrecting or defying its original function, as when Susan Meiselas installs a reproduction of a picture that she took twenty-five years earlier, in 1978, during the Nicaraguan revolution, in the same place where it was taken. Like many of the photographs in the exhibition, these works meditate on the nature of the photographic archive in general and on the relation between different stages in photography's history.

Plate 85. Manel Esclusa, *Naufragi* (Shipwreck), 1984 (printed later). Chromogenic print, 29.5 x 28.5 cm. Private collection

Plate 86. Florencia Blanco (born 1971, Montpellier, France; lives and works in Buenos Aires),
Anonymous Photograph (Chacarita Cemetery, Buenos Aires), from *Painted Photos Series*, 2008.
Archival inkjet print on archival paper, 60 x 60 cm. Courtesy of the artist

Plate 87. Florencia Blanco, *Lucas (San Miguel del Monte)*, from *Painted Photos Series*, 2008.
Archival inkjet print on archival paper, 60 x 60 cm. Courtesy of the artist

Plate 88. Marcelo Brodsky, *La camiseta* (The undershirt), 1979 (printed 2012).
LAMBDA digital photographic print, 62 x 53.5 cm. Courtesy of the artist

Plate 89. Susan Meiselas, Still from *Reframing History*, 2004 (printed 2013).
Chromogenic print, 60.5 x 76.2 cm. Courtesy of the artist

Reframing History is a Nicaragua-based mural project utilizing the original photographs taken during the 1978 popular insurrection against Somoza. This mural was installed at the "Cuesta del Plomo," a hillside outside Managua that was a well-known site of many assassinations carried out by the National Guard.

Plate 90. Toni Catany (born 1942, Llucmajor, Spain; lives and works in Barcelona),
1-Mèxic: Homenatge a Paul Strand (Tribute to Paul Strand), 2008. Gelatin silver print,
16.5 x 22 cm. Collection Foto Colectania Foundation, Barcelona (Núm reg. 2681)

OVERLEAF: Plate 91. Esteban Pastorino Díaz (born 1972, Buenos Aires; lives and works in Madrid),
Municipalidad de Carhué (Carhué Town Hall, Buenos Aires Province, Argentina), 2012,
from the series *Salamone*. Gum print on watercolor paper, 64 x 80 cm. Courtesy of the artist

Plate 92. Gian Paolo Minelli (born 1968, Geneva; lives and works in Buenos Aires), *Chicas* (Girls), from
Zona Sur—Barrio Piedra Buena, 2003. Chromogenic prints (diptych), 100 x 120 cm each. Courtesy of the artist

Plate 93. Gian Paolo Minelli, *Cité Desnos #51*, 2010. Chromogenic print,
100 x 140 cm. Courtesy of the artist

Plate 94. RES (born 1957, Córdoba, Argentina; lives and works in Buenos Aires), *Arrabal de Buenos Aires*
(Buenos Aires outskirts), from the series *J. L. Borges o el enloquecimiento de la esfera de Pascal*
(J. L. Borges or the maddening of Pascal's sphere), 1996. Gelatin silver print, 40 x 50 cm. Courtesy of the artist

Plate 95. Cássio Vasconcellos, *Múltiplos: É NÓIS (personas)* (Multiples: It is us [people]), 2011.
Inkjet print from a digital file, exhibition copy, 130 x 112.5 cm. Courtesy of the artist

Plate 96. Cássio Vasconcellos, *Vidal de Negreiros—Ilha Bela*, 1988.
Gelatin silver print, 34.2 x 51.4 cm. Courtesy of the artist

Plate 97. Rosângela Rennó (born 1962, Belo Horizonte, Brazil; lives and works in Rio de Janeiro),
A Última Foto / The Last Photo: Eduardo Brandão Holga 120, 2006. Framed color photograph and Holga 120s camera
(diptych), print: 78 x 78 x 9.5 cm; camera: 14.8 x 21.9 x 10 cm. Collection of Jorge G. Mora

Plate 98. Bruno Dubner (born 1978, Buenos Aires; lives and works in Buenos Aires),
Untitled, 2009, from the series *Testimonio de un contacto* (Testimony of a contact), 2007–10.
Cameraless chromogenic print, 130 x 100 cm. Courtesy of the artist

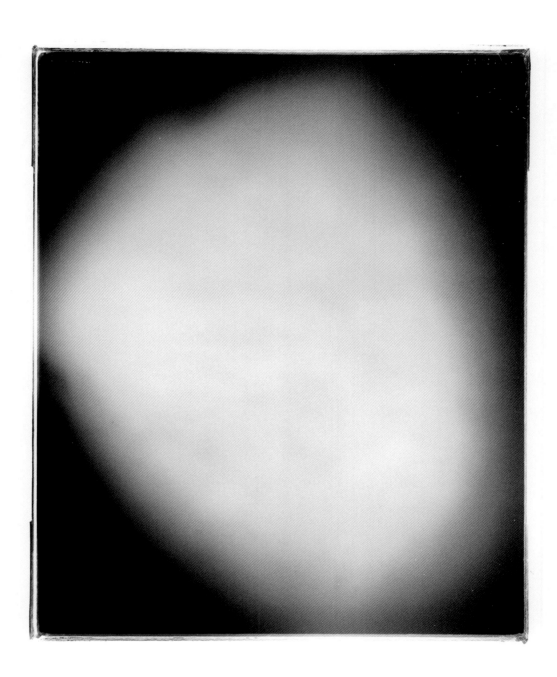

Works in the Exhibition

Lola Alvarez Bravo (Mexican, 1907–1993)
El sueño de los pobres 1 (The sleep of the poor;
or, The poor people's dream 1), 1949
Gelatin silver print, 17.1 x 23.6 cm
Lola Alvarez Bravo Archive, Center for Creative
Photography, University of Arizona (93.6.33)
(Plate 41)

Manuel Alvarez Bravo (Mexican, 1902–2002)
Dos pares de piernas (Two pairs of legs), 1928–29
Gelatin silver print, 23.2 x 18.3 cm
Princeton University Art Museum, Gift of Frederick M.
and Elizabeth Myers (x1981-78)
(Plate 47)

Obrero en huelga, asesinado (Striking worker, assassinated)
(portfolio #13), 1934
Gelatin silver print, 18.8 x 24.5 cm
Princeton University Art Museum, Gift of Mr. and
Mrs. Gerald Levine (x1991-257.10)
(Plate 43)

Señor de Papantla (The man from Papantla), 1934–35
Gelatin silver print, 18.2 x 13.6 cm
Princeton University Art Museum, Gift of Frederick M.
and Elizabeth Myers (x1979-137)
(Plate 48)

Luz restirada (Lengthened light), 1944 (printed 1977)
Gelatin silver print, 24.1 x 17.6 cm
Princeton University Art Museum, Gift of Frederick M.
and Elizabeth Myers (x1979-133)
(Plate 45)

El umbral (Threshold), 1947
Gelatin silver print, 24.3 x 19.4 cm
Princeton University Art Museum, Gift of Frederick M.
and Elizabeth Myers (x1981-82)
(Plate 46)

Michele Amodio (Italian, active ca. 1850–ca. 1880)
*Pompeii (Italy): Human Cast, Pregnant Woman,
Excavations*, 1868 (printed 1873)
Albumen print, 19.2 x 24.1 cm
D. Thereza Christina Maria Collection, Archive of the
National Library Foundation, Brazil
(Plate 4)

Florencia Blanco (born 1971, Montpellier, France;
lives and works in Buenos Aires)
Anonymous Photograph (Chacarita Cemetery, Buenos Aires),
from *Painted Photos Series*, 2008
Archival inkjet print on archival paper, 60 x 60 cm
Courtesy of the artist
(Plate 86)

Lucas (San Miguel del Monte), from *Painted Photos Series*, 2008
Archival inkjet print on archival paper, 60 x 60 cm
Courtesy of the artist
(Plate 87)

Samuel Boote (Argentine, 1844–1921)
*South American Continental Exhibition, Brazilian Section,
Buenos Aires, Argentina*, 1882
Albumen print, 27.9 x 36 cm
D. Thereza Christina Maria Collection, Archive of the National
Library Foundation, Brazil
(Plate 6)

Enrique Bostelmann (Mexican, 1939–2003)
América: Un viaje a través de la injusticia (America:
A journey through injustice), 1970 (2nd ed., 2007)
Mexico: Siglo XXI Editores
Photo book, open: 20 x 55 cm; closed: 20 x 27 x 1.4 cm
Private collection
(Plate 75)

Hugo Brehme (1882–1954, born in Germany, active in Mexico)
Zapata Cuernavaca, 1911
Inkjet print from a digital file, exhibition copy, 12.7 x 17.8 cm
Fondo Casasola, SINAFO-Fototeca Nacional del INAH (Inv. #5672)

Xochimilco, D.F., ca. 1920
Gelatin silver print (postcard), 8.3 x 13.3 cm
Princeton University Art Museum, Gift of Forrest D. Colburn
(2006-445)
(Plate 23)

Hugo Brehme (?)
Emiliano Zapata with Rifle, Sash, and Saber, Cuernavaca, June 1911
Inkjet print from a digital file, exhibition copy, 25.4 x 17.8 cm
Fondo Casasola, SINAFO-Fototeca Nacional del INAH (Inv. #63464)
(Plate 31)

Marcelo Brodsky (born 1954, Buenos Aires;
lives and works in Buenos Aires)
La camiseta (The undershirt), 1979 (printed 2012)
LAMBDA digital photographic print, 62 x 53.5 cm
Courtesy of the artist
(Plate 88)

Visual Correspondences / Correspondencias visuales, 2006–10
With Manel Esclusa (born 1952, Vic, Spain; lives and works in
Barcelona); Horst Hoheisel (born 1944, Poznań, Poland; lives and
works in Kassel, Germany); Pablo Ortiz Monasterio (born 1952,
Mexico City; lives and works in Mexico City); Martin Parr (born
1952, Epsom, UK; lives and works in Bristol, UK); and Cássio
Vasconcellos (born 1965, São Paulo; lives and works in São Paulo)
Digital images displayed on dual monitors
Courtesy of the artists
(Plates 82–84)

Henri Cartier-Bresson (French, 1908–2004)
Mexico City, 1934
Gelatin silver print, 26.5 x 39.5 cm
Princeton University Art Museum, Gift of Elliott J. Berv,
Portland, Maine (x1977-94)
(Plate 42)

Miguel Casasola (?)
*Government Minister José Ives Limantour (Shaded by Umbrella)
in Mexico City for the Opening of the Works to Bring Drinking
Water from Xochimilco*, March 18, 1910
Inkjet print from a digital file, exhibition copy, 14.3 x 20.3 cm
Fondo Casasola, SINAFO-Fototeca Nacional del INAH
(Inv. #35001)
(Plate 24)

Juan Manuel Castro Prieto (born 1958, Madrid;
lives and works in Madrid)
Sombras a cuchillo (Shadows made with a knife), *Sipán,
Perú*, 1999
Gelatin silver print, 46 x 57 cm
Collection Foto Colectania Foundation, Barcelona (Núm reg. 103)
(Plate 65)

Toni Catany (born 1942, Llucmajor, Spain;
lives and works in Barcelona)
1-Mèxic: Homenatge a Paul Strand (Tribute to Paul Strand), 2008
Gelatin silver print, 16.5 x 22 cm
Collection Foto Colectania Foundation, Barcelona (Núm reg. 2681)
(Plate 90)

Joan Colom (born 1921, Barcelona; lives in Barcelona)
Gente de Raval (People of the Raval), ca. 1958 (printed later)
Gelatin silver print, 43 x 33 cm
Collection Foto Colectania Foundation, Barcelona (Núm reg. 2011)
(Plate 61)

Gente de la calle (People on the street), 1958–64
Gelatin silver print, 23 x 17 cm
Collection Foto Colectania Foundation, Barcelona (Núm reg. 185)
(Plate 57)

Gente de la calle (People on the street), 1958–64
Gelatin silver print, 26 x 18 cm
Collection Foto Colectania Foundation, Barcelona (Núm reg. 187)
(Plate 58)

Gente de la calle (People on the street), 1958–64
Gelatin silver print, 23.3 x 11.9 cm
Collection Foto Colectania Foundation, Barcelona (Núm reg. 1536)
(Plate 59)

Gente de la calle (People on the street), 1958–64
Gelatin silver print, 24 x 18.5 cm
Collection Foto Colectania Foundation, Barcelona (Núm reg. 179)
(Plate 62)

Fiesta Mayor, 1960
Gelatin silver print, 40 x 30 cm
Collection Foto Colectania Foundation, Barcelona (Núm reg. 189)
(Plate 60)

Horacio Coppola (Argentine, 1906–2012)
Buenos Aires 1936: Cuarto centenario de su fundación
(Buenos Aires 1936: Fourth centennial of its foundation), 1936
Buenos Aires: Edición de la Municipalidad de Buenos Aires
Photo book, open: 32 x 46 cm; closed: 32 x 24 x 1.3 cm
Collection of Marcelo Brodsky
(Plate 74)

H. Delie and **E. Bechard** (French, active 1870s)
*Brazilian Emperor D. Pedro II, Empress D. Thereza Christina, and
the Emperor's Retinue next to the Pyramids, Cairo, Egypt*, 1871
Albumen print, 19.8 x 26.3 cm
D. Thereza Christina Maria Collection, Archive of the National
Library Foundation, Brazil
(Plate 3)

Bruno Dubner (born 1978, Buenos Aires; lives and works in
Buenos Aires)
Untitled, 2009, from the series *Testimonio de un contacto*
(Testimony of a contact), 2007–10
Cameraless chromogenic print, 130 x 100 cm
Courtesy of the artist
(Plate 98)

Manel Esclusa (born 1952, Vic, Spain;
lives and works in Barcelona)
Naufragi (Shipwreck), 1984 (printed later)
Chromogenic print, 29.5 x 28.5 cm
Private collection
(Plate 85)

Marc Ferrez (Brazilian, 1843–1923)
Itapuca Rock, Rio de Janeiro, ca. 1876
Albumen print, 20 x 27 cm
Gilberto Ferrez Collection, Instituto Moreira Salles Archive, Brazil
(Plate 15)

The Market and Saint Francis Church by the Brazilian Colonial Sculptor and Architect Aleijadinho, Ouro Preto, ca. 1880 (printed later)
Gelatin silver print, 18 x 23 cm
Gilberto Ferrez Collection, Instituto Moreira Salles Archive, Brazil
(Plate 19)

Soil Preparation for the Construction of the Railroad Tracks, Paranaguá-Curitiba Railroad, Paraná, ca. 1882 (printed later)
Gelatin silver print, 23 x 29 cm
Gilberto Ferrez Collection, Instituto Moreira Salles Archive, Brazil
(Plate 20)

Araucárias, Paraná, ca. 1884 (printed later)
Gelatin silver print, 29 x 39 cm
Gilberto Ferrez Collection, Instituto Moreira Salles Archive, Brazil
(Plate 16)

Entrance to Guanabara Bay, ca. 1885
Albumen print, 18 x 35 cm
Gilberto Ferrez Collection, Instituto Moreira Salles Archive, Brazil
(Plate 14)

Naturalist and Mining Engineer Paul Ferrand in the Itacolomy Mountains, Ouro Preto, ca. 1886 (printed later)
Gelatin silver print, 18 x 24 cm
Gilberto Ferrez Collection, Instituto Moreira Salles Archive, Brazil
(Plate 17)

Botanical Gardens, Rio de Janeiro, ca. 1890 (printed later)
Gelatin silver print, 17 x 23 cm
Gilberto Ferrez Collection, Instituto Moreira Salles Archive, Brazil
(Plate 18)

View of the Peak Pão de Açúcar, Rio de Janeiro, ca. 1915
Autochrome, exhibition copy, 10 x 12 cm
Gilberto Ferrez Collection, Instituto Moreira Salles Archive, Brazil
(Plate 21)

Joan Fontcuberta (born 1955, Barcelona; lives and works in Barcelona)
Googlegram: Niépce, 2005
Inkjet print from a digital file, exhibition copy, 120 x 160 cm
Courtesy of the artist
(Plate 1)

Paolo Gasparini (born 1934, Gorizia, Italy; lives and works in Caracas, Venezuela)
Retromundo (Retro world), 1986
Caracas: Grupo Ed. Alter Ego
Photo book, open: 35 x 52.5 cm; closed: 35 x 26.7 x 1.3 cm
Collection of Marcelo Brodsky
(Plate 78)

Eduardo Gil (born 1948, Buenos Aires; lives and works in Buenos Aires)
Siluetas y cana (Silhouettes and cops), September 21–22, 1983, from the series *El siluetazo* (The silhouette action), Buenos Aires, 1982–83
Gelatin silver print, 31 x 50 cm
Courtesy of the artist
(Plate 68)

Prosper-Mathieu Henry (French, 1849–1903) and **Paul-Pierre Henry** (French, 1848–1905)
Part of the Milky Way, Paris Observatory, June 10, 1885
Albumen print, 26.3 x 22 cm
D. Thereza Christina Maria Collection, Archive of the National Library Foundation, Brazil
(Plate 8)

Gerónimo Hernández (?) (Mexican, 1878–1955)
Soldaderas on a Train Platform in the Buenavista Station, Mexico City, April 1912
Inkjet print from a digital file, exhibition copy, 14.3 x 20.3 cm
Fondo Casasola, SINAFO-Fototeca Nacional del INAH
(Inv. #5670)
(Plate 30)

José Hernández-Claire (born 1949, Guadalajara, Mexico; lives and works in Guadalajara)
La mirada (The look), 1990
Inkjet print from a digital file, exhibition copy, 17.8 x 12 cm
Courtesy of the artist
(Figure 32)

Joaquim Insley Pacheco (Portuguese, ca. 1830–1912)
Pedro II, Emperor of Brazil, Rio de Janeiro, 1883
Platinum print, 37.5 x 29.2 cm
D. Thereza Christina Maria Collection, Archive of the National Library Foundation, Brazil
(Plate 2)

Graciela Iturbide (born 1942, Mexico City; lives and works in Coyoacán, Mexico)
Mujer ángel, Desierto de Sonora, México (Angel woman, Sonoran Desert, Mexico), 1979 (printed later)
Gelatin silver print, 24.8 x 33 cm
Private collection
(Plate 70)

Jano (Janus), *Ocumichu, Michoacán*, 1981
Gelatin silver print, 32.1 x 20.9 cm
Princeton University Art Museum, Gift of Douglas C. James, Class of 1962 (1999-185)
(Plate 49)

Cholos, Harpys, East L.A., 1986 (printed 1990)
Gelatin silver print, 40.6 x 50.8 cm
Courtesy of the artist
(Plate 69)

Cementerio (Cemetery), *Juchitán, Oaxaca*, 1988
Gelatin silver print, 32.2 x 22 cm
Princeton University Art Museum, Gift of Douglas C. James,
Class of 1962 (1999-3)
(Plate 52)

Pájaros en el poste de luz, Carretera a Guanajuato (Birds on
light pole, Road to Guanajuato), Mexico, 1990 (printed 2013)
Gelatin silver print, 40.6 x 50.8 cm.
Courtesy of the artist
(Plate 53)

El baño de Frida Kahlo (Frida Kahlo's bathroom), 2011
Barcelona: RM
Photo book, open: 22.2 x 34.2 cm; closed: 17.1 x 22.2 x 1.2 cm
Private collection

Revert Henrique Klumb (ca. 1830s–ca. 1886, born in Germany,
active in Brazil)
Cascatinha Waterfall Retreat, Petrópolis, Rio de Janeiro, 1865
Albumen print, 30 x 24 cm
Gilberto Ferrez Collection, Instituto Moreira Salles Archive, Brazil
(Plate 11)

Petrópolis's Cemetery, Petrópolis, Rio de Janeiro, 1870
Albumen print, 24 x 30 cm
Gilberto Ferrez Collection, Instituto Moreira Salles Archive, Brazil
(Plate 13)

Cascatinha, Petrópolis, Rio de Janeiro, ca. 1870
Albumen print, 30 x 24 cm
Gilberto Ferrez Collection, Instituto Moreira Salles Archive, Brazil
(Plate 10)

*Petrópolis's Mountain Range (Night View), Petrópolis, Rio de
Janeiro*, ca. 1870
Albumen print, 24 x 30 cm
Gilberto Ferrez Collection, Instituto Moreira Salles Archive, Brazil
(Plate 9)

Quitandinha River, Petrópolis, Rio de Janeiro, ca. 1870
Albumen print, 24 x 30 cm
Gilberto Ferrez Collection, Instituto Moreira Salles Archive, Brazil
(Plate 12)

Víctor León (born 1953, Mexico City;
lives and works in Xalapa, Mexico)
No habrá huelga general (There will be no general strike), 1979
Inkjet print from a digital file, exhibition copy, 11.7 x 17.8 cm
Courtesy of the artist
(Figure 34)

Nacho López (Mexican, 1923–1986)
La Venus se fue de juerga por los barrios bajos (Venus went
partying in the poor neighborhoods), 1953
Inkjet print from a digital file, exhibition copy, 16.5 x 25.4 cm
SINAFO-Fototeca Nacional del INAH (Inv. #405623)
(Plate 63)

La Venus se fue de juerga por los barrios bajos (Venus went
partying in the poor neighborhoods), 1953
Inkjet print from a digital file, exhibition copy, 16.5 x 25.4 cm
SINAFO-Fototeca Nacional del INAH (Inv. #405641)
(Plate 64)

Hermanos Mayo (active in Spain and Mexico 1931–82)
*Untitled (David Alfaro Siqueiros Painting a Mural from a
Mayo Photo)*, 1959
Gelatin silver print, 12.7 x 17.8 cm
Collection of John Mraz
(Figure 37)

Julio Mayo (Julio Souza Fernández, born 1917, La Coruña,
Spain; lives in Mexico)
Untitled (Mother and Dead Son), 1952
Gelatin silver print, 12.7 x 17.8 cm
Collection of John Mraz
(Figure 36)

José Medeiros (Brazilian, 1921–1990)
*Pátio do Palácio Gustavo Capanema, antigo Ministério da
Educação* (Courtyard of the Gustavo Capanema Palace,
former Ministry of Education), *Rio de Janeiro, Brasil*, 1960
Gelatin silver print, 30 x 40 cm
Instituto Moreira Salles Collection, Brazil
(Plate 55)

Elsa Medina (born 1952, Mexico City;
lives and works in Mexico City)
El migrante (The migrant), *Cañon Zapata, Tijuana,
Baja California, México*, 1987 (printed 2011)
Gelatin silver print, 21.2 x 32 cm
Princeton University Art Museum, Museum purchase,
David L. Meginnity, Class of 1958, Acquisition Fund (2012-97)
(Plate 71)

*Presidente Carlos Salinas and Secretary of Agrarian Reform
Víctor Cervera Pacheco at the Presidential Residence,
"Los Pinos," in a Meeting with Campesino Organizations
to Reform Article 27 of the Constitution*, Mexico City, 1991
Inkjet print from a digital file, exhibition copy, 17.8 x 11.7 cm
Courtesy of the artist
(Figure 29)

Susan Meiselas (born 1948, Baltimore;
lives and works in New York City)
*Soldiers Searching Bus Passengers along the
Northern Highway, El Salvador*, 1980 (printed 2013)
Gelatin silver print, 20 x 30 cm
Courtesy of the artist
(Plate 67)

Still from *Reframing History*, 2004 (printed 2013)
Chromogenic print, 60.5 x 76.2 cm
Courtesy of the artist
(Plate 89)

Enrique Metinides (born 1934, Mexico City; lives and works in Mexico City)
Rescate de un ahogado en Xochimilco con público reflejado en el agua (Retrieval of a drowned person in Lake Xochimilco with the public reflected in the water), 1960 (printed 2006)
Gelatin silver print, 35 x 52.8 cm
Princeton University Art Museum, Museum purchase, David L. Meginnity, Class of 1958, Fund (2007-92)
(Plate 44)

Pedro Meyer (born 1935, Madrid, lives and works in Mexico City)
Sandino, Estelí, Nicaragua, 1984
Inkjet print on cotton paper, 31.9 x 48.1 cm
Courtesy of the artist
(Plate 66)

Gian Paolo Minelli (born 1968, Geneva; lives and works in Buenos Aires)
Chicas (Girls), from *Zona Sur—Barrio Piedra Buena*, 2003
Chromogenic prints (diptych), 100 x 120 cm each
Courtesy of the artist
(Plate 92)

Cité Desnos #51, 2010
Chromogenic print, 100 x 140 cm
Courtesy of the artist
(Plate 93)

Xavier Miserachs (Spanish, 1937–1998)
Via Laietana, Barcelona, 1962
Gelatin silver print, 24 x 30 cm
Collection Foto Colectania Foundation, Barcelona (Núm reg. 192)
(Plate 56)

Tina Modotti (1896–1942, born in Italy, active in Mexico)
Printed by Richard Benson (American, born 1943)
Untitled, 1923–30 (printed 1976)
Palladium print, 24 x 18.9 cm.
The Museum of Modern Art, Courtesy of Isabel Carbajal Bolandi (SC 1976.252)
(Plate 39)

Workers' Parade, 1926
Gelatin silver print, 21.5 x 18.6 cm
The Museum of Modern Art, New York, Anonymous gift (95.1964)
(Plate 40)

Eustasio Montoya (Mexican, active early 20th century)
Photographers and a Dead Man in Nuevo León after Being Attacked by Huertistas, July 5, 1913
Inkjet print from a digital file, exhibition copy, 16.5 x 20.3 cm
Archive González Garza, Universidad Panamericana
(Plate 29)

Charles Moussette
Four Series of High-Voltage Sparks from a Holtz Electric Machine, Paris, 19th century
Albumen print, 18.2 x 13.1 cm
D. Thereza Christina Maria Collection, Archive of the National Library Foundation, Brazil
(Plate 7)

Riza Niru
No habrá huelga general (There will be no general strike), 1989
Photomontage, 20.3 x 15.2 cm
Collection of John Mraz
(Figure 35)

Pablo Ortiz Monasterio (born 1952, Mexico City; lives and works in Mexico City)
Y es plata, cemento o brisa (And it is silver, cement, or breeze), ca. 1985
Gelatin silver print, 27.9 x 35.6 cm
Courtesy of the artist
(Plate 72)

D.F., 1987
Gelatin silver print, 30.5 x 45.7 cm
Courtesy of the artist
(Plate 54)

La última ciudad (The last city), 1996
Mexico City: Casa de las Imágenes
Photo book, open: 25 x 38.5 cm; closed: 25 x 18.4 x 1.7 cm
Collection of Marcelo Brodsky
(Plate 77)

Vincenzo Pastore (1865–1918, born in Italy, active in Brazil)
Group of People around a Peddler Playing a Barrel Organ in the Square of the Republic, São Paulo, ca. 1910
Gelatin silver print, 9 x 12 cm
Instituto Moreira Salles Collection, Brazil
(Plate 22)

Esteban Pastorino Díaz (born 1972, Buenos Aires; lives and works in Madrid)
Municipalidad de Carhué (Carhué Town Hall, Buenos Aires Province, Argentina), 2012, from the series *Salamone*
Gum print on watercolor paper, 64 x 80 cm
Courtesy of the artist
(Plate 91)

Rosângela Rennó (born 1962, Belo Horizonte, Brazil; lives and works in Rio de Janeiro)
A Última Foto / The Last Photo: Eduardo Brandão Holga 120, 2006
Framed color photograph and Holga 120s camera (diptych), print: 78 x 78 x 9.5 cm; camera: 14.8 x 21.9 x 10 cm
Collection of Jorge G. Mora
(Plate 97)

RES (born 1957, Córdoba, Argentina;
lives and works in Buenos Aires)
Arrabal de Buenos Aires (Buenos Aires outskirts), from the
series *J. L. Borges o el enloquecimiento de la esfera de Pascal*
(J. L. Borges or the maddening of Pascal's sphere), 1996
Gelatin silver print, 40 x 50 cm
Courtesy of the artist
(Plate 94)

Paul Strand (American, 1890–1976)
Boy, Hidalgo, 1933 (printed 1967)
Photogravure, 16 x 12.4 cm
Princeton University Art Museum, Gift of David H. McAlpin,
Class of 1920 (x1971-335 n)
(Plate 50)

Church—Coapiaxtla, 1933 (printed 1967)
Photogravure, 16.1 x 12.4 cm
Princeton University Art Museum, Gift of David H. McAlpin,
Class of 1920 (x1971-335 b)
(Plate 51)

Cássio Vasconcellos (born 1965, São Paulo;
lives and works in São Paulo)
Vidal de Negreiros—Ilha Bela, 1988
Gelatin silver print, 34.2 x 51.4 cm
Courtesy of the artist
(Plate 96)

Noturnos (Nocturnes) *São Paulo*, 2002
São Paulo: Bookmark
Photo book, open: 17.5 x 30.5 cm; closed: 17.5 x 14 x 3.2 cm
Collection of Marcelo Brodsky
(Plate 80)

Múltiplos: É NÓIS (personas) (Multiples: It is us [people]), 2011
Inkjet print from a digital file, exhibition copy, 130 x 112.5 cm
Courtesy of the artist
(Plate 95)

Pierre Verger (French, 1902–1996, active in Brazil)
Fiestas y danzas en el Cuzco y en los Andes (Festivities
and dances in Cuzco and the Andes, Peru), 1945
Buenos Aires: Sudamericana
Photo book, open: 25.5 x 41 cm; closed: 25.5 x 19.7 x 3 cm
Collection of Marcelo Brodsky
(Plate 73)

Bob Wolfenson (born 1954, São Paulo;
lives and works in São Paulo)
Encadernação dourada / antifachada (Golden binding /
anti-facade), 2004
São Paulo: Cosac & Naify
Photo book and 10 posters, book open: 30.2 x 48 cm;
closed: 30.2 x 26.7 x 3.8 cm; posters: dimensions variable
Collection of Marcelo Brodsky
(Plate 79)

Facundo de Zuviría (born 1954, Buenos Aires;
lives and works in Buenos Aires)
Siesta argentina (Argentine siesta), 2003
Buenos Aires: Ediciones Larivière
Photo book, open: 18.5 x 612 cm; closed: 18.5 x 24.9 x 1.6 cm
Collection of Marcelo Brodsky
(Plate 81)

Works by unidentified artists

Mastodon [skeleton], Boston, United States, June 12, 1876
Albumen print, 33.2 x 41.3 cm
D. Thereza Christina Maria Collection, Archive of the National
Library Foundation, Brazil
(Plate 5)

*Emiliano Zapata, Manuel Asúnsolo, and Other Revolutionaries
during the Surrender of Cuernavaca*, April 1911
Inkjet print from a digital file, exhibition copy, 12.7 x 17.8 cm
Fondo Casasola, SINAFO-Fototeca Nacional del INAH (Inv. #5868)

*People Fleeing from the Combat Zone during the Truce
during the Tragic Ten Days (Decena Trágica), Mexico City*,
February 16, 1913
Inkjet print from a digital file, exhibition copy, 16.1 x 20.3 cm
Fondo Casasola, SINAFO-Fototeca Nacional del INAH (Inv. #37311)
(Plate 27)

*General Jesús Carranza and Men Looking at the Destroyed
Rail Tracks*, ca. 1913
Inkjet print from a digital file, exhibition copy, 20.3 x 14.3 cm
Fondo Casasola, SINAFO-Fototeca Nacional del INAH (Inv. #32942)
(Plate 25)

*Rurales under Carlos Rincón Gallardo's Command Boarding
Their Horses on Their Way to Aguascalientes*, n.d.
Inkjet print from a digital file, exhibition copy, 14.6 x 20.3 cm
Fondo Casasola, SINAFO-Fototeca Nacional del INAH (Inv. #6345)
(Plate 26)

Troops Boarding a Train, n.d.
Inkjet print from a digital file, exhibition copy, 14.6 x 20.3 cm
Fondo Casasola, SINAFO-Fototeca Nacional del INAH (Inv. #5291)
(Plate 28)

Cover of *Frente a Frente: Organo Central de la Liga de Escritores
y Artistas Revolucionarios*, no. 3 (April 1936)
Benson Latin American Collection, University of Texas Libraries

Mexican, unknown artist
Fotoescultura portrait of a man, ca. 1940
Hand-colored gelatin silver print mounted on wood,
30.5 x 21.6 x 6.3 cm
Princeton University Art Museum, Museum purchase,
David L. Meginnity, Class of 1958, Acquisition Fund (2010-2)

Independent sex workers, September 15, 2008
Poster, 43.2 x 55.9 cm
Collection of John Mraz
(Figure 31)

Selected Bibliography

Alfredo Jaar: The Way It Is; An Aesthetics of Resistance. Berlin: RealismusStudio, Neue Gesellschaft für bildende Kunst, 2012.

Amelunxen, Hubertus von. "Photography after Photography: The Terror of the Body in Digital Space." HyperArt.com. http://hyperart.com/lib/ph_after_ph.html.

Andermann, Jens. *The Optic of the State: Visuality and Power in Argentina and Brazil*. Pittsburgh: University of Pittsburgh Press, 2007.

Andrade, Mário de. *O turista aprendiz*. São Paulo: Livraria Duas Cidades, 1976.

Andujar, Claudia. *Amazônia*. São Paulo: Praxis, 1978.

———. *Marcados*. São Paulo: Kosac & Naify, 2009.

Azoulay, Ariella. *The Civil Contract of Photography*. New York: Zone, 2012.

Banks, Marcus, and Richard Vokes, eds. "Introduction: Anthropology, Photography, and the Archive." *History and Anthropology* 21 (December 2010): 337–49.

Barthes, Roland. *Camera Lucida: Reflections on Photography*. Translated by Richard Howard. New York: Farrar, Straus & Giroux, 1981.

Batchen, Geoffrey. *Burning with Desire: The Conception of Photography*. Cambridge, MA: MIT Press, 1999.

———. *Each Wild Idea: Writing, Photography, History*. Cambridge, MA: MIT Press, 2002.

Beckman, Karen, and Jean Ma, eds. *Still Moving: Between Cinema and Photography*. Durham, NC: Duke University Press, 2008.

Beckman, Karen, and Liliane Weissberg, eds. *On Writing with Photography*. Minneapolis: University of Minnesota Press, 2013.

Benjamin, Walter. "Little History of Photography." Translated by Edmund Jephcott and Kingsley Shorter. In *Selected Writings*, vol. 2, *1927–1934*, edited by Michael W. Jennings, Howard Eiland, and Gary Smith, 507–30. Cambridge, MA: Belknap Press of Harvard University Press, 1999.

———. *The Work of Art in the Age of Its Technological Reproducibility and Other Writings on Media*. Edited by Michael W. Jennings, Brigid Doherty, and Thomas Y. Levin. Cambridge, MA: Belknap Press of Harvard University Press, 2008.

Berger, John. *About Looking*. New York: Pantheon, 1980.

———. *Ways of Seeing*. New York: Viking, 1972.

Berman, Merril. *Photomontage before the War, 1918–1939*. Madrid: Fundación Juan March, 2012.

Bostelmann, Enrique. *América: Un viaje a través de la injusticia*. Mexico City: Siglo XXI, 2007.

Bourdieu, Pierre. *Photography: A Middle-Brow Art*. Translated by Shaun Whiteside. Stanford, CA: Stanford University Press, 1996.

Brizuela, Natalia. *Fotografia e empério: Paisagens para um Brasil Modern*. São Paulo: Companhia das Lettras, Instituto Moreira Salles, 2012.

Brodsky, Marcelo, *Buena memoria*. Buenos Aires: La Marca, 2007.

———. *Memory under Construction*. Buenos Aires: La Marca, 2008.

Brodsky, Marcelo, Manel Esclusa, Cássio Vasconcellos, Pablo Ortiz Monasterio, Martin Parr, and Horst Hoheisel. *Visual Correspondences / Correspondencias visuales*. Buenos Aires: La Marca, 2010.

Brunet, François. *Photography and Literature*. London: Reaktion, 2009.

Buchloh, Benjamin H. D., Jean-François Chevrier, Rainer Rochlitz, and Armin Zweite. *Photography and Painting in the Work of Gerhard Richter: Four Essays on Atlas*. 2nd ed. Barcelona: Consorci del Museu d'Art Contemporani de Barcelona, 2000.

Cadava, Eduardo. "Drawing in Tongues." In *Leon Golub: Live and Die Like a Lion*, 54–93. New York: Drawing Center, 2010.

———. *Words of Light: Theses on the Photography of History*. Princeton, NJ: Princeton University Press, 1997.

Cadava, Eduardo, with Paola Cortés-Rocca. "Notes on Love and Photography." *October*, no. 116 (Spring 2006): 3–34.

Catany, Toni. *Obscura memoria*. Barcelona: Lunwerg, 1994.

Chambi, Martín, and Juan Manuel Castro Prieto. *Perú*. Madrid: La Fábrica, 2011.

Chun, Wendy Hui Kyong, and Thomas Keenan, eds. *New Media, Old Media: A History and Theory Reader*. New York: Routledge, 2005.

Cohen, Tom. *Hitchcock's Cryptonomies*. Vol. 1, *Secret Agents*. Vol. 2, *War Machines*. Minneapolis: University of Minnesota Press, 2005.

Colom, Joan. *Raval*. Göttingen, Germany: Steidl, 2006.

Cooke, Lynne, ed. *You See I Am Here after All: Zoe Leonard*. New York: Dia Art Foundation, 2010.

Coppola, Horacio, and Facundo de Zuviria. *Buenos Aires*. Buenos Aires: Zagier & Urruty, 2012.

Cortés-Rocca, Paola. *El tiempo de la máquina*. Buenos Aires: Colihue, 2011.

Cotton, Charlotte. *The Photograph in Contemporary Art*. London: Thames & Hudson, 2009.

Debroise, Olivier. *Mexican Suite: A History of Photography in Mexico*. Translated by Stella da Sá Rego. Austin: University of Texas Press, 2001.

Derrida, Jacques. *Archive Fever: A Freudian Impression*. Translated by Eric Prenowitz. Chicago: University of Chicago Press, 1998.

———. *Athens, Still Remains: The Photographs of Jean-François Bonhomme*. Translated by Pascale-Anne Brault and Michael Naas. New York: Fordham University Press, 2010.

———. *Copy, Archive, Signature: A Conversation on Photography*. Edited by Gerhard Richter. Translated by Jeff Fort. Stanford, CA: Stanford University Press, 2010.

Didi-Huberman, Georges. *Images in Spite of All: Four Photographs from Auschwitz*. Chicago: University of Chicago Press, 2008.

Diller, Elizabeth, and Ricardo Scofidio, eds. *Back to the Front: Tourisms of War*. Caen, France: FRAC Basse-Normandie, 1994.

Doane, Mary Ann. *The Emergence of Cinematic Time: Modernity, Contingency, the Archive*. Cambridge, MA: Harvard University Press, 2002.

Druckrey, Timothy. *Electronic Culture: Technology and Visual Representation*. New York: Aperture, 1996.

Dyer, Geoff. *The Ongoing Moment*. New York: Vintage, 2007.

Easton, Elizabeth. *Snapshot: Painters and Photography, Bonnard to Vuillard*. New Haven, CT: Yale University Press, 2011.

Edwards, Elizabeth, and J. Hart. *Photographs, Objects, Histories: On the Materiality of Images*. New York: Routledge, 2004.

Enwezor, Okwui. *Archive Fever: Uses of the Document in Contemporary Art*. Göttingen, Germany: Steidl, 2009.

———. *Rise and Fall of Apartheid: Photography and the Bureaucracy of Everyday Life*. New York: International Center of Photography; Munich: DelMonico Books Prestel, 2013.

———. *Snap Judgments: New Positions in Contemporary African Photography*. New York: International Center of Photography; Göttingen, Germany: Steidl, 2008.

Esclusa, Manel. *Silencios latentes*. Barcelona: Lunwerg, 2012.

Ernst, Wolfgang. *Digital Memory and the Archive*. Minneapolis: University of Minnesota Press, 2013.

Faivovich, Guillermo, and Nicolás Goldberg. *The Campo del Cielo Meteorites*. Vol. 2, *El Chaco*. Cologne: König, 2012.

Fernández, Horacio. *The Latin American Photobook*. New York: Aperture, 2011.

Ferrez, Marc. *O Brasil de Marc Ferrez*. São Paulo: Instituto Moreira Salles, 2005.

Fineman, Mia. *Faking It: Manipulated Photography before Photoshop*. New York: Metropolitan Museum of Art, 2012.

Fontcuberta, Joan. *Fauna*. Seville: Photovision, 1999.

———. *Landscapes without Memory*. New York: Aperture, 2005.

———, ed. *Photography: Crisis of History*. Barcelona: Actar, 2002.

Foster, David William. *Urban Photography in Argentina: Nine Artists of the Post Dictatorship Era*. Jefferson, NC: McFarland, 2007.

Foster, Hal. "An Archival Impulse." *October*, no. 110 (Fall 2004): 3–22.

Flusser, Vilém. *Towards a Philosophy of Photography*. London: Reaktion, 2005.

Folgarait, Leonard. *Seeing Mexico Photographed: The Work of Horne, Casasola, Modotti, and Álvarez Bravo*. New Haven, CT: Yale University Press, 2008.

Font-Reaulx, Dominique de. *Painting and Photography, 1839–1914*. Paris: Flammarion, 2013.

Foucault, Michel. "Photogenic Painting." Translated by Dafydd Roberts. In *Gérard Fromanger: Photogenic Painting*, 82–104. London: Black Dog, 1999.

Gabara, Esther. *Errant Modernism: The Ethos of Photography in Mexico and Brazil*. Durham, NC: Duke University Press, 2008.

Geary, Christraud M., and Virginia-Lee Webb. *Delivering Views: Distant Cultures in Early Postcards*. Washington, DC: Smithsonian Institution Press, 1998.

Gitelman, Lisa. *Always Already New: Media, History, and the Data of Culture*. Cambridge, MA: MIT Press, 2008.

Grinschpun, Alejandra, and Manuel Lázaro Bendersky, eds. *Otra mirada: Buenos Aires fotografiada por los chicos que viven en sus calles / Buenos Aires Photographed by the Children Who Live in Its Streets*. Buenos Aires: Asociación Civil Los Chicos de la Calle, 2005.

Grynsztejn, Madeleine. *Alfredo Jaar: Venezia Venezia*. New York: Actar, 2013.

Harbord, Janet. *Chris Marker: La Jetée*. London: Afterall, 2009.

Harrison, Martin. *In Camera: Francis Bacon; Photography, Film, and the Practice of Painting*. London: Thames & Hudson, 2006.

Hughes, Alex, and Andrea Noble, eds. *Phototextualities: Intersections of Photography and Narrative*. Albuquerque: University of New Mexico Press, 2003.

Iturbide, Graciela. *Eyes to Fly With: Portraits, Self-Portraits, and Other Photographs*. Austin: University of Texas Press, 2006.

Iturbide, Graciela, and Mario Bellatin. *El baño de Frida Kahlo*. Barcelona: RM, 2011.

Jennings, Michael W. "Agriculture, Industry, and the Birth of the Photo-Essay in the Late Weimar Republic." *October*, no. 93 (Summer 2000): 23–56.

JR and José Parlá. *The Wrinkles of the City: Havana, Cuba*. Bologna, Italy: Damiani, 2012.

Kossoy, Boris. *Um olhar sobre O Brasil: A fotografia na construção da imagem da naçao*. Rio de Janeiro: Objetiva, Fundación Mapfre, 2012.

Kracauer, Siegfried. "Photography." In *The Mass Ornament: Weimar Essays*, ed. and trans. Thomas Y. Levin, 47–64. Cambridge, MA: Harvard University Press, 1995.

Krauss, Rosalind. *A Voyage on the North Sea: Art in the Age of the Post-Medium Condition*. London: Thames & Hudson, 2000.

Lestido, Adriana. *Madres e hijas*. Buenos Aires: La Azotea, 2003.

Lissovsky, Mauricio. *A máquina de esperar: Origem e estética da fotografia moderna*. Rio de Janeiro: Maud X, 2008.

Makarius, Sammer. *Fotohistoria argentina*. Buenos Aires: Centro de Investigaciones Históricas, 1990.

Manuel Alvarez Bravo: Photopoetry. San Francisco: Chronicle, 2008.

Massota, Carlos. *Indios en las primeras postales fotográficas argentinas del siglo XX*. Buenos Aires: La Marca, 2007.

———. *Paisajes en las primeras postales fotográficas argentinas del siglo XX*. Buenos Aires: La Marca, 2007.

Medeiros, José. *José Medeiros: Chroniques bresiliennes*. Edited by Sergio Burgi and d'Elise Jasmi. Paris: Hasan, 2011.

Meiselas, Susan. *Kurdistan: In the Shadow of History*. Chicago: University of Chicago Press, 2008.

———. *Nicaragua: June 1978–July 1979*. Edited by Claire Rosenberg. New York: Pantheon, 1981.

Meyer, Pedro. *Truths and Fictions: A Journey from Documentary to Digital Photography*. New York: Aperture, 1995.

Michaud, Philippe-Alain. *Aby Warburg and the Image in Motion*. Translated by Sophie Hawkes. New York: Zone, 2004.

Minelli, Gian Paolo. *Zona Sur, Barrio Piedra Buena, Buenos Aires, Argentina, 2001–2006*. Geneva: Attitudes, 2007.

Mitchell, W. J. T. *Picture Theory: Essays on Verbal and Visual Representation*. Chicago: University of Chicago Press, 1995.

———. *What Do Pictures Want? The Lives and Loves of Images*. Chicago: University of Chicago Press, 2006.

Moholy-Nagy, László. *Painting, Photography, and Film*. Translated by Janet Seligman. Cambridge, MA: MIT Press, 1973.

Morris, Rosalind, ed. *Photographies East: The Camera and Its Histories in East and Southeast Asia*. Durham, NC: Duke University Press, 2009.

Mraz, John. *Looking for Mexico: Modern Visual Culture and National Identity*. Durham, NC: Duke University Press, 2009.

———. *Photographing the Mexican Revolution: Commitments, Testimonies, Icons*. Austin: University of Texas Press, 2012.

Nancy, Jean-Luc. *The Ground of the Image*. Translated by Jeff Fort. New York: Fordham University Press, 2005.

———. *The Muses*. Translated by Peggy Kamuf. Stanford, CA: Stanford University Press, 1997.

Ortiz Monasterio, Pablo, ed. *Frida Kahlo: Her Photos*. Mexico City: RM, 2010.

———. *The Last City*. Santa Fe, NM: Twin Palms, 1995.

———, ed. *Mexican Portraits*. New York: Aperture; Mexico City: Fundación Televisa, 2013.

Parr, Martin. *Small World*. Text by Simon Winchester. Stockport, UK: Dewi Lewis, 1995.

Parr, Martin, and Gerry Badger. *The Photobook: A History*. 2 vols. London: Phaidon, 2004–6.

Pinney, Christopher. *Photography and Anthropology*. London: Reaktion, 2011.

Pinney, Christopher, and Nicolas Peterson. *Photography's Other Histories*. Durham, NC: Duke University Press, 2003.

Poole, Deborah. *Vision, Race, and Modernity: A Visual Economy of the Andean Image World*. Princeton, NJ: Princeton University Press, 1997.

Príamo, Luis, ed. *Los años del daguerrotipo: Primeras fotografías argentinas, 1843–1870*. Buenos Aires: Fundación Antorchas, 1995.

Prochaska, David, and Jordana Mendelson. *Postcards: Ephemeral Histories of Modernity*. University Park: Pennsylvania State University Press, 2010.

Rabb, Jane, ed. *Literature and Photography: Interactions, 1840–1990; A Critical Anthology*. Albuquerque: University of New Mexico Press, 1995.

Rancière, Jacques. *The Future of the Image*. Translated by Gregory Elliot. New York: Verso, 2009.

RES. *Intervalos intermitentes*. Buenos Aires: Dilan, 2008.

———. *La verdad inútil / The Useless Truth*. Edited by Guido Indij. Buenos Aires: La Marca, 2006.

Ribalta, Jorge. *Universal Archive: The Condition of the Document and the Modern Photographic Utopia*. Barcelona: Museu d'Art Contemporani de Barcelona, 2008.

Richard, Nelly. *Crítica de la memoria, 1990–2010*. Santiago, Chile: Ediciones Universidad Diego Portales, 2010.

Richin, Fred. *Bending the Frame: Photojournalism, Documentary, and the Citizen*. New York: Aperture, 2012.

Rivas, Humberto. *Los enigmas de la mirada*. Valencia, Spain: IVAM Centre Julio González, 1996.

Rugg, Linda Haverty. *Picturing Ourselves: Photography and Autobiography*. Chicago: University of Chicago Press, 1997.

Ruiz, Alma. *Rosângela Rennó: Cicatriz*. Los Angeles: Museum of Contemporary Art, 1996.

Salgado, Sebastião. *Workers: An Archaeology of the Industrial Age*. New York: Aperture, 1993.

Schwarcz, Lilia Moritz. *The Emperor's Beard: Dom Pedro II and the Tropical Monarchy of Brazil*. Translated by John Gledson. New York: Hill & Wang, 2004.

Schwartz, Marcy, and Mary Beth Tierney-Tello, eds. *Photography and Writing in Latin America: Double Exposures*. Albuquerque: University of New Mexico Press, 2006.

Sekula, Allan. "The Traffic in Photographs." *Art Journal* 41 (Spring 1981): 15–25.

Siegert, Bernhard. *Passage des Digitalen: Zeichenpraktiken der neuzeitlichen Wissenschaften, 1500–1900*. Berlin: Brinkmann & Bose, 2003.

———. *Relays: Literature as an Epoch of the Postal System*. Translated by Kevin Repp. Stanford, CA: Stanford University Press, 1999.

Sliwinski, Sharon. *Human Rights in Camera*. Chicago: University of Chicago Press, 2011.

Smith, Graham. *Photography and Travel*. London: Reaktion, 2012.

Sontag, Susan. *On Photography*. New York: Anchor, 1990.

Stern, Grete. *Sueños: Fotomontajes de Grete Stern; Serie complete*. Buenos Aires: Fundación CEPPA, 2003.

Stewart, Garrett. *Between Film and Screen: Modernism's Photo Synthesis*. Chicago: University of Chicago Press, 2000.

Sutton, Damian. *Photography, Cinema, Memory: The Crystal Image of Time*. Minneapolis: University of Minnesota Press, 2009.

Tagg, John. *The Disciplinary Frame: Photographic Truth and the Capture of Meaning*. Minneapolis: University of Minnesota Press, 2009.

Tanney, Edward, and Publio Lopez Mondejar. *Martin Chambi, 1891–1973*. Washington, DC: Smithsonian Institution Press, 1993.

Tejada, Roberto. *National Camera: Photography and Mexico's Image Environment*. Minneapolis: University of Minnesota Press, 2009.

Toomey-Frost, Susan. *Timeless Mexico: The Photographs of Hugo Brehme*. Austin: University of Texas Press, 2011.

Torres, Francesc. *Dark Is the Room Where We Sleep / Oscura es la habitación donde dormimos*. Barcelona: Actar, 2007.

Townsend, Richard P., and Cecilia Fajardo-Hill. *Changing the Focus: Latin American Photography, 1990–2005*. Long Beach, CA: Museum of Latin American Art, 2010.

Valéry, Paul. "The Centenary of Photography." In *Classic Essays on Photography*, ed. Alan Trachtenberg, 191–98. New Haven, CT: Leete's Island, 1980.

Vanderwood, Paul, and Frank Samonaro. *Border Fury: A Picture Postcard Record of Mexico's Revolution and the U.S. War Preparedness, 1910–1917*. Albuquerque: University of New Mexico Press, 2012.

Vives, Christina, and Mark Sanders, eds. *Korda: A Revolutionary Lens*. Göttingen, Germany: Steidl, 2008.

Weber, Samuel. *Mass Mediauras: Form, Technics, Media*. Stanford, CA: Stanford University Press, 1996.

Young, Cynthia, ed. *The Mexican Suitcase: The Rediscovered Spanish Civil War Negatives of Capa, Chim, and Taro*. 2 vols. Göttingen, Germany: Steidl; New York: International Center of Photography, 2010.

Contributors

Eduardo L. Cadava teaches in the Department of English at Princeton University. He is the author of *Words of Light: Theses on the Photography of History* (1997) and *Emerson and the Climates of History* (1997) and coeditor of *Who Comes After the Subject?* (1991), *Cities without Citizens* (2004), and a special issue of the *South Atlantic Quarterly* titled *And Justice for All? The Claims of Human Rights* (2004). He is presently translating Nadar's memoirs for MIT Press, and his book *Paper Graveyards: Essays on Art and Photography* is forthcoming from Princeton University Press in 2014.

Gabriela Nouzeilles is professor and chair of the Department of Spanish and Portuguese at Princeton University. She is the author of *Ficciones somáticas: Naturalismo, nacionalismo y políticas médicas del cuerpo* (2000) and *Of Other Places: Patagonia and the Production of Nature* (forthcoming) and the editor of *La naturaleza en disputa: Retoricas del cuerpo y el paisaje* (2002) and coeditor of *The Argentina Reader: History, Culture, and Politics* (2003). She is currently working on a new book titled *Off-Camera: Readings on Literature and Photography*, which addresses five articulations of literature and photography in modern Latin American culture and literature.

Joan Fontcuberta is a photographer and essayist and a lecturer in audiovisual communication at the Universitat Pompeu Fabra in Barcelona. He is the author of *El beso de Judas: Fotografía y verdad* (1997), and his more recent projects include *Deconstruir Ossama* (Deconstructing Osama), *Deletrix*, *Googlegrames*, and *Miracles & Co.* He has been awarded the David Octavius Hill Prize from the Deutsche Fotografische Akademie (1988), the Chevalier de l'Ordre des Arts et des Lettres from the Ministry of Culture of France (1994), the National Photography Award (1998), and most recently the 2013 Hasselblad Foundation International Award in Photography.

Valeria González is an independent scholar and curator who teaches contemporary art and photography at the Universidad de Buenos Aires and the Universidad Torcuato Di Tella. Since 1996 she has worked as an independent curator. Among her books are *El pez, la bicicleta y la máquina de escribir* (2005), *Como el amor: Polarizaciones y aperturas del campo artístico en la Argentina, 1989–2009* (2009), *En busca del sentido perdido: 10 proyectos de arte argentine, 1998–2008* (2010), and *Fotografía en la Argentina, 1840–2010* (2011).

Thomas Keenan is associate professor of comparative literature and director of the Human Rights Project at Bard College. He is the author of *Fables of Responsibility* (1997) and of articles in *PMLA*, the *New York Times*, *Wired*, *Aperture*, *Bidoun*, *Political Theory*, and other journals. He has edited *The End(s) of the Museum* (1996) and has coedited *New Media, Old Media* (2005), *Responses: On Paul de Man's Wartime Journalism* (1989), and *Paul de Man: Wartime Journalism, 1939–1943* (1988). He cocurated, along with Carles Guerra, the award-winning exhibition *Antiperiodismo* (Antiphotojournalism) at La Vireinna in Barcelona in 2010.

Mauricio Lissovsky is associate professor at the School of Communications of the Federal University of Rio de Janeiro and a member of the advisory board of the Centre for Iberian and Latin American Visual Studies, Birkbeck College, University of London. He is the author of *Escravos brasileiros do século XIX* (1988), *Colunas da educação* (1996), *Retratos modernos* (2005), and *A máquina de esperar: Origem e estética da fotografia moderna* (2008). He also has written the scripts for several feature-length films, including *Serra Pelada* (dir. Victor Lopes, 2010); *Eliezer, engenheiro do Brasil* (dir. Victor Lopes, 2009); and *A Pessoa é para o que nasce* (dir. Roberto Berliner, 2004).

John Mraz is research professor at the Instituto de Ciencias Sociales y Humanidades, Universidad Autónoma de Puebla (Mexico). He has published widely in Europe, Latin America, and the United States on the uses of photography, cinema, and video in recounting the histories of Mexico and Cuba. Among his recent books are *Photographing the Mexican Revolution: Commitments, Testimonies, Icons* (2012), *Looking for Mexico: Modern Visual Culture and National Identity* (2009), and *Nacho López, Mexican Photographer* (2003). He has curated international photographic exhibitions in Europe, Latin America, and the United States.

Index

Photography Credits

© Aperture Foundation Inc., Paul Strand Archive: 156–57

© Archivo General de la Nación, Fondo Hermanos Mayo, Chronological Section, #3959: 68; #13428: 69

© Wafaa Bilal: 87

© Florencia Blanco: 204–5

© Enrique Bostelmann: 188

© Estate of Hugo Brehme: 64, 126

© Marcelo Brodsky: 21, 34, 197 (bottom), 198 (center), 199 (left and right), 200 (center), 201 (left and second from right), 206

© Bibi Calderaro: 61

© 2013 Henri Cartier-Bresson / Magnum Photos, courtesy Fondation Henri Cartier-Bresson, Paris: 145

© Juan Manuel Castro Prieto: 173

© Toni Catany: 209

© Collection Center for Creative Photography, The University of Arizona: 55; © Collection Center for Creative Photography, The University of Arizona © 1995 The University of Arizona Foundation: 144

© Joan Colom: 8, 165–67, 169

© CONACULTA-INAH-SINAFO-FN-MEXICO, #63464: 63 (left), 135; #35001: 128; #32942: 129; #6345: 130; #37311: 131; #5291: 132; #5670: 134

© Horacio Coppola: 186–87

© Bruno Dubner: 40, 223

© Manel Esclusa: 35, 197 (top), 203

Photo by Jeffrey Evans: 52, 65 (left), 66, 67 (bottom), 68–69, 127, 145–58, 180, 181, 185–95, 202

© Joan Fontcuberta: 29, 94–95

© Paolo Gasparini: 189, 192

© Eduardo Gil: 176–77

© Adenor Gondim: 54

© Luis González Palma / image courtesy the Schneider Gallery, Chicago: 25

© José Hernández-Claire: 65 (right)

© Graciela Iturbide: 155, 158, 178–80, back cover; images courtesy the Rose Gallery, Santa Monica: 39, 159

© Erik Kessels: 85

© Víctor León: 67 (top)

© Zoe Leonard / photo by Bill Jacobson, New York: 41

Erich Lessing / Art Resource, NY: 59

© Estate of Nacho Lopez / CONACULTA-INAH-SINAFO-FN-MEXICO #405623: 170; #405641: 171

© José Medeiros: 4–5, 163

© Elsa Medina: 63 (right), 181

© Susan Meiselas / Magnum Photos: 33, 175, 207

© Enrique Metinides: 42, 148–49

© Pedro Meyer: 174

© Gian Paolo Minelli: 212–14

© Xavier Miserachs: 164

© Gabriel de la Mora: 43

Image © The Museum of Modern Art / Licensed by SCALA / Art Resource, NY: 141, 143

Image courtesy National Gallery of Art, Washington: 56 (left)

© Riza Niru: 67 (bottom)

© Pablo Ortiz Monasterio: 190–91, 200 (left and right), 201 (right and second from left); images courtesy the Rose Gallery, Santa Monica: 160–61, 183

© Martin Parr: 198 (left and right), 199 (center)

© Esteban Pastorino Díaz: 210–11

© Walid Raad: 79, 81

© Rosângela Rennó: 50–52

© Rosângela Rennó and Eduardo Brandão: front cover; photo by Ding Musa: 221

© RES: 71–75, 215

© Eva Salmerón Catalán: 58, 60

© Joachim Schmid: 90

© Penelope Umbrico: 89

© Colette Urbajtel / Archivo Manuel Alvarez Bravo, SC: 66, 146–47, 151–54

© Cássio Vasconcellos: 6–7, 194, 217, 219

© Pierre Verger: 185

© Bob Wolfenson: 193

© Facundo de Zuviría: 195

Every effort has been made to identify and contact the copyright holders of images published in this book. Errors or omissions in credit citations or failure to obtain permission if required by copyright law have been either unavoidable or unintentional. The authors and publisher welcome any information that would allow them to correct future reprints.